The Bikini
A Cultural History

Patrik Alac

Publishing Director: Jean-Paul Manzo
Text: Patrik Alac
Translation from French: Mike Darton
Design: Cédric Pontes
Layout: Stéphanie Angoh
Cover and jacket: Cédric Pontes

We would like to extend our special thanks to Mike Darton for his invaluable cooperation.

Parkstone Press Ltd, New-York, USA, 2002
Printed and bound in Hong Kong
ISBN 1 85995 795 1

The Bikini
A Cultural History

Patrik Alac

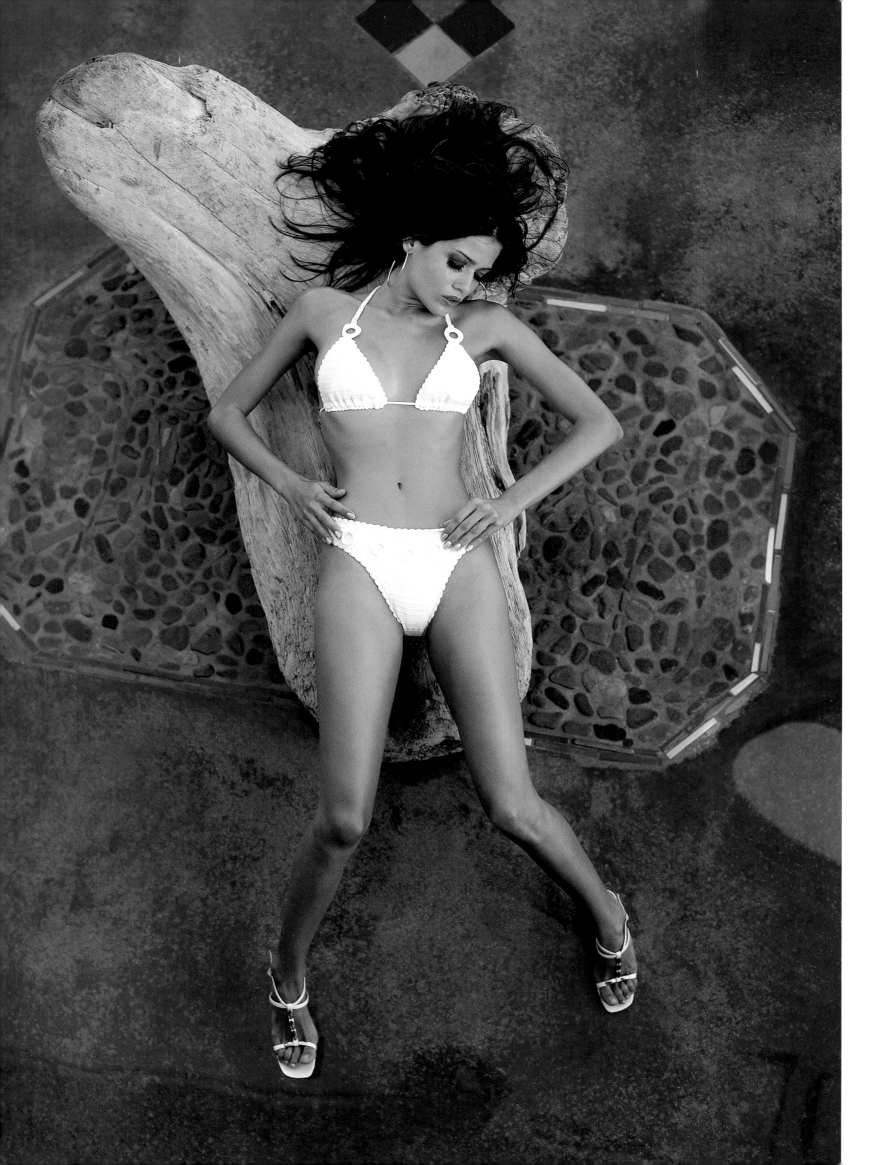

Contents

Introduction

1.

Punta del Este: bikini, seen from behind.

2.

Retouched photo dating from the end of the 19th century showing a temporary changing-cubicle. The lady in the middle has already changed, and now waits within the shelter of a shell-shaped structure for her lady-friend to change behind a curtain. A third woman, perhaps the mother, is still fully dressed on the right. She wears a hat and a neckerchief, and sits upright on a chair holding a parasol. In the distant background, two other women are walking on the beach. The whole scene is undoubtedly staged very carefully to present a somewhat risqué view of the state of undress of the young lady who is changing. In the event, this could be classed as an erotic picture..

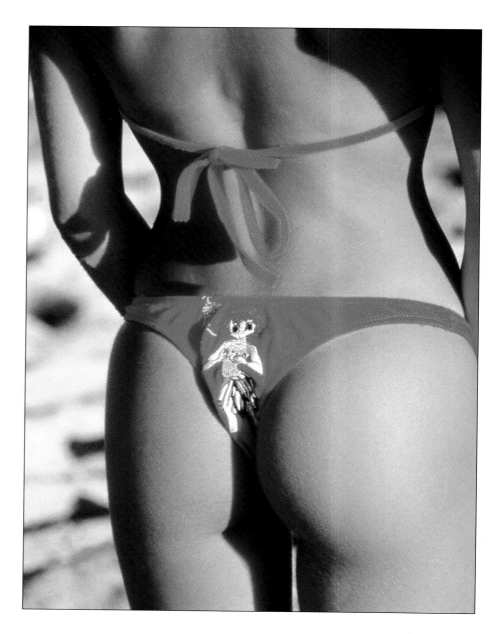

The beginning of a new millennium – let alone a new century – simply demands a quick but thorough look back at the past hundred years. Different outline sketches of the history of the 20th century might all too quickly resort to headline-style formulae about "a century of war and terrorism", "a century of barbarism", and omit any mention of a great number of events and triumphs that should be rightfully regarded as entirely positive. These might seem to have been of secondary significance in relation to more sombre events, but they certainly cannot be excluded if our historical round-up of a hundred years is to retain its proper balance, if it is to be truly historical, and not be reduced to checklists of damage and destruction, of wars and disasters and their costs in lives and property, of the numbers of casualties, and of the people, places and things that are now as if they had never been.

Made possible by the decline of prudish Christianity, the return of the human body to a status in which it could once more be looked at and admired was surely one of these positive events. The process of liberalization began at the end of World War II, and eventually extended across the entire Western world. It was parallelled by moralizing court judgements and injunctions against it, many of them relying on ancient laws well overdue for repeal – and was decisively assisted by the invention of the bikini.

Measurement of the effect of this new culture of the body has itself become a basis of scientific theory. For it is often a level of "dress formality" that represents a means of establishing precisely where on the equivalent scale of personal liberties a given society has reached. In another sense, dress formality (or the lack of it) is no

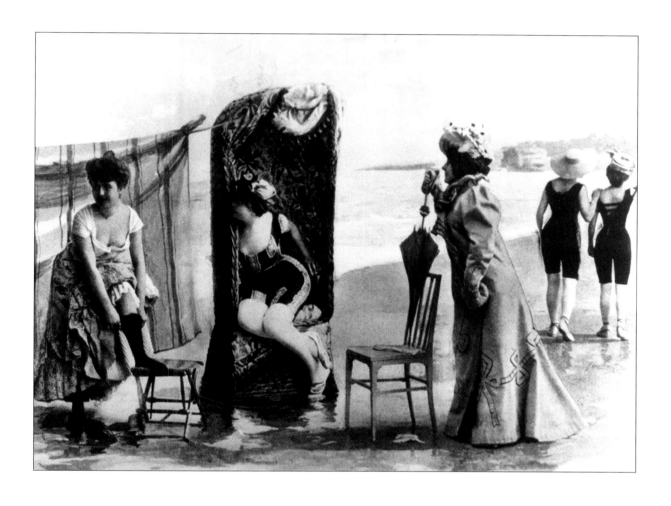

more than a very old – and very elementary – method of communication between people. Besides indicating class, rank and social status, clothes since the 1960s have also had ideological implications. It is interesting in this regard that even something that bears no resemblance at all to an official uniform may nonetheless become the equivalent of a uniform for one group or another. At the head of such revolutionary sartorial tendencies – with one or two scandals to celebrate its birth, and one or two outbursts of moral outrage to celebrate its coming of age – proudly stands the bikini.

Another aspect of the upheavals since 1945 may be grasped all the better in the light of the words "consumer demand and mass communications" used to betoken the totality of social activities. A history lesson on the bikini would at once point out the importance of the combination of saleable goods and the benefits of advertising following World War II. It should perhaps be recalled that it was during a time of economic depression that the bikini was launched and the cinema relaunched. At the beginning of the 1950s, film directors made much of the "almost nude" look of the itty-bitty bathing costume in the hope of attracting ever more customers to their auditoriums. The popularity of the films they produced was in turn utilized by the designers of bikinis as a showroom to display their latest creations. It was possible to foresee the day of the publicity film-clip which had everything: goods that people wanted, described with attractive enthusiasm, all done artistically.

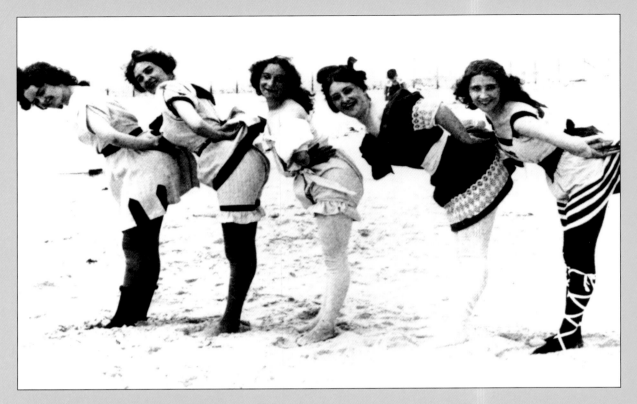

3.
Photo of Coney Island at the beginning of the 20th century. The holiday resort regarded by some as "Sodom-on-Sea" seems to be living up to its reputation as these five ladies lift their skirts in the style of a dubious rendition of the French can-can. They are wearing swimming costumes that cover the entire body with the exception of the arms. It is interesting to note how many layers of material are involved. Over a woollen body-stocking a short pair of trunks is held in place by straps at the thighs; on top of which is the bathing costume proper. The Rubenesque proportions of the carefree dancing girls are typical of their time.

4.
Another photo from the beginning of the 20th century shows the American holiday resort of Coney Island and a group of happy bathers. The women are wearing swimsuits that resemble nightshirts. Most often deep blue with white stripes (a colour scheme that was widely used, and especially in beach costumes for boys) in spirals, vertical lines or horizontal hoops. Such costumes extended down to the calves of the legs.

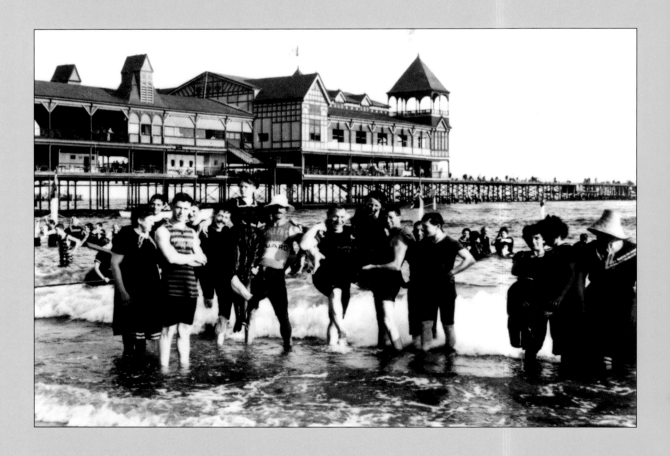

All the same, the spread of "the smallest swimsuit in the world" did not follow solely from the newly liberalized social perception of the human body but relied on the application of that perception to the realm of women's fashions. Anorexia and other eating disorders, the fanatical pursuit of sport and of bodybuilding, are only the latest manifestations of the changed vision of the human body that began in the 1950s – first as a new freedom, and then, for some, as a new norm that required discipline or constraint.

All those aspects that might be included in the traditional history books are equally and demonstrably allied to the evolution of the bikini.

This book tells the story of the bikini – its birth in a Parisian swimming-pool in the course of a stiflingly hot July afternoon in 1946, the scandal that followed (which relegated the bikini for ten years to the pages of illustrated magazines for men), its astounding breakthrough onto the cinema screen, the interest that suddenly aroused in the fashion-houses, and finally its triumphant and eventually universal appearance on the beaches the world over. For from Brazil to the Mediterranean via the sandy stretches all along the Californian coast, the bikini has become an irreplaceable part of our aquatic recreational landscape.

It may be brightly coloured, multicoloured or a decent single colour; it may be made of expensive material, of cotton or lycra; it may spread across the hips or leave them largely bare with just a thong or string at the back [Illustration 1]; or it may consist of no more than brief triangles, like leaves that have somehow gotten stuck on the skin. Alternatively, it may be designed strictly for effect and present a veritable barricade over the breasts. All of these forms are known and seen on a daily basis everywhere we go.

Comprising two pieces of fairly thin material, generally following a double-triangular design, it does not seem to hold much promise when seen dangling from a hanger. But on a woman it undergoes an incredible transformation to behold! Those two pathetic bits of cloth you might have thought were only accidentally on the shop's swimwear shelf suddenly change in form and dimension as if someone had breathed life into them. These patches of material on the skin are all at once points of interest, ornaments, even statements. The bikini reveals as much as it clothes, and there is no red-blooded male observer who is not filled with enthusiasm at the sight of such a transformation.

There is virtually no other item of clothing linked with so many ideas, images and preconceived impressions. For the bikini belongs to the mythology of today that shapes our concept of reality. In much the same way as the speed of a motorcar bestows on its driver an intoxicating sense of power, and indeed just as a gold credit card has the power to avail its possessor of infinite possibilities, the bikini represents a blank screen open to a person's imagination. When we acquire such things or begin to use them, some of the magic they have, the scope for imagination that we credit them with, rubs off on us and can change our lives forever.

So when a woman wears a bikini, she is not simply dressed in any old bathing costume. On the contrary, she is wearing a magical thing, something that will transform her and turn her into someone else – like the magic wand in fairy tales. She becomes, you might say, an actress acting out her own life. For those new virtues bestowed on her by the bikini will take her into a world of new and hitherto unseen possibilities, nothing like the ordinary everyday world – a new world in which everything that should happen does happen, and happens as if destined to happen.

But for a bather in a bikini to be able to reach that world of new possibilities, she must find herself enough space to enable the metamorphosis to take place. Only then does the full range of possibilities become fully available to her. This special kind of space is to be found in what have already been described as "aquatic recreational landscapes" – the sands and beaches along the coasts of the continents: a strip of "space" consisting of an almost infinite number of shorelines and banks, where the rules and regulations that normally govern our lives may be put aside, their authority ignored.

Indeed, we all know this aquatic recreational landscape very well. It forms an irreplaceable part of all our lives. Yet even for a swimsuit as dazzlingly wonderful as the bikini, the process of reaching that landscape and then becoming established in it was neither short nor straightforward.

The first bathers to compete for space on our beaches made their appearance at the end of the 19th century. Until that time the sea had been regarded as disturbingly dark and mysterious. So often extolled by classical authors and poets, the sea had become almost entirely hidden in the murky and morbid world that was the medieval experience of human life. It represented the unknown and the perilous. Even to be near the sea was

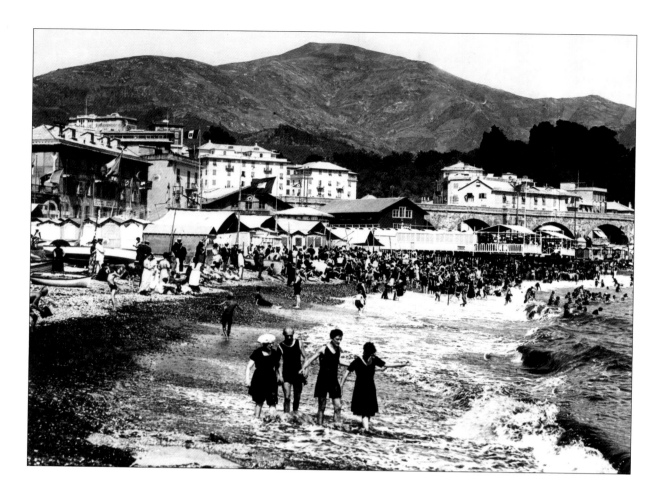

hazardous and unhealthy. People who lived on the coasts kept well clear of the edge, especially when building their houses, in order to be protected from "dangerous currents", not to mention evil spirits.

This belief that certain areas' were injurious to health lasted right up until the beginning of the 20th century. It was always said, for example, that the Coliseum in Rome gave off "unwholesome vapours" – of which much was written by Stendhal in his *Promenades à Rome*. Henry James' *Daisy Miller* contained something similar: the eponymous heroine dies after a night of madness spent in an ancient amphitheatre.

The seaside was prescribed as treatment only for those suffering from incurable illnesses. On the periphery of the unknown, beyond what had long been presumed as the Edge of the World, the Abyss and the Void, it was not so much a seaside resort as a last resort. In much the same vein, during the 17th century to plunge head-first into the sea three times was held to be an efficacious remedy for rabies.

But during the 19th century, the genuine medical advantages of residence beside the sea began to be extolled. Salt water, well shaken until foamy, was declared to have health-giving qualities and prescribed for anaemia, nervous conditions, convalescence after

fractures or sprains, asthma, and skin diseases. Such "cures", however, were strictly science based (as indeed was just about everything during the 19th century), and a patient was required to follow very precise instructions as listed. You might thus be required, with your feet in water that was neither too shallow nor too deep and reasonably close to the beach, to practise supple movements for precisely five minutes, and then to stride forward boldly until the water reached the level of your ears, and to remain in that position for as long as possible without moving. Having finally left the water, it would then be imperative to restore your badly slowed circulation by means of stretching exercises on the beach.

It is rather like what happened when public services began on the trains. Passengers were advised to protect themselves from being thrown around by the high speeds by strapping cushions on the stomach and back. Again it was a matter of protecting the body from the terrors of a new and unknown environment.

Costumes for bathing were first designed for practical use on the beach and in the sea. Initially, there was a great difference between beachwear and costumes for the swimming-pool or inland lake. The latter was modelled virtually precisely on items of clothing that were stitched together layer upon layer as worn by women at the end of the 19th century in town or village.

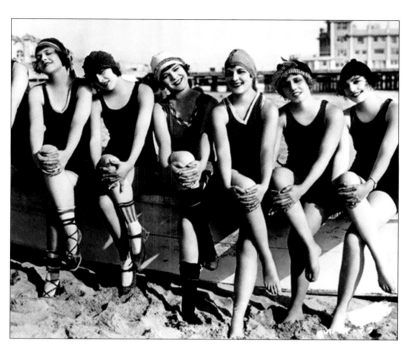

5.

A beach in northern Italy between Genoa and Santa Margherita in around 1900. In the foreground are two couples walking at the water's edge. The men are wearing dark-coloured costumes not unlike sportswear, while the women's swimsuits are longish, reaching down to the knees. In the background are the crowds who have thronged to the semicircular beach of the bay – a scene that remains much the same today. To the right are the heads of a few swimmers. And to the left at the back is a complex of beach huts and entertainment tents.

6.

Beachwear fashion at the beginning of the 20th century. Six women gracefully adopt a uniform pose aboard a boat. They wear swimming-caps (one of which is decorated with a feather) and one-piece costumes inspired by sportswear that was particularly fashionable at the time. With the right leg crossed over the left, they bring their hands together over their right knees. The costumes, which only just cover the thighs, clearly show the new minimalist tendency in swimwear fashion that was hereafter also to be seen in various sports. All six are wearing makeup – notably using lipstick to alter the shape of their mouths – including whitening their facial skin to contrast with their darkened lips, giving a doll-like look that is enhanced by the hair jammed under the swimming-caps and the rather fixed smiles. This is evidently a time when innocence had begun to be taken less seriously as the body might be revealed more and more openly.

Therefore, trips to the seaside were then by no means necessarily associated with swimming. In any case, to enter the water at all usually meant no more than a headlong plunge before coming out again – literally a "quick dip." This is why the first "bathing costumes" were as full and as ornate as everyday clothing, and designed to cover as much as possible. Another function was to keep the bather warm, whether on the beach or in the water, for which reason most were made of thick material with insulating properties, such as cotton. Bathing costumes were certainly not meant for ogling.

Until World War I, the distance across the beach and into the water might be traversed in a "bathing machine", a sort of changing-cubicle on wheels that was itself pushed into the water; the bather might then jump from it straight into "the sea."

Illustrations 2 to 7 clearly demonstrate how beach-wear fashion has changed since the early days. The need not to offend contemporary views on modesty, the difficulties of making bathing costumes in which it was actually possible to swim – these were the great problems that real creativity had to solve. At the same time it should be noted – in light of these photos of an era now long gone – that it was at this point that the space of the beach began to be appreciated. The somewhat vaudevillean elements of dress shown in the last of these pictures imply an atmosphere of popular festivity appropriate to summer at the seaside.

Originally, the beach made no allowance for the separation of people by class or type: its supposedly bracing virtues thus also made it a place of unusual civil liberty. In time too, and equally noticeable, the leisure industry – from which the tourist industry would later stem – began to gain a foothold along the shoreline. The great constructions several floors high on Coney Island, which dominate the coastline like a sort of maritime Champs Elysées on stilts, and the masses of sun-seekers on the beach near Genoa behind which a wild forest of tents has been erected, afford us an idea of what it must have been like at the fumblingly improvised beginnings of our aquatic recreational landscape.

But it is on the faces of those early bathers that the true purpose of this newly constituted space is shown still more clearly. These are smilingly joyful faces that might have been working for some publicity agency. They are the extraordinarily striking evidence of the total freedom of the beach as a place of pleasure and fun. They are proof to us of the successful inauguration of a world in which only tranquillity and the pleasures of relaxation reign.

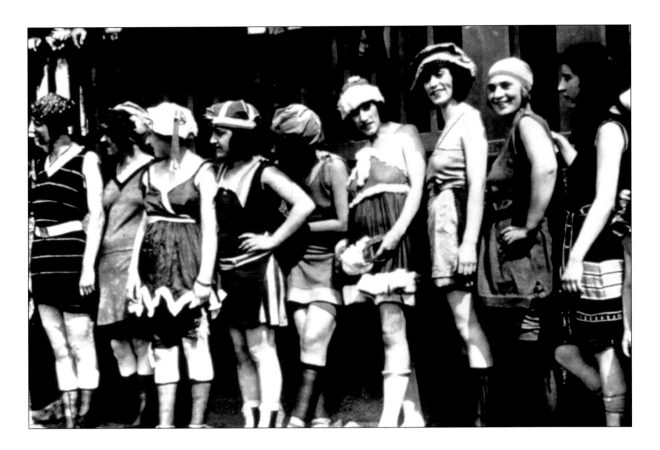

7.
A group of ladies around 1910. They wear longish bathing costumes down to the knees – but these are costumes worthy of some outlandish festival with the evident variety of their colours and their imagination. In the middle is a Santa Claus with white trimmings. On the left are two characters who might well be jesters at some medieval royal court. And further left is a striped dress meant to be a swimming costume. That there is a close connection between swimwear fashion and lingerie could hardly be made plainer. All the women are wearing shoes (the one fourth from the left seems even to be wearing boxing trainers) and tights.

Once World War I was over, all the conditions were set in place for beach life as we know it today. A picture of 1925 shows a woman in a fairly rudimentary one-piece costume sitting between two couches at Deauville [Illustration 8]. The costume, which resembles a nightgown raised to the level of the thighs, is designed for straightness of line in trim with the contours of the body. But it does not yet reveal those contours. The woman, who peers out at us somewhat anxiously, is extremely slender and looks quite different from the bathers of around 1900. In the background it is possible to make out the slope of the beach on which couches and beachtowels have replaced the crammed baskets and tents. For the invasion of the world's beaches by the masses has now begun. The scene shown could pretty well – apart from the style of clothing – be seen taking place at a coastal bathing-site (of any kind at all) today. The accessories left unattended in the background – the sandals and, a bit farther back, a bag, a towel and a sunshade – bear witness to a family excursion to the beach.

In no more than 20 years, going to the beach in this way was to become a truly global phenomenon in which men and women of every country and every language shared their passion for sea-bathing and disporting themselves on the sands. It was also exactly 20 years before the bikini would be born ...

8.
Bathers on the beach at Deauville around 1925. The swimming costume that looks like a long shirt reaching down to the hips is close-fitting and emphasizes the form of the body. The woman with the rather anxious air is extremely slim and obviously quite different from the bathers of 1900. In the distant background it is possible to discern the settles and sheets that had replaced wicker beach-baskets and voluminous beach tents. This is the beginning of the assault by the masses on beaches all over the world.

The Bikini

The bikini is a bathing costume that is narrow and in two parts, of a maximum area of 7 square inches (45 square centimetres), and not specifically intended for bathing. It can be sold in a matchbox, or folded easily into a handbag compact. It represents clothing for a woman such that she does not feel completely naked, yet leaves her sufficiently undressed to be irresistibly attractive to men.

9.
The jam-packed Deligny Pool in Paris on July 2, 1958. Evidently, most of the people there are men. The few women present are wearing one-piece or two-piece costumes indiscriminately.

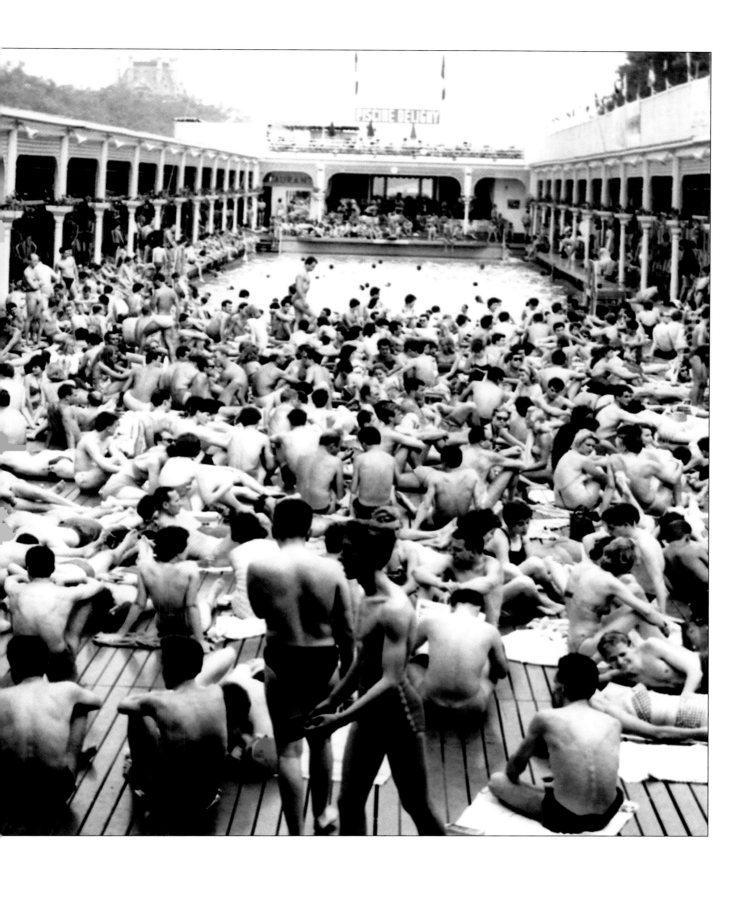

Chapter 1:
The Birth of the Bikini

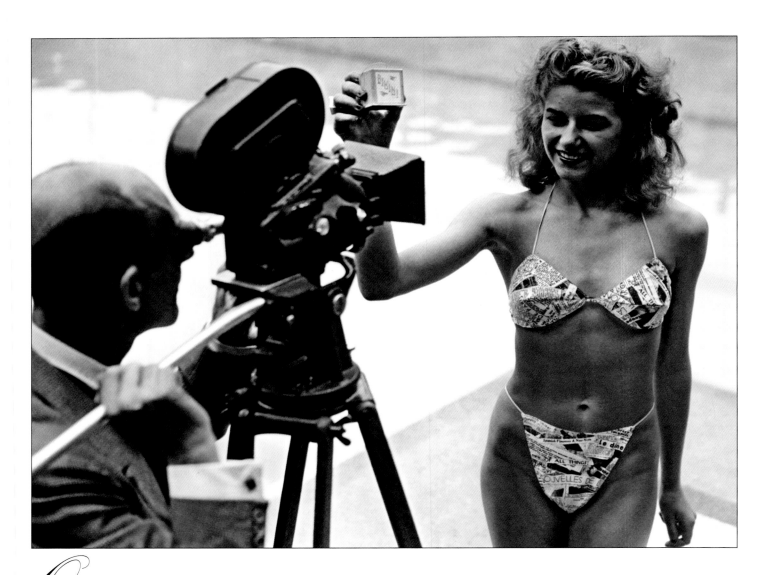

On July 1, 1946, at 9 o'clock in the morning, an atomic bomb exploded with a force of 23,000 tons above Bikini, a coral atoll in the South Pacific hitherto virtually unheard of. More than six disarmed warships of the Japanese and American fleets were sunk, and more than twice that number were seriously damaged.

Weather conditions were ideal for the test. The sky was clear. There was no wind at all. All at once, an enormous column of smoke towered above the archipelago. At the foot of it was what seemed like a ball of fire. At first blindingly white, it then turned orange, wine-red, and finally greyish green. The cloud of smoke – some 33,000 feet (10,000 metres) high, according to some watching aircraft pilots' estimates – was regularly penetrated by radio-controlled planes containing live guinea-pigs and banks of highly sensitive scientific measuring aparatus.

This was the first "official" nuclear experiment since the end of World War II when the bombs dropped so devastatingly on Hiroshima and Nagasaki. All the major newspapers made much of its effects on the paradise that had been the Southern Seas, their reports motivated at least partly by propaganda – the United States, the sole atomic power of the age, was demonstrating to its Soviet adversaries the terrifying extent of that power.

Incoporated into that propaganda were rumours about the bomb's potentially destructive effect on the planet. These were rumours spread at informal levels and kept circulating due to genuine fears and concerns. Yet the world continued on as it always had, and humanity very soon felt confident enough to declare in a French newspaper that, "the Earth has not been turned to liquid, the sky not become streaked with flames, the oceans not dried up into rocky deserts."

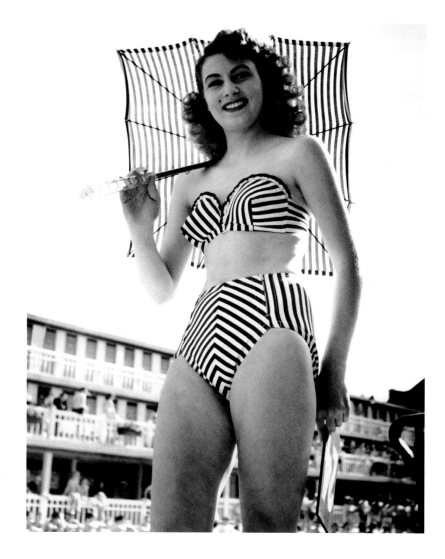

10.
July 5, 1946: Réard's line-up with Micheline Bernardini at the Molitor Pool in Paris for the title of "Most Beautiful Swimmer."

11.
Bikini from the Réard collection, June 12, 1949.

All the same, from a military point of view the outcome – apart from finding out what the atomic bomb was capable of when exploded over water – was nothing less than a complete fiasco. By no means all of the target ships, painted bright yellow and orange for the occasion, had been sunk, and the primary target vessel, the destroyer Nevada, had escaped damage altogether. The Soviet Russian observers, admitted to the atoll by the Americans, left smirking. Grudgingly, a US admiral conceded that the bomb should only be used against maritime targets in combination with some other more detonative weapon – a torpedo, perhaps.

American hopes for the test results were thus frustrated, and accordingly, the name "Bikini" became familiar all over the world shorn of any of its potentially frightening connotations.

Only four days later, on July 5, in a public swimming pool in Paris where a beauty contest was in process, there was a minor sensation. Of only slight scandal value, it was nonetheless enough to make the term bikini famous for ever. The promoter of the beauty contest, a certain Louis Réard, a clothing designer, used the opportunity to introduce his own latest creation. Even before the contest judges' final verdict, a number of spectators around the edge of the pool had been remarking on how one of the girls (who had been particularly careful to remain facing the audience, as if rapt in thought) had extraordinarily little on. When this girl was then summoned up to the podium as one of the finalists selected by the jury, a murmur of appreciation ran like lightning through the assembly. It was a reaction not to the girl's own beauty or her personality, but to the costume she was wearing.

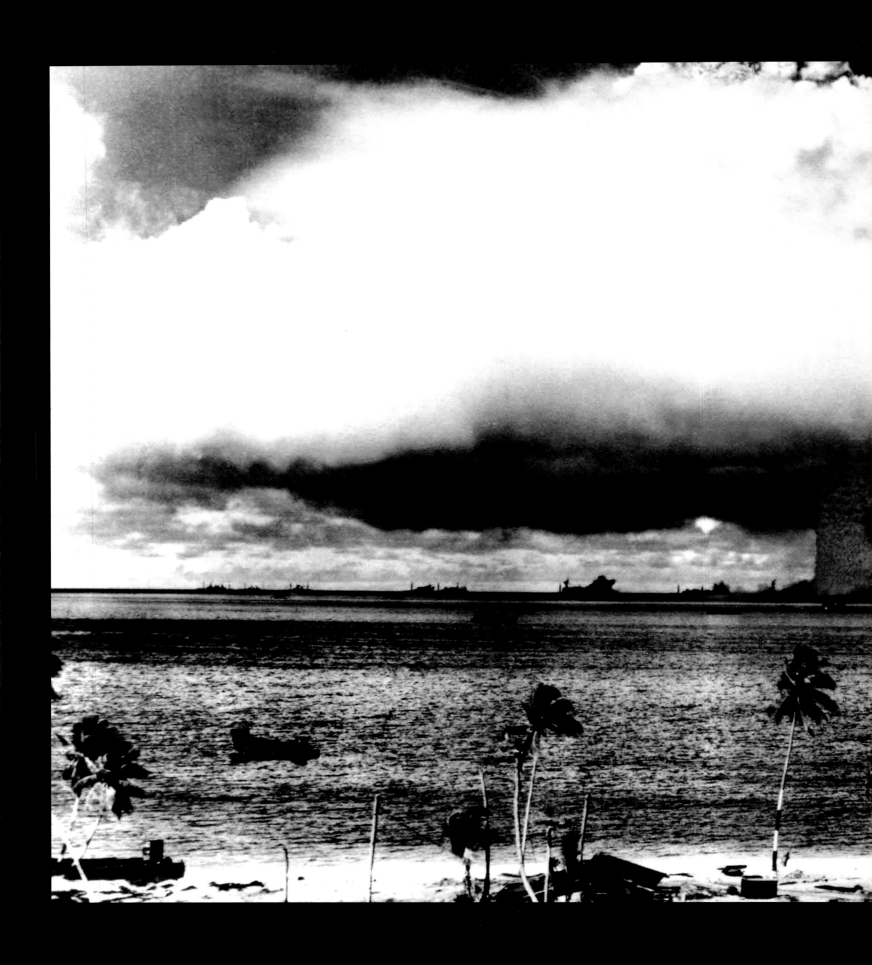

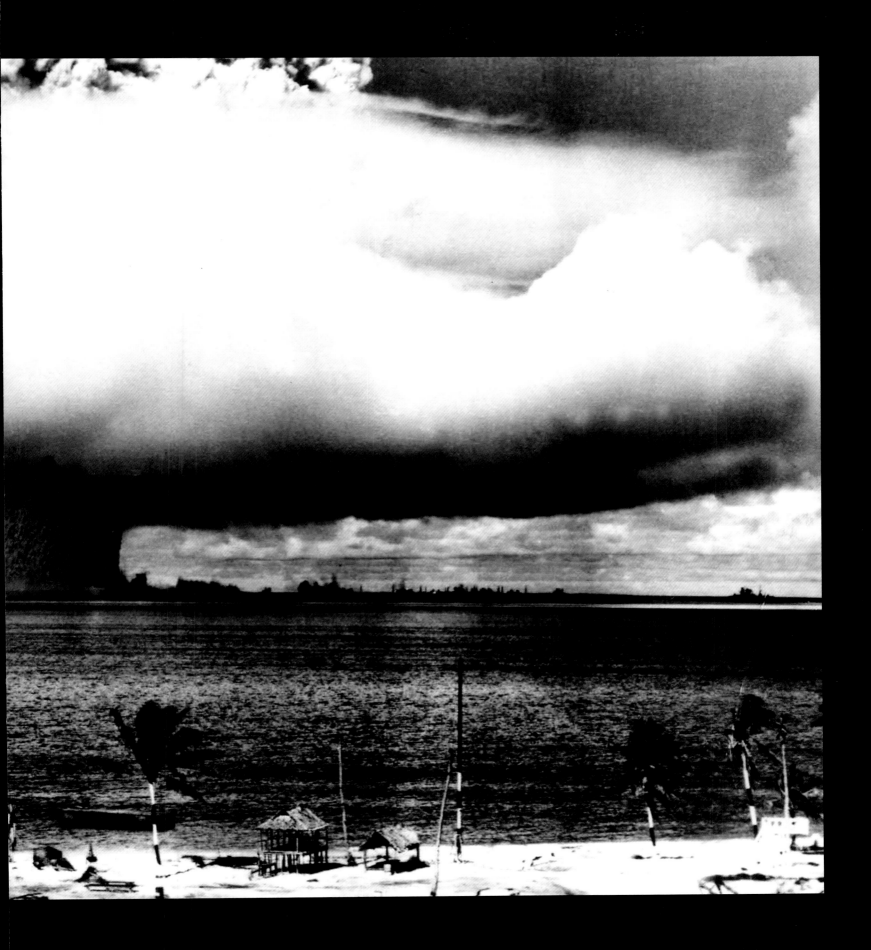

Symbols 1

"Our bomb is the blossoming out, the natural expression in all its truth and glory, of our society – just as Plato's *Dialogues* were the expression of the ancient Greek polis, as the Coliseum was of ancient Rome, as Raphael's Madonnas were of Renaissance Italy, as the gondolas were of aristocratic Venice, as the tarantellas were of certain rustic but musical Mediterranean communities... and as the extermination camps are for our petty-minded bureaucracy which seems already to contain a rabid desire for atomic suicide..." This paragraph by Elsa Morante ("For and Against the Atomic Bomb", Conference at the Teatro Carignano, Turin) claims to pinpoint the image that identifies and characterizes our times. It is that of the atomic explosion and its mushroom-shaped cloud – an image in which all the mental and technological efforts of the past two and a half centuries of "progress" are concentrated, representing both goal and result. But the words also throw light on another side of our civilization: the accompanying desire in our frenetic activities for self-destruction. Like a poisonous mushroom, the atomic bomb has become the symbol for the last 50 years. It shines like an artificial "orange, wine-red, green, and light grey" sun, over empty beaches. When humanity ate for the second time the fruit of the Tree of Knowledge, humans got nothing better or more spiritual out of it than the introduction into this "other Eden, demi-Paradise" a series of scientifically applied atomic tests. But what satisfaction there was on the faces of those lit up by the artificial sun! What pleasure there was in finally having at one's command a weapon that could effect the collective suicide of humanity! What a blessed relief it was to know that it all might no longer exist – the world, humankind, life, dreams and aspirations – and that if things did not measure up and a better future could not be foreseen, one could at least annihilate everything at the press of a button. "An apple from the Garden of Eden" might well describe the circular steel construction designed during World War II and the cheerfully christened Gilda, an image of the perfect woman painted on its outside casting. The term might also be applied to the space-probe sent a few decades later into the depths of the universe containing within it an outline sketch of the human form. Humanity, looking to exterminate itself while yet seeking to preserve the memory of its life-form among distant galaxies, resembles nothing more than a spoiled child who has not received the birthday present longed for, and so in a tantrum destroys all the rest.

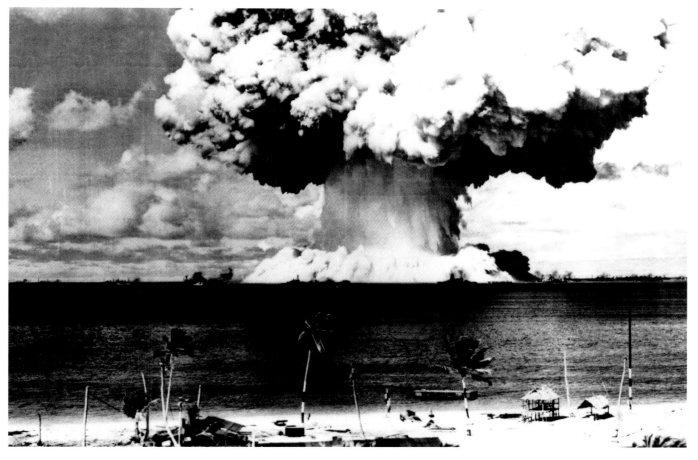

12.
Atomic bomb explosion over the Bikini Atoll in 1946.

13.
Nuclear testing on the Bikini Atoll in the South Pacific, July 1, 1946.

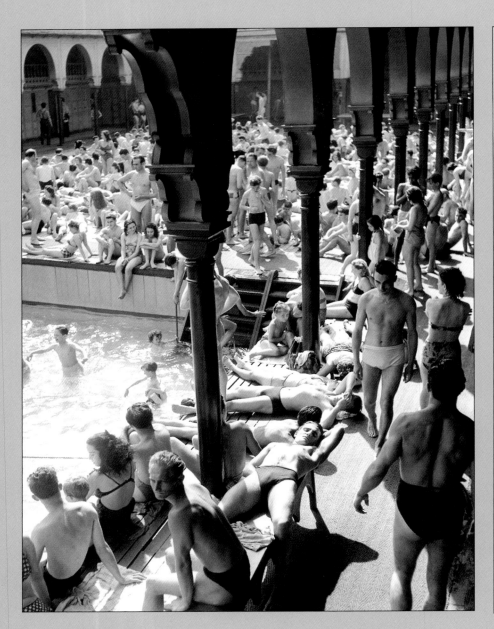

14.
The Deligny Pool in Paris on July 1, 1946. The two-piece models were hardly economic with cloth, as would have been appropriate for the era.

LA PLUS BELLE BAIGNEUSE DE 1946

a été choisie à la fête féminine de l'eau

C'est Jean-Gabriel Domergue qui a décerné la palme

LA piscine Molitor avait retrouvé hier l'éclat des galas qu'on y donnait avant guerre, avec cette Fête féminine de l'eau qui réunissait les meilleures équipes parisiennes de nageuses et quelques-unes des plus charmantes vedettes de la scène et de l'écran.

Malgré le ciel gris, les maillots multicolores, qui se promenaient d'étage en étage, donnaient au nombreux public l'illusion des plages lointaines. On applaudit, bien sûr, aux prouesses des « Mouettes » et autres nymphes, mais le spectacle commença vraiment lorsque les girls du Casino de Paris exécutèrent leur numéro, vêtues de pareos verts, sur la « plage » rouge et blanche.

Il y avait là Madeleine Sologne, Andrex, Nita Raya et, présentant des ensembles inédits, Paulette Dubost, Claudine Céréda, Denise Bosc.

Mais il y avait aussi, débarqué jeudi de l'« Ile-de-France », Léonide Moguy, le célèbre metteur en scène de « Mioche », qui rentre d'Hollywood après cinq ans d'absence.

S'arrachant aux nombreux amis qu'il ne retrouvait pas sans beaucoup d'émotion, Léonide Noguy confia ses projets à l'Aurore :

— Je vais commencer bientôt « Lycée de jeunes filles », d'après un scénario de Serge Veber. Comme je l'ai toujours fait, je donnerai leur chance à des jeunes qui n'ont jamais tourné. Ensuite, j'espère réaliser une production franco-améri-

caine, qui s'appellera « Gardez le sourire » et sera dédiée à l'amitié des deux pays.

Ce que Léonide Moguy ne dit pas, c'est qu'il ne cessa pendant cinq ans de lutter là-bas en faveur de cette amitié. Vice-président de l'association « France for ever », il devint l'un des meilleurs metteurs en scène d'Hollywood. On verra, sans doute, bientôt en France son « Paris after dark », qui évoque nos batailles clandestines.

Mais il a déjà disparu, appelé par Jean-Gabriel Domergue, qui l'installe à ses côtés, à la table d'un jury qui doit désigner la plus jolie baigneuse 1946. Quinze jeunes femmes rescapées de nombreuses éliminatoires, défilent, présentées avec esprit — pensez donc ! — par Jacques Meyran. Un orchestre joue « Paris, c'est une blonde ».

Une vieille rengaine, peut-être. Mais toujours d'actualité.

H. S.

AURORE

Caveant consules !

AU dernier concours d'entrée à l'Ecole normale d'instituteurs de Lyon, 24 cand dats seulement se sont présentés pour une promotion de 35 élèves.

La fonction ne nourrit plus son homme et on comprend que les jeunes gens orientent leur destin vers des professions plus lucratives.

Mais jusqu'où va descendre notre enseignement public ?

Un démenti inutile

NOUS avions souligné, à cette même place, l'amoncellement scandaleux de planches en bordure des Etablissements Couthia, — où s'est installé le Génie de l'Air, à Pierrefitte — et noté qu'un « foyer des vieux » en bois, œuvre admirable, avait surgi non loin de là, alors que M. Charles Tillon, ancien ministre de l'Air, venait de « présenter comme député » dans ce secteur.

Là-dessus, un collaborateur de M. Charles Tillon, ministre de l'Armement, s'était indigné de notre insinuation.

— M. le ministre, nous avait-il écrit, en subs-

tance, à l'étranger dans le ... Et cependant, maire de ce « F... pol » de 1946 : « Ouverture square « Etienne-De... » mis à par M. Th... l'Armemen...

Trop pe...

UN de ... enfants ... concl... plus s'occ... alimentai... à un peti... de Saint-A... vadosi, 9 ... au prix de zaine.

Les œuf... pas au pèr... breuse, ma... reçut une ... Contrôle ... quai de G... œufs aya... gare de S... Bois Et ... s'écrier ...

— Une ... par person... ré ! Et qu... procher, a... ment, l'œu... vente libre... crémiers d... francs pièc... « Me pr...

Le maillot le plus original de la fête s'appelait « Bikini ». Ce n'est pas son nom, d'ailleurs, qui fit son charme...

15.
Written account of the most beautiful bather contest of 1946. July 6, 1946.

Like her companions, she had on a two-piece swimsuit – but hers was of such diminutive dimensions that she seemed more naked than clothed. Her breasts were modestly concealed behind two triangles of cloth held up by a halter strap tied around the neck. The base of the costume was also cut in the shape of a triangle, the widest spread of which was across the abdomen, leaving most of the hips and all of the thighs entirely bare. Only a thin strip of material connected the points of the triangle around the back, well below the level of the navel.

16.
French couturier Jacques Heim's evening dress for the "Maid of Cotton 1962", Penne Percy. The long cotton dress is decorated with large flowers printed upon it in colour. It was first featured on June 19, 1962, in Deauville on the occasion of the International Cotton Convention.

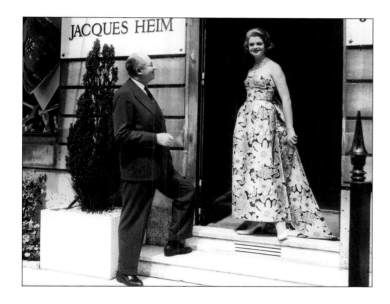

It was a costume that has since become a standard on our beaches today. But to those present at the Molitor Pool on that hot summer afternoon, it was the height of shamelessness and close to obscene.

Thus the bikini was born. It was the first event of a scandal that continued for 20 years. But for the little-known clothes designer specializing in bathing costumes it was an event that represented the peak of his endeavours. Born at the very end of the 19th century, Louis Réard had restricted his activities to beachwear since the 1930s. His avowed ambition was to dress the celebrities of the time in his costumes, Réard costumes. He did make some contact with Maurice Chevalier, among others.

The bombshell that exploded the bikini onto the scene had been set up a long time beforehand, with meticulous preparation. At first Réard had tried to persuade his usual models to take part in his pool-side show. They all refused point-blank, scandalized in particular by the back of the bikini bottom, which left almost all the buttocks uncovered. So Réard was well aware in advance of the outraged reaction likely to follow the pleasure he gained by presenting his latest collection.

But he soon found a suitable model in Micheline Bernardini, a strip-dancer at the Casino de Paris. She would certainly feel dressed, even in the skimpiest bikini. All that was left was for Réard to find an appropriate location in which to present his new costume – and that was not so easy. But on July 2 he read a report in *France Soir* on a fashion parade held on the plane flight between Paris and Moscow, during which "stewardesses" walked up and down the aisle dressed in two-piece outfits in different colours, under the astounded gaze of the passengers.

It was in the light of this that Réard decided to put on his own show during a beauty contest. The midday edition of *France Soir* on July 5 accordingly invited the public to attend the Molitor Pool that very afternoon, where the title of "most beautiful swimmer" would be competed for by gorgeous models and shapely sporting stars under the eyes of a select panel of judges. The prize was to be the Réard Cup – which makes it clear to us now what the real object of the whole exercise at the pool was.

Réard was also obliged to cast around for a memorable name to call his revolutionary two-piece swimsuits. Recent world events, specifically the nuclear tests at the Bikini Atoll – the paradisal isles of the Southern Seas – gave him an excellent pretext.

Several fashion-design historians have suggested that Réard's bikini was in fact named in the light of another recent creation. The celebrated couturier Jacques Heim had himself had the temerity to present – in that same summer of 1946 – a two-piece outfit he called *Atome*. The base of the outfit, different from the customary style for such two-pieces, substituted a rectangular piece of cloth across the hips. Unusual as it was, though, it was nothing like Réard's provocative bikini. It covered the navel (the modesty boundary of the 1940s) and thus required quite a lot more cloth in its manufacture. The only "daring" thing about it was that Heim, as a

to our beaches. Now, in harmony with the mood of the times, he presents his latest… his latest… (What can we call it? The word "costume" is surely too much for it.) His latest beachwear, which he calls the *Atome* – see the picture below…"

Both Heim and Réard took their inspiration from political history of the era, for during the first days of the year 1946 the newspapers were full of the most detailed reports of the atomic tests at Bikini Atoll. It was almost as if a sort of madness had taken over, in which everything was somehow linked with the bomb and its explosive power. Seductive actresses and movie stars were suddenly (and from then on) described as "blonde bombshells on an atomic scale", suggesting that they exuded the torrid heat of sexuality with nuclear force. The word "atomic" was used as an intensifying adjective in virtually every context.

And to some extent Heim could not but be affected by this – although it is also true that his first thoughts for names for his two-piece outfits focused on the themes of reduction and division anyhow.

Réard reinforced this idea, supporting it by christening his creation after the islands so fully and emotively described in the newspapers: the tropical archipelago in the Southern Seas. The name Bikini presented Réard with many possibilities, for it held within it many different connotations. It referred to a particular time and date, and yet was modern and on-going; it evoked notions of swimming in a tropical paradise; and it came to represent a costume for a seductive beauty who revealed much of her skin with all the supposed innocence of a native Pacific islander.

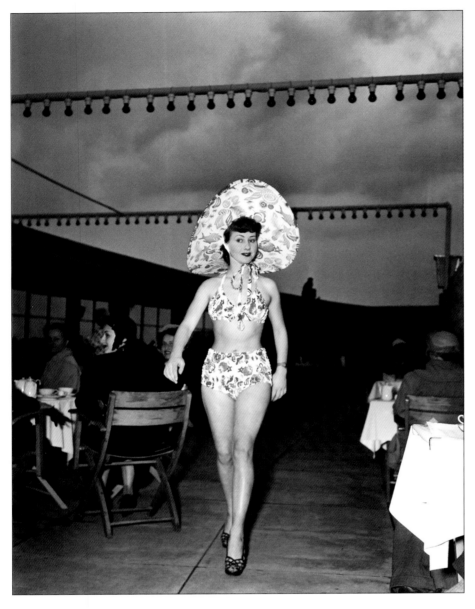

17.
Beachwear in 1952: fashion parade in the Janika Bar, Berlin.

Later, the name of this bathing costume of considerably reduced dimensions would be credited with even further linguistic meaning. Tongue in cheek, designers equated the initial syllable Bi- with the Latin prefix bi- "twice over, two" (which was certainly not the meaning in the atoll's name) in order to derive (with execrable etymological inconsistency) such models as the monokini (which has a Greek prefix) and the trikini.

celebrated designer, had put his own name to it in front of the world. Yet by doing so, he was genuinely associating himself with the more scandalous and rebellious elements in society: those prepared to undermine the accepted rules without openly flouting them.

And it does seem that Heim's *Atome* was designed before Réard's bikini. The French fashion magazine *Fémina* reported in its special July-August holiday edition: "Every now and then Jacques Heim shows us what a special talent he has for swimwear. It was he who, a long time ago now, brought the Tahitian-style pareu

The name also took on something of a sexual connotation which, in a very real way, became implicit in the cultural behaviour of a stratum of society, a metaphor for the improvement of life in general. During

the entire second half of the 20th century the word "bikini" was associated with a particular attitude, a particular image, a particular lifestyle.

It would surely be possible, in a convoluted pseudo-psychological thesis, to prove the existence of a strange link between on the one hand, a murderous weapon and on the other, a girl wearing a sexy bathing costume. The apparent confusion between a symbol of death and an image of love might perhaps have added to the fascinations that we already enjoy in literature, where a name or a title can change all or reveal all.

But on that afternoon of July 5, 1946, we are only at the beginning of our story of the bikini. Not one of the protagonists in the events of that day had any notion of what was to follow. The temperature at the Molitor Pool reached 96° (35°C). The roguishly profane Micheline Bernardini in her sensational two-piece swimsuit winked at the photographers as their cameras flashed incontinently. And at length the beauty contest came to an end.

That evening, the girl's photo showing her with the Réard Cup (actually a silver bowl) in her hand, would appear in *France Soir*. Thereafter she would disappear back into oblivion. But with no concern at all for the girl or her victory, Micheline Bernardini was posing for the same photographers at the same time. Smiling brightly, one leg carefully in front of the other, she had climbed onto an upturned crate and had assumed the stance of the celebrated statue that welcomes new arrivals across the Atlantic in the New York harbour.

That first bikini had an astonishing impact in terms of the material. What seemed from a distance to be cloth with a pattern on it – flowers perhaps – turned out on closer inspection to be a collage of newspaper cuttings and headlines. The bikini thus took every advantage of the media uproar it was bound to provoke, using every means it had in hand.

This lighthearted but yet explicitly knowing gesture by the designer could not emphasize more perfectly the complexity of ways in which this tiny costume would be important. Fashionable and contemporary, shocking by being the least it could possibly be, the bikini nonetheless – from the very first photo shoot, and in the most public way – set itself up as being far more than it

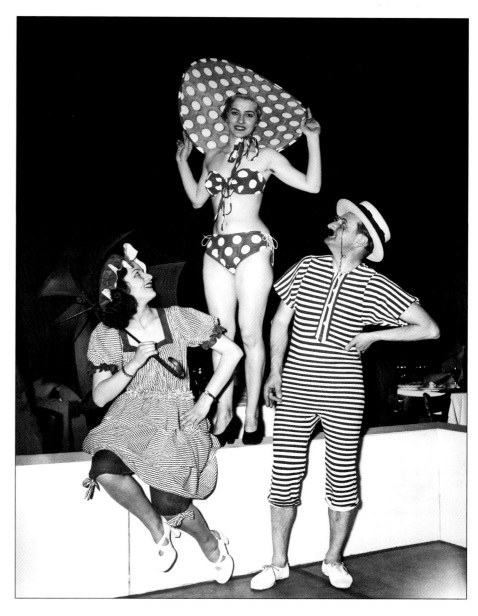

18.
Beachwear in 1952: fashion parade in the Janika Bar, Berlin.

truly was: a scrap of cloth in which a person could go swimming. It embodied fashion's ideals to be more than just an item of clothing, to tell a story, to emanate an aura of imagination and mystique around itself and around the person wearing it.

Fashion, after all, is nothing without a human body on which to display it. It achieves significance only because the human body lends it life and purpose – although the reaction is reciprocal for the fashionable object also lends the body some of its own qualities. Without clothing, the body is virtually without expression: the body has to rely on movement, on

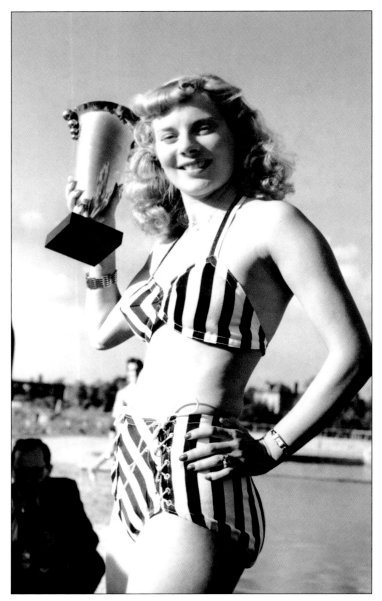

concentrated in the lens of the camera that took the photo of Micheline Bernardini. The beautiful girl paraded once more in front of the astonished throng, hesitating as it was between applause and loud indignation, and then coquettishly made her exit – but not without one last smile from the back of a changing-room.

On the following day nothing happened. A scandal was brewing in the city of Paris, still sweltering in its 96° (35°C), where the inhabitants crowded in amazing numbers around the edges of the swimming pools. Yet in the press there was no mention what so ever of the incipient scandal of the previous day, neither in the newspapers nor in the fashion magazines.

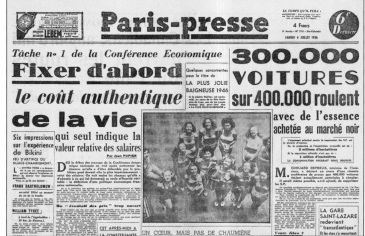

This was evidently a new kind of scandal altogether, a totally silent one. Nothing was said about it on the following day, the following weeks, the following months, not even the following years. The scandal that was the bikini was just not talked about. Its impact could nonetheless be gauged in the numbers of the articles that shrilly praised all those swimsuits that were different from the "tasteless bikini." But there was never any picture. Not even a description. You might well believe that the scandal was so serious that the only way to counter it was with utter silence.

physical activity, to be given any attention. Clothing without the body, meanwhile, is a skin that has been sloughed off, an empty envelope.

It was precisely in this that Réard showed his genius, for he imbued his bikini with importance right from the start, integrating publicity for his creation within the creation itself. The creation thus promoted itself too. It was not simply an item of clothing but a dream, and the stuff of dreams besides.

And so, on July 5, 1946, at the very beginning of the Cold War, when an atoll was reduced to ashes and humanity debated the consequences of the coming atomic age, all these considerations were for an instant

Conversely, during that summer of 1946, everybody was talking about Heim's sensational *Atome*. It was the first fashion season after the war and, the general

mood was to celebrate the return of freedom. The fashion magazines duly gave themselves entirely over to Heim's work.

Publicity for Heim's "revolutionary" two-piece outfits – featured on streamers towed behind light aircraft over France's Côte d'Azur, and describing the *Atome* as "the smallest swimsuit in the world" – was at once parried by

tly improving, and even returning to some pretensions of elegance.

The colours and materials of the extremely brief two-piece costumes were undoubtedly nice to see. But, if we may say so, those who wore them had something of the look of shipwreck survivors, haphazardly covered in scraps and tatters of cloth no larger than a handkerchief.

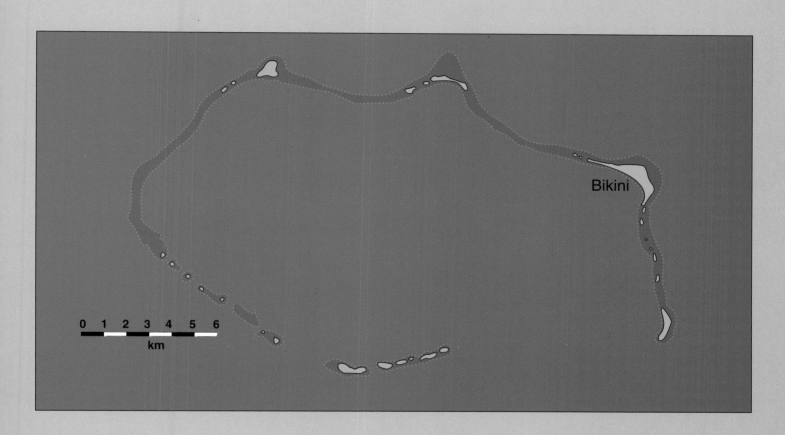

Réard (who was of course equally astute in the art of advertising). His slogan was "The bikini – the bathing costume even smaller than the smallest swimsuit in the world." Women and girls on the beaches followed the trend, even if they did not buy Réard's costumes: it was not difficult, after all, with some deft tucks to adapt a classic two-piece costume at home and turn it into what looked like a bikini that showed almost as much bare skin as the original. It was not until 1954 that Réard was finally allowed advertising space, in the *Vogue* summer special.

In fact, the magazine had not remained silent on the subject for all the intervening period. In 1948 it had expressed its own opinions on the thorny matter, commenting also that current beachwear was distinc-

19.
Jacqueline Maraney (20), secretary, winner of the "Most Beautiful Swimmer" competition on June 26, 1948.

20.
Photograph of participants for the title of the most beautiful bather. *Paris Press*, July 6, 1946.

21.
Map of the Bikini Atoll.

JACQUES HEIM

Readers of *Vogue* had to wait until July 1948 to see the first two-piece costume. Even then it appeared without accompanying text as an illustration in an advertisement for the latest Helena Rubinstein sun cream. Was it a genuine bikini or a classic number that by convention covered the navel? Impossible to tell. The model in the ad had a sash knotted around her waist.

Other magazines such as *Fémina* simply mentioned Heim, whose more conventional work was already beginning to cause some disquiet: "Are there any items of clothing that stand out particularly? Costumes? Well, this year it is on the beach that women are revealing all. Jacques Heim's latest creation he calls the *Atome* – and the name describes its size very aptly. A little too revealing? Indecently so? What can we say? The

23.
Portrait of Jacques Heim.

Jacques Heim was born in Paris in 1899, the son of Isidore and Jeanne Heim, Polish Jewish immigrants who had already acquired French nationality and set up, in their home at 48 Rue Laffitte, a fashion house under the name Heim. It soon counted among its clientele Madame de Toulouse-Lautrec, Madame Claude Debussy, Her Majesty Queen Victoria-Eugenia of Spain (wife of King Alfonso XIV) and a number of other celebrated women. After World War I, Isidore Heim began to produce fur capes made of rabbitskin – a significant innovation in the world of fashion – and thereby attracted the custom of another doyenne of contemporary society, Coco Chanel, who greatly admired his work .

In time, and following an education biased towards design, Jacques Heim found himself entrusted with the side of the business devoted to "young fashion". He presented his first collection in 1931. Three years later, the Heim fashion house moved to the Champs Elysées and also opened junior branches in London, Biarritz, Cannes, Deauville and Rio de Janeiro. In August 1936 the shop transferred to the Avenue Matignon, which became the registered address of Jacques Heim's many publications, notably the *Revue Heim*, followed by the *Gazette Matignon*.

22.
Jacques Heim examines his sketches for the "Maid of Cotton 1962"

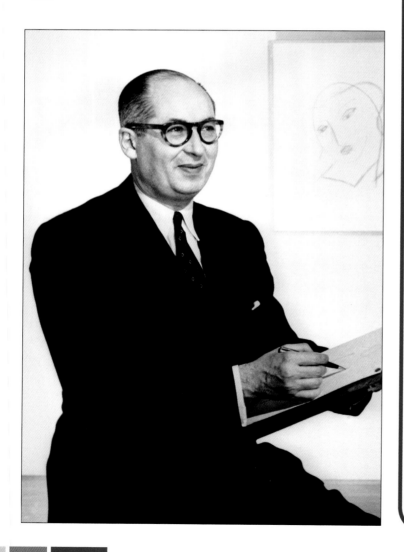

Just before World War II, Jacques Heim tried to escape across the Channel to England, but was interned in Spain until the end of the hostilities. In 1949, having returned to Paris, he set up a company called Parfums Jacques Heim and, until his death in 1967 remained one of the pivotal personalities in the Paris fashion world. His work is generally considered a model of classic elegance.

Particularly important was his major contribution in the field of beachwear and summer clothes. He was the first to utilize cotton in haute couture in 1934, and dreamed up a beach ensemble inspired by the Tahitian pareu (skirt or loincloth). In 1946, he created the two-piece *Atome* – since unjustly forgotten – which might certainly be regarded as the immediate precursor to the bikini.

costume covers everything that should be covered. On the other hand, it shows everything – and how it shows everything! – that can be shown."

The most popular women's magazine of the time was *Elle*. Its headline on July 9 read "At Cannes, the women are wearing the trousers this year!" In the same issue, the magazine showed some pictures of beach scenes (including among others one of a swimmer in an audaciously brief two-piece costume). *Elle* carefully spoke only of "two-piece costumes" and did not name the bikini as such, but managed nonetheless to report on the latest swimwear trends: "Dressed to the nines, women this year are taking to wearing trousers. Less formally dressed, women are wearing virtually nothing at all …"

24.
The celebrated Parisian couturier Jacques Heim and his models fly to Vienna to show the women of the city their latest line in clothes, "Tailwind" (a title suggesting smooth and easy progress forward). The photo shows "the ambassador of fashion" on arrival at the Vienna airport.

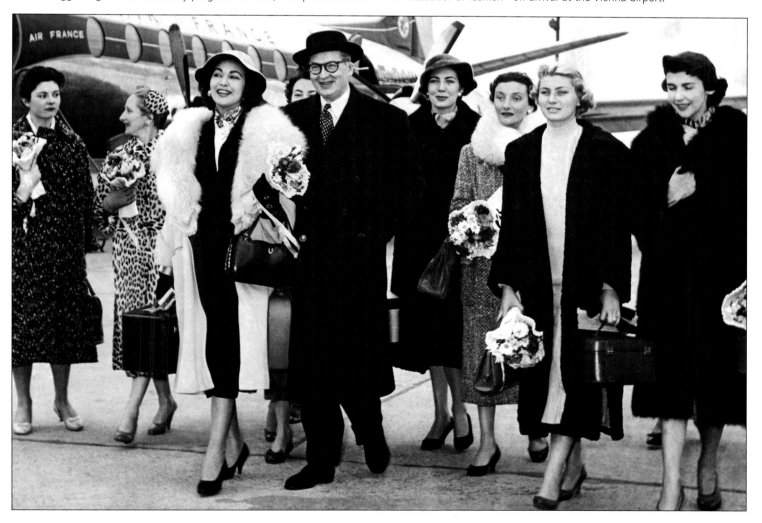

Symbols 2

After years of Cold War strategies and of rivalry in the shadow of the Iron Curtain, we might now prefer – especially in light of the less oppressive world perspective at the turn of the millennium – to choose a different symbol of the atomic age that began with Hiroshima. The bikini perhaps, for that in its carefree style and its naturalistic display of corporeal realities certainly chimes well with what we imagine of the early postwar years and the mentality that then prevailed. A girl smiling among palm trees, a bottle of sun lotion in her hand, is an image as well entrenched in folklore as any standard postcard. It is in this form that we now perceive what was a blind enthusiasm for the burgeoning atomic age, blind also to the potentially cataclysmic effects of releasing such energies. Through the striking metaphor that this era conceived in representing the bomb as a sex symbol, an image of our desire for life (a woman's body in its divine perfection) blends with the representation of our measureless desire for destruction (an atomic bomb in its simple streamlined perfection). Not that the bikini is the symbol that best represents the era. It represents, rather, the other side of the atomic mushroom-cloud which, at the beginning of current history, rose above the paradise of the Southern Seas. It is as if we wanted to swap over our two deepest desires – for life and for death – and were striving to obscure the marked differences that distinguish them, by the passion with which we pursue them (the passion with which we go to war, the passion with which we climb into the bed of a beauty before or after such a war). If we could now bring ourselves to see these as "male-oriented disorders" – as generated by a patriarchal society – we might then find it a reassuring change from a state of things in which woman is for some reason failing to play the role assigned to her with the self-sacrificial devotion that man wants to discern in her. That is the kind of role depicted as an image of her painted on the rounded outer-casing of an atomic bomb or on the hot sands of an island in the Southern Seas.

25.
Réard-Bikini, 1949.

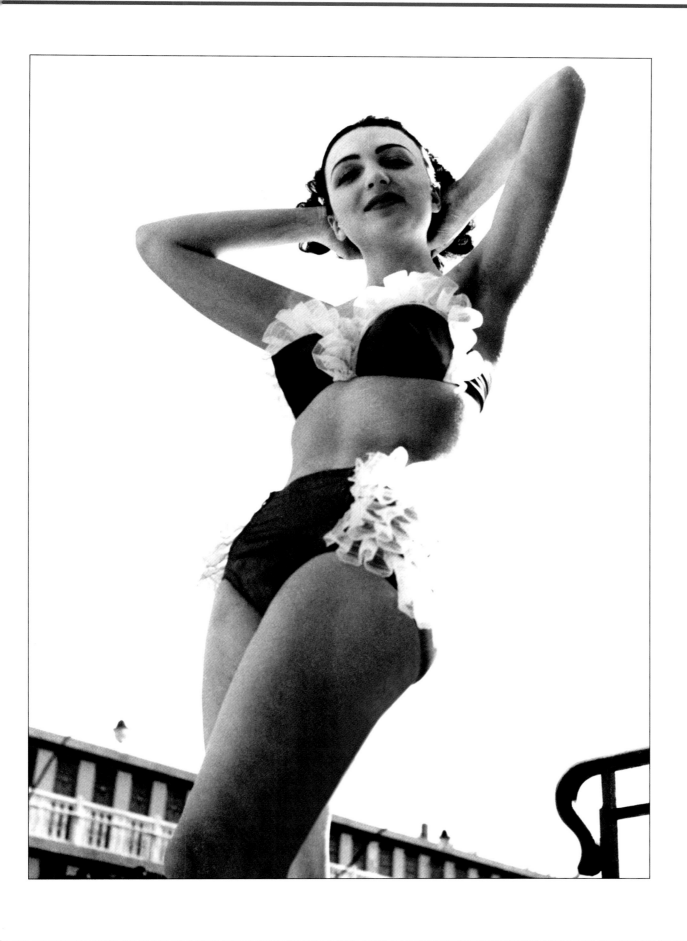

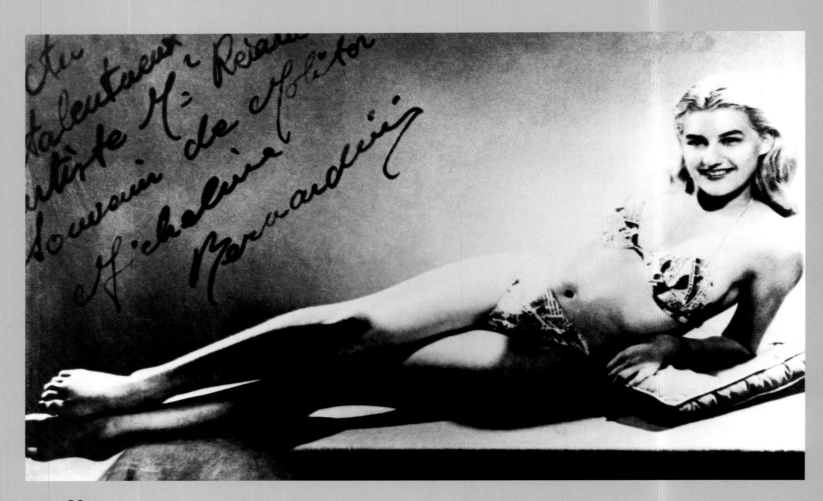

26.
Micheline Bernardini in Louis Réard's original bikini. The photo records the handwritten dedication "To the talented artist M. Réard. A souvenir from Molitor, Micheline Bernardini."

On July 23, the magazine found it necessary to declare a complete turnaround, a radical change in its opinion of swimwear. Accompanying pictures featured only small two-piece costumes, while at the end of the article the caption under a photo of a one-piece costume read, "The exception: a swimsuit comprising just one element."

Three weeks later a knitting pattern for making a one-piece costume was printed under the subheading "For those who do not like two-piece costumes."

It was in this way that two-piece bathing costumes at this rather late stage, but hereafter for ever, took on the status of standard beachwear and favourite of swimmers.

Strangely, any scandal that surrounded the bikini never reached the text pages of the magazines. On the contrary, magazines at this time tended to concentrate instead on such problematical questions as "Is my marriage in danger if I go on vacation by myself?" and "Should I take my children on holiday to the seaside?" They likewise gave full instructions on how you could make your costume for a masked ball out of old curtains.

So despite everything, there were only one or two scattered insinuations that there might have been a scandal going on somewhere behind closed doors. A French journalist wrote, "This summer you do not just take your clothes off at the seaside – you give a full navel review!" No one seemed to have the courage to come out and confront the theme of nudity. *Vogue* as always, thought there would be only one burning question this season: "Should a girl wear a hat or not?"

But mindsets were changing. And the covers of the weekly magazine *Elle* showed how much they were changing. On June 25, the headline was "Holiday-time at last!" and the picture was of the buxom torso of a Rita-Hayworth-style blonde in a one-piece blue costume. On each side was an equally blonde young girl in a one-piece costume, representing a daughter. This family idyll in several ways took a downhill turn over the following two weeks as it presented women of a more mature age-group who attracted attention only by their unusual hairstyle or headdress (a coronet apparently made of buckles, for instance, or a sun-hat outlined in bright red and black circles).

The cover of the July 16 issue was distinctly different. It showed a girl in a straw hat wearing transparent overalls and holding a kitten in her arms. The background was rustic, featuring bales of hay, pitchforks, hay-carts and so forth.

On July 23, any attempt at a family scenario had vanished. In full colour, the front cover again presented a seductive blonde. This time she was wearing a two-piece costume very similar to a bikini somewhat hidden beneath a Tahitian-style pareu, with a fishing-rod in one hand and a scoop-net in the other. What was visible of the costume – white, with red streaks – was highly effective, emphasizing the girl's very feminine figure and clearly suggesting some sexual connotation, heightened by the symbolism of her "fishing". The scoop-net, in form not unlike a butterfly-net, was evidently meant to represent the nebulous contrast between vulnerable innocence and seductive charm (appropriate to a "fisher of men").

A variation on this cover picture, featuring the same girl, appeared in an advertisement for "Your Daily Paper" *France Soir*. On this occasion the beautiful damsel lied on the edge of a swimming pool, taking an afternoon siesta. To one side of her, lying casually there, was a pair of trainers. Her half-open pareu afforded a glimpse of the bottom of a classic swimsuit covering the navel.

This was the first time (certainly in France) that a magazine cover deliberately used what was really a pin-up picture in addressing its usual readers, who were of course mainly housewives, secretaries and working women. And it represents an eloquent proof of the stunning change – which took place over a matter of a few weeks – in the way women were portrayed. All mocking opposition, any suggestion of public outrage, had evidently faded away altogether.

It was only toward the end of that year that women's magazines really discovered the pleasures of summertime. Thereafter their pages were full of hot-weather recipes and instructions on sunbathing. It was then too that advertisements for sun oils and barrier creams as well as slimming products, first made an appearance.

The new emphasis involving such increased publicity makes it much easier now to trace the further spread of the briefer version of the two-piece bathing costume.

A line-drawing advertisement in the issue of *Elle* dated July 16, drawing the public's attention to "Uviol, the sun cream that guarantees you a tan like a Creole's," showed a beautiful woman largely unclothed – and with navel exposed.

Later in the summer of 1947, the same magazine contained the first advertisement for natural slimming. "Slim without medication and without regular dieting", it warbled alluringly, while proposing nonetheless a course of treatment based on seaweed algae. In the same issue, the writers suggested that women about to take their summer vacation should "sculpt their bodies for the beach" with the help of special gymnastic exercises. Moreover, users of certain other creams and potions mentioned in related articles are promised "firmness of bosom". "Do you want a bigger bust? You can have one – if you use our breast-tensioning cream." Other articles actually detailed dietary regimes for slimming. And still others gave "prescriptions for sunbathing," outlining to their evidently inexperienced readers the secrets of sun-tanning: the optimal times of exposure for different types of skin, together with suitable protective measures against the sun's forceful radiation.

It was at this time in France that the first publicity material appeared for the bathing sites along the Côte d'Azur. Whole sections of magazines were devoted to it, featuring the coastal locations as unbeatable holiday resorts for people from inland regions of the country. Not to go to visit them would be to turn one's vacation plans into a waking nightmare.

Holidays, sunshine, beaches – in their way these were indications of the progressive spread of brief two-piece bathing costumes. Special care of the legs, the bust, and the skin, protection against the sun, and methods for slimming, all very clearly reflected the evolution of a new cult of the body evidently promoted by the ever greater areas of visible skin. "The legs of a statue and the bosom of Venus" were the height of ambition for many bathers in a bikini, who now had to be concerned with her appearance in a way very different from when she had worn a one-piece garment.

LOUIS RÉARD

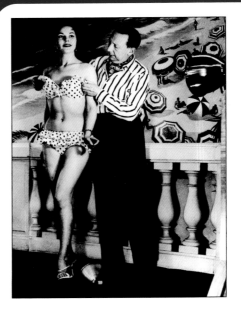

27.
Louis Réard in 1946, during a fitting of one of his bikinis.

Born in Paris in 1897, Louis Réard began in the 1930s to design beachwear that appealed at once to his wealthy and somewhat worldly clientèle. Indeed, his declared goal was to dress "the beautiful, the rich, and the fortunate" in a style appropriate for them to enjoy the sandy shoreline. If the publicity material about his 1950s bathing costumes he himself disseminated is in any way to be believed, he then sprang to worldwide fame from nowhere. But the fact is that in the eyes of the official world of fashion (in which swimsuits were regarded as of fleeting and secondary importance, and they generally still are), Réard's ascent was hardly noticed, despite the fame and success he undoubtedly achieved. In the august salons de couture in the Avenue Matignon – where members of royal families and the aristocracy themselves paid their respects in order to try on a new hat or a pair of silk gloves – such ideas as his seemed more or less frivolous.

So when in 1946 his bikini broke all the standard rules of good taste, all the moral norms accepted by clothiers round the globe, it made little difference to the general disdain in which the fashionable crowd already held him. Réard had nonetheless patented his design ahead of the market, and when the name bikini became the recognized general term for a particular style of costume, he acted at once. Every unwarranted use of the name of that style registered under the patent number 19431 – even if it was merely a mention in some newspaper article, such as the one in which the name bikini was applied to a

two-piece outfit that came up as high as the navel – was followed by immediate legal action.

It may well have been this extraordinary effort to protect his "copyright" that took Réard beyond the pale, as far as the world of high fashion was concerned. It may also have contributed greatly to the curious fact that after 1946 – when the name bikini had become a word of virtually universal familiarity – the name Réard dropped out of sight altogether. There was not a single press review of the sensational line-up at the Molitor Pool on July 5, 1946; not a single article on the life and works of the bikini's creator. Réard's final penetration into the world of fashion was greeted by it in stony silence – a silence that if anything spread to bestow even further obscurity upon him.

His name is now rarely to be found in the histories of fashion, and when it is, it is simply as "the inventor of the bikini." The best reference sources give his life-dates (1897–1984) and the probable locations of his birth (Paris or Lille) and death (Lausanne), but nothing else.

Shortly before his death, a well-known American magazine asked if it might interview "the father of the bikini." Even Réard himself seemed surprised. In a photo that shows him in a sort of classroom scene together with a tailor's dummy dressed in a bikini, the old man smiles rather hesitantly at the lens, half-turned to one side and peering over his glasses across the top of one shoulder. Was he himself astonished at all the kerfuffle stirred up by his simple little bathing costume? Perhaps he believed he could have received such celebrity fifty years earlier? But other than in this strange smile – the latest and last official record we have of Réard – he has disappeared once and for all.

Nothing is known any more about the different collections he presented during the 1950s and 1960s, the collections he intended to embody the evolution of the bikini. No details are forthcoming about his life, other than that he continued to reside in the heart of Paris. There are, however, one or two odd pictures scattered among the larger photo agencies, without captions or commentary – silent and fragmentary footnotes to his work.

And there are a couple of anecdotal stories. The first bikinis were sold in what looked like match-boxes, emphasizing not only how small the costume was but how scandalous it might seem. On the top of these matchboxes was the legend "Maximum 45 centimetres [18 inches] of material" so people knew what they were getting and could not complain about the high price. Obscured by his own creation, Réard disappeared into the shadowy background and into fashion's mythology.

But there is another way to track the rise of the two-piece costume's predominance, apart from via the fashion magazines. The issue of *Elle* dated July 30, 1946, provided a knitting pattern for a one-piece costume "for those who do not like two-piece costumes." Throughout 1947, the magazine was chock-full of instructions on how to sew together two-piece costumes for women and swimming trunks "for husband and/or son" in cotton, using 100 grams of lemon yellow cotton fabric.

Line-drawings and other illustrations from the same year show groups of bathers among whom all the women are wearing two-piece costumes that leave the navel exposed.

On June 22, sewing instructions were published for a two-piece costume in red and white using 175 grams of cotton. Two weeks later, in the issue dated July 5, there was a photo of a bather in a genuine Réard bikini. And two weeks later still, there was the first bikini cartoon. A matronly woman in a two-piece costume practically non-existent, tries to breast-feed a squalling infant, while two young damsels of ethereal beauty dressed in briefish bathing costumes pass close by her – and affect not to see anything unusual at all.

For the whole of this period, *Vogue* remained reactionary and conservative, going merely as far as to present a two-piece costume by Schiaparelli in which the material was lined and slightly padded, and which covered more than it left showing. The only costume that remotely resembled the bikini was the one in the Helena Rubinstein ad for sun cream. At the same time, the prestigious magazine was regrettably prepared to provide disinformation; it claimed that women in general considered the short two-piece costumes repellent. Especially loathed was the bikini, the very name of which women hated and regarded as devilish. It was not too devilish for *Vogue* to bring itself to print, apparently, provided it was accompanied by sharply disparaging words. The magazine went on in its peremptory fashion to state that the bikini was being altogether shunned, and expressed its relief that in time to come, when beachwear had once more turned to less provocative styles, the immoral bikini (which it had said no one was wearing) would – God be praised – be outcast once and for all.

It was in a remarkably similar spirit, during the summer of 1948, that the magazine reported that formal evening wear was beginning to relax and show a bit more skin. In an unexpected reversal of status, the bikini – that swimsuit reduced to no more than two scraps of cloth – was now beginning to claim the modesty that until this time belonged to the evening dress, while the evening dress in revenge was wilfully giving up its virtue.

The "two scraps of cloth" cliché suggesting immorally insufficient cover for parts of the body with sexual connotations very plainly demonstrates the magazine's opinion of Réard's creation.

It was the end of 1950 before *Vogue* started to print regular features on beachwear fashion. Reports might then in considerable detail inform readers, for example, of beach cloaks and ponchos, illustrated with models by Rochas, Carven, Dior and Schiaparelli.

In the same year, a new feature entitled "The Joys of Sunshine" appeared, and showed all kinds of summer costumes – even if the subheading "The joys of the water" then depicted outfits for going sailing in rather more imaginative swimming costumes.

Sport was something *Vogue* was always advising women to enjoy – in moderation. Sport – exercise for young people that may initially be strenuous, before years of discretion are reached and activities are better regulated, until they finally become no more than a strict health-routine – is one of the secrets of beauty.

The tone of a matriarch's solemnly wise counsel is all too evident. Yet the cotton manufacturers had better reason to be unhappy at the bikini's success. The arrival of synthetic materials, and particularly nylon – of which the bikini had so instantly been made – constituted a real threat to the cotton industry. That industry now felt obliged to widely advertise the advantages of cotton, and specifically for swimming costumes. It was cheap to use, it required and responded to artistry, it was light, and it retained heat when in the water.

In parallel, the advantages of a one-piece costume were contrasted with more revealing swimsuits. It was certainly more practical to swim in than a bikini – and to

illustrate this, the same publication featured the extraordinary "Hara-kiri costume", a one-piece creation by Calixte for the great diving star Mme Monsenergue. It was a costume that had a wide slot at the level of the stomach: once in the water, the swimmer could pull a slide across, therefore opening the costume and facilitating movement. The opening, which looked rather like a shark's mouth in the middle of the costume, strikes us as ludicrous today.

But all these efforts at resistance on the part of groups in the fashion world who never accepted Réard, nonetheless contributed to a significant change in fashion itself.

With the introduction of Dior's *New Look,* the diversity of materials became an essential trait of contemporary fashion, after years of wartime restrictions and scarcity. "We had just endured a period of war," Christian Dior was to write later, "a period of uniforms, and of women in those uniforms which gave them all uniformly the shape of prize-fighters. I used to dream of women delicate as flowers, with slender shoulders, their necklines low and cut with the fine curves of lianas, their skirts flared wide like the petals of flowers."

Réard's reductionist concept, which had corresponded so well with the notions of freedom, suddenly became no more than the product of its era, unattached to current trends. For the guardians of morals in the fashion world, such a fate for it was indeed welcome.

Réard and his creation were thus relegated into the shadows...

28.
A Réard bikini, May 1, 1956.

29.
A Réard bikini, May 18, 1956.

Atomic Inspiration

In the beginning, on July 1, 1946, the atomic tests on the Bikini Atoll were reported in just a single French newspaper. The scientific correspondents in the testing area wrote down all the details of everything they saw but, on running out of what they believed to be of general interest, they did not hesitate to exaggerate on details. The paper *France Soir* thus spent several days discussing the fate of the animals exposed to the atomic blast – pigs, mice, and goats. On July 2, banner headlines announced that the mice placed well within the mushroom-shaped cloud had triumphantly survived the experience. July 3's headlines read PIGS ALL OK! But in the same edition a few pages further and under a heading in very small type, an article mentioned that the state of health of the mice was now deteriorating – their hair was falling out and they were turning yellow. On July 3, readers in Paris learned that another sort of bomb had gone off – American movie star Rita Hayworth, in her latest film, was "emanating the torrid heat of an atomic explosion". Miss Hayworth at this time did not yet truly qualify as a "sex bomb" herself but was attributed explosive qualities on account of wearing a single-piece costume that accentuated her curvaceous form, hyperbolically described somewhere as "the most perfectly powerful weapon of war since Creation." Two days after the real atomic explosion, the Americans sent two marine artists by air to the scene to depict its "torrid heat." Various newspapers took to printing in question-and-answer form what selected celebrities said they would have done if the Bikini bomb had destroyed the world. Environmental experts mean-while informed readers of how the coral sea and the islands (and the scientific establishment) would take on an "atomic architecture" following the blast at Bikini. It was in this frenzied atmosphere that Réard found the inspiration that was to lead him to christen his two-piece swimsuits that generated scandal. The initial presentation of the costume was planned with meticulous foresight. Réard sponsored a prize at the Molitor Pool for "the most beautiful girl-swimmer." A brief photo-report in the *France Soir* of July 2 no doubt confirmed him in his intentions. Its evening edition reported on a fashion parade that had taken place in mid-air on a Paris-New York flight. Stewardesses with shapely legs had promenaded up and down the central aisle under the stupefied gaze of the passengers. Then came July 5. It was a day on which there was genuinely "torrid heat," for the temperature was 96° (35°C) in the shade. Everything conspired to scribe Réard's bikini on the collective conscious once and for all – tremendous heat imaginably as an echo of the atomic explosion, exotic sands, and the seductive silhouette of a native girl with long legs, bronzing her skin between the sun and the sea. The legend of the bikini was born.

30.
In 1965 Réard dreamed up an even briefer costume than the bikini: le sexy-bikini, precursor of the Rio-style thong.

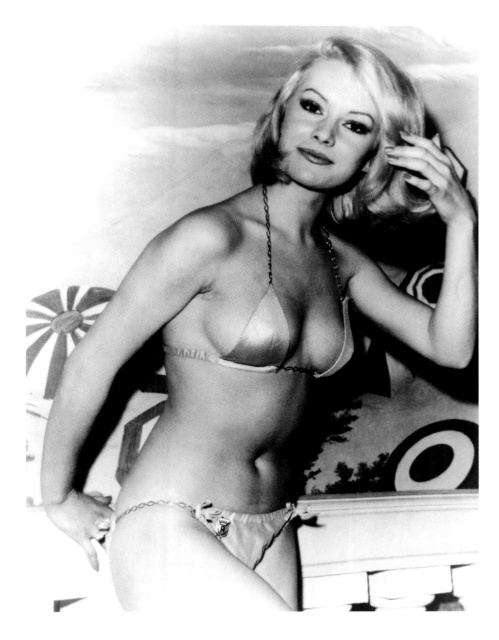

Chapter 2:
From Scandal to Scandal

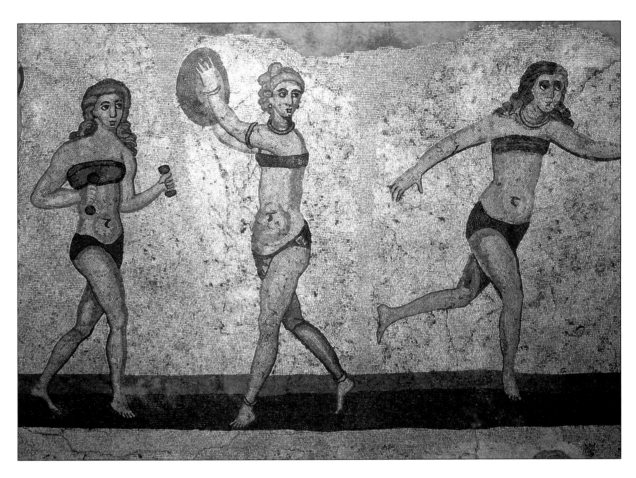

31.
Mosaic dating from the 3rd or 4th century AD, depicting girls at play wearing bikini-like two-piece costumes. Two chunks of mosaic found in the Villa Romana del Casale – possibly once owned by the Roman Emperor Maximian – in the Piazza Armerina, Sicily.

For the first few years after World War II the revolutionary concept introduced by Réard did not achieve the success that was to come to him in following decades. In the well-known – even hackneyed – phrase, he was "ahead of his time." But this is where we pick up once more on the story of the initial bikinis.

It is not actually impossible that even Réard himself at first had only a passing interest in the modest bikini (which was nonetheless slated as "revealing all"). His next few collections visibly returned towards the conventional dimensions for two-piece costumes and, understandably, towards a more significant, if distant, buying public. So he might have only dreamed up the bikini as a publicity stunt, returning to it afterward simply because it was accepted by a new era.

However, the fact remains that publicity material for Réard swimsuits at the end of the 1940s and the beginning of the 1950s made no mention of the scandalous two-piece costumes. On the contrary, it showed a line-drawing of a voluptuous blonde in a one-piece costume that accentuated the outline of her body, wearing shoes and stockings, attracting the eye with a mildly lascivious pose, the index finger of her right hand twirling a spiral in her hair. The caption assertively gave it to be understood that "RÉARD costumes have no need for publicity for they are the world leaders. Not everyone can wear a RÉARD." Not a single word was mentioned about the bikini.

The text went on to declare that "Réard's clients include celebrities from all over the world". And yet such highly desirable costumes were available for sale only from a shop at 47 Rue de Clichy. Three years later in an advertisement in a 1957 issue of *Vogue*, Louis Réard finally alluded to his famous bikini. Under a line-drawing very similar to the previous one came the credit: "RÉARD, inventor of the bikini."

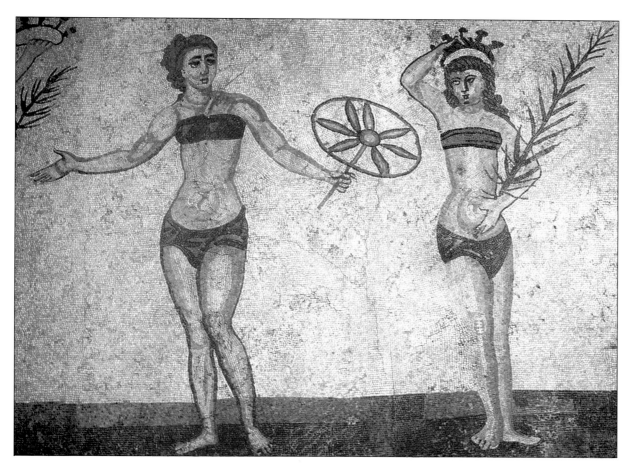

32.
Mosaic dating from the 3rd or 4th century AD, depicting girls at play wearing bikini-like two-piece costumes. Two chunks of mosaic found in the Villa Romana del Casale – possibly once owned by the Roman Emperor Maximian – in the Piazza Armerina, Sicily.

As the years elapsed, the bikini turned out to be neither the most banned nor even the most shocking of fashion innovations. We will probably never know whether Réard truly meant to stand by his "invention" or whether it was really no more than a publicity stunt for his later collections which afforded equal importance to one-piece costumes.

In any event, the postwar years were not a particularly appropriate time for Réard's bikini. Material of any kind was scarce, and had been for years (sometimes rationed, as food had been). The accent remained on making the most of the little one had, which hardly went far towards satisfying the newly burgeoning desires of most of the population.

When Dior launched his *New Look* in 1947 – a style that involved the uninhibited use of various materials – he therefore eclipsed the minimalist ideals represented by the bikini. In his *New Look*, Dior evidently saw a dress as an almost orgiastically limitless expanse of material up to 45 feet (14 metres) long – and at first certainly aroused some fiercely indignant criticism (in 1948, furious women in Los Angeles publicly demanded that Dior be burned at the stake.) It has to be said, however, that such wrath was provoked more by shortages of material than by outrage at the new style of fashion.

In 1951, five years after the Réard scandal, everything seemed to have returned to normality and *Vogue* could report enthusiastically: "Novelty on the beach and in the sunshine! Beachwear goes decent! We are quite sure that our readers will have had nothing to do with the infamous bikini, which turned some of the coastal shorelines into vaudeville sideshows and music-hall scenarios – and which, moreover, never looked nice on any woman. Fashion specialists always knew that, and have continued to stick with one-piece costumes

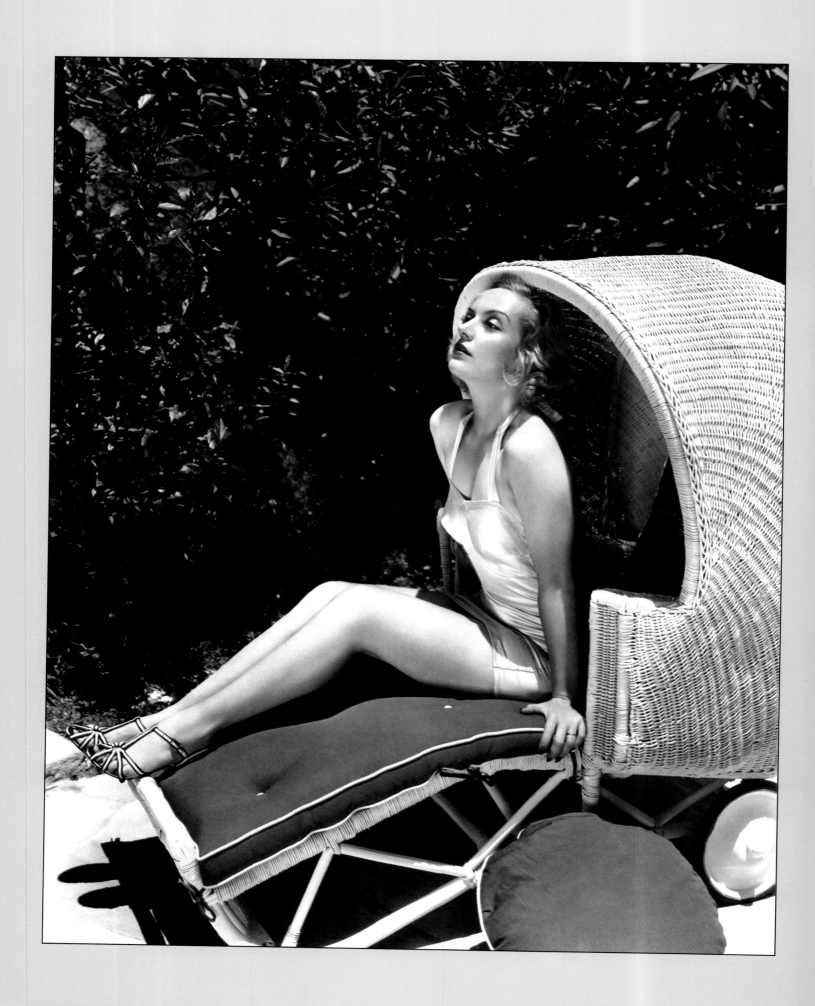

designed with intelligence. Not only more comfortable, they are also more pleasant to swim in."

If such reactionary prophets of swimwear fashion and guardians of public morality are to be believed, the history of the bikini came to a standstill at that point. It would be more accurate to say, however, that during these years the fashion world was equally inspired by the now dominant *New Look*, which made clothing more stately and required an infinity of accessories.

The question of the origins of the bikini seems to have been of more significance. In the moral campaign led by certain fashion magazines read by the better-off and aimed at eradicating the bikini from the beaches, writers evidently did not realize how paradoxical were their arguments intended to besmirch the bikini's reputation. After all, those same magazines in which readers might admire the stately dresses of princesses and other aristocrats also published sensationalized reports on the "true origins" of "the smallest swimsuit in the world."

They featured pictures of the Villa del Casale in the Piazza Armerina, in Sicily [illustrations 31 and 32], and its mosaics of the 3rd or 4th century AD which showed Roman athletes in a costume not unlike a bikini. Two women play with a ball. They wear brownish two-piece costumes – a sash of cloth covers the breasts, and another is wrapped across the hips and between the legs – that are presumably reproduced in the magazine to show how spurious the innovation of the bikini was. At the same time, of course, that argument actually lends legitimacy to the bikini's claim to a genuine historical background. And women might in fact likewise be encouraged, rather than be put off by such pictures of near-nudity, themselves to play with a ball on a beach in a practical and light costume.

Not reproduced in the magazine were less emotive pictures from the Villa del Casale that did not show bikinis. They depicted sporting costumes that were no doubt the kind of thing the people of those ancient times were accustomed to wearing, different from today as they may be.

The immediate precursor to the bikini, a two-piece costume, was at its most widespread during the 1930s [illustration 35]. But the first design in modern times for a two-piece costume – that is, a costume for swimming

33.
Carole Lombard (1908–1942) sunbathing on a chaise-longue during the 1930s. She is wearing shoes with her one-piece costume. The American movie actress was tragically killed when the aircraft in which she was a passenger crashed into a hillside near Las Vegas. Before becoming one of the best-known movie stars in America, she was one of Mack Sennett's celebrated "bathing beauties". Later, she played a leading role in Ernst Lubitsch's *To Be or Not To Be* (1942).

34.
Beach ensemble from around 1930 by Jean Patou. The French couturier (1880–1936) opened his fashion house in 1913, but presented his first collection five years later because war had intervened in the meantime. He then left for the Dardanelles (the area around the Hellespont), where he encountered not only the diplomatic milieu of eastern Europe but the cloths available in the Balkan region, practically unknown elsewhere. Wimbledon tennis winner Suzanne Lenglen gave him his first real taste of success when she wore a tennis skirt designed by him on court in 1921. In 1924 he introduced both "sportswear" and a knitted swimsuit to the market. He also patented the first suntan lotion – *Huile de la Chaldée* – in 1927. Jean Patou's fashion house at 7 Rue St Florentin, Paris, has since been taken over by Christian Lacroix and Jean-Paul Gaultier.

in that has two elements – dates from the final years of the 19th century. It corresponds to no more than a large one-piece costume covering most of the body with a gap of an inch or two (a few centimetres) cut "daringly" across the middle, over the stomach. Only the design for such a costume has survived; there is no photo to prove it was ever actually made.

The two-piece costumes of the 1930s in many ways recall women's underclothing meant to enhance the body shape, as was the fashion right up until the 1960s. The base corresponds to close-fitting bathing-trunks descending from the navel to one-third of the way down the thighs. Possibly just daring, sexy it definitely is not. The top, which came to rely more and more on braces or suspenders, was designed principally to permit suntanning of the shoulders and the arms. But for the ensemble to remain "decent," any woman (especially if not intending to swim) would normally take along an additional beach-cloak or poncho and perhaps also a beach-skirt or Tahitian-style pareu. Yet a 1930s advertisement – publicizing a bathing site on the Côte d'Azur in France – shows us the body of a woman in much the terms of today's ideal: tanned, slender and wearing a two-piece costume with a beach-skirt.

The most shocking thing of the 1930s, though, were beach-pants or beach-trousers, known in some quarters as "beach pyjamas" [illustration 34], which looked like the pantaloons worn by circus clowns, and which surely no one could have actually wanted to put on. The emancipation of women's clothing was evidently still in its infancy.

Another factor that emphasizes the difference between then and now is the stature of women who wore two-piece costumes before the war. They could have been models for the artist Rubens. All were of generous proportions, with powerful calves and thighs, and rotund arms. Yet these women apparently seemed slim in their day. If any were to show themselves unclothed in this way in public – as did the German movie star Maria Solveig in a 1931 film – it was quite simply regarded as obscene.

Under the Fascist regimes of Germany and Italy, the status of women evolved radically. Their function in life, as decreed by the state, was to procreate. Their bodies

35.
A lady in a two-piece swimsuit in the process of putting her shoes back on the beach at Wannsee (Berlin, Germany) in 1940. From the French edition of the Nazi propaganda magazine *Signal*.

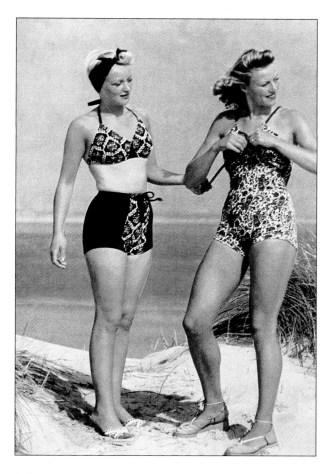

36.
Two ladies in two-piece swimming costumes on the beach at Wannsee (Berlin, Germany) in 1940. From the French edition of the Nazi propaganda magazine *Signal*.

were thus the assets of the nation, their main task was the essential one of providing their country with the soldiers of the future. Such an exceptional mindset caused many changes in the ways people thought about their bodies, morally and practically.

Being both chastely celibate and sexually alluring, and outside the context of procreation, a woman had the freedom to "divest herself of clothing." A photo of 1940 shows two blonde German women among some sand-dunes on the northern coast, one in a one-piece costume, the other in a two-piece [illustration 36]. The two-piece costume – with a conventional but close-fitting base covering the navel, and a top with a strap around the neck – certainly leaves a lot of skin bare. But the colours, in which black and white predominate, lend the whole scene something of the ethereal. No attempt to be provocative, or even to be coquettish – just well-formed bodies enjoying a healthy sport...

The woman conditioned by the ideology of Fascist dictatorships shows her body in all its naturalness and innocence. The swimsuits she wears, black for the most part, relieve her of sexual desirability and turn activities on the beach into a healthy sport useful to the well-being of the nation (if not also to the increase of the nation).

The black bandeau through the hair of the 1940 bather reinforces the sense of austerity and of remoteness from us. But it was of course only an outward manifestation of the countrywide discipline that then ruled everyday life. This discipline – like the discipline to be found in sporting activities, among groups of young people playing in the woods at trench warfare, or in situations where strict conformity to the ethics of working in the equivalent of a beehive was required – served to prepare an entire nation for war, and applied to children as much as it did to the elderly. Effectively it stoked up the military machine and kept it on standby, ready to strike for the target – nothing less than the conquest of the world.

Another photo of 1940 shows a blonde woman on the shores of the Wannsee, Berlin [illustration 35]. She wears a two-piece costume that is almost in camouflage coloration (black, red and blue) with large, wide trousers and a modern top tied behind the neck.

37.
Two ladies in swimming costumes in 1941; one has a one-piece costume on, the other a two-piece costume. From the French edition of the Nazi propaganda magazine *Signal*.

38.
"Beach fashion for Her and for Him," photographed on behalf of VVB Konfektion, textile manufacturers, East Germany, 1971.

It is the perfect illustration of the best points of erotic undress. Even the cliché of the woman putting on a white sandal very clearly distinguishes it from future representations of seductive girls in bikinis on the beach.

Unlike American girls in bikinis, and pin-up girls, a German bather would have appeared no more or no less naturally. National Socialist realism required as honest a scene as possible, a picture of daily life that was wholesome and gratifying, and certainly not a picture of divine bodies against an idealized landscape background. Its purpose was to sharpen the image in the mind's eye, not to blur it.

Another photo, showing the same blonde person together with a smallish brunette on the shore of the Wannsee [illustration 37], goes some way towards clarifying the overall scenario for us. The two women look smilingly past the left edge of the picture, where something is evidently happening. Behind them, on the right, is a comfortable settle, and below left in the background is the beach and a turbulent mass of bathers. On the surface of the water, white sails glide smoothly along, opposite the darkish green forest. The caption to the picture is somewhat cryptic: "As you see, they are both smiling at the moment."

It is just past one o'clock. The men on the asphalt promenade are all wearing black bathing-trunks. The fuller costumes of the several women that can also be made out are of the same colour. It is a peaceful Sunday. The bathing area of this beach close to Berlin is full of summer visitors taking it easy, no doubt making the most they can of the weekend. Elsewhere – somewhere else altogether, and certainly not visible in the picture – there is a war going on. For this is the summer of 1940, and the photographs of these two German women, with their contented faces as they admire each other in their swimsuits, put on a sandal, or gaze at the throng of bathers, are those published in the magazine *Signal* – an illustrated periodical also printed and published in the local languages in the German-occupied territories. This, then, is specifically also a form of propaganda seeking to mask the realities of war while suggesting the benefits of life after the expected German victory.

That is why there is no real exuberance in these pictures – actions, gestures are all measured, calm, and collected. Even immobility can have meaning: it reflects peace, peaceability, peacefulness. The people in the pictures are not shown as conquerors but as guarantors of the future order, of future stability, that is going to turn the whole of Europe into a bathing beach paradise. They are, you might say, puritanical ambassadors whose mission is primarily to conceal the excesses of contemporary events, to pacify and to tranquillize. It is not against the German people, the *Volksdeutschen*, that you are fighting, for they are not a warrior nation, there is nothing specially military about them – none of these faces expresses the slightest hostility.

But it's neither the first nor the last time that bathers and beach scenes have been used for propaganda purposes. Communism after 1945, and particularly after 1968 and the crushing of the Prague Spring, found itself in peculiar difficulties vis-à-vis its rival capitalist bloc in terms of representing the blissful pleasures of leisure-time.

But habits die hard. From 1968 in a number of Communist countries, leisure activities were publicized (by means of what was known to the West as economic propaganda) as if they were sold merchandises.

Above all, it was essential that they could have whatever people in the West had to gratify their own desires and to while away their free time. Everyone was thus able to read all about the rewards available for industrious groups and to peruse the severely controlled reports and advertisements in the newspapers.

From our own contemporary viewpoint, Communist publicity could not help but be something of a parody of what it should have been. It merely turned to ape whichever way the wind was blowing in the West, without any reliance on a socialist economy planned or unplanned.

An East German advertisement of 1971 for "Beachwear his and hers" [illustration 38] demonstrates precisely this kind of propaganda concerning consumer goods.

Shock, horror!

Following its first appearance on the beaches of Europe the bikini was banned. In 1948 it was formally proscribed in Italy and Spain, and in 1949 a local government official prohibited its use on all the Atlantic coastlines of France. Hollywood yielded to the outraged protestations of religious organizations and feminist groups and, from 1965, refused to allow it to be seen on the cinema screen. The organizers of the Miss World competition in 1951 banned it from their beauty parade, and for a further five years. But it was back in 1949 that the cries of fury and abuse reached their peak in, of all things, an article about it in the Vatican newspaper *Osservatore Romano*. To protect a delicate and susceptible woman, declared the article succinctly, she should be aware that the Four Horsemen of the Apocalypse were alive and well and had taken the form of the bikini. In public swimming pools in Germany until as late as the 1970s the bikini was explicitly cited as banned under the standard swimwear code. And so for twenty years or more after its appearance, the bikini was all but submerged under a swelling tide of indignation. Communist groups condemned it as "capitalist decadence" fanning the flames of the class struggle. Many Christian Churches saw it as "the seed of corruption". Feminists lambasted it as the ultimate in male chauvinist piggery. And even the mayors of seaside resorts, beach service proprietors, and a fair proportion of the general public regarded the bikini as causing "a shameless exhibition of the supposedly private parts." Throughout this period, the bikini was in fact selling very well, if discreetly. It actually inspired a new form of leisure literature, the pin-up

magazine; the prudish Miss World competition was parallelled by a less inhibited Miss Bikini contest; and millions of film fans the world over went to see movies in which an actress removed her clothes until she was dressed only in a bikini. Nonetheless, an American journalist hit the nail on the head when describing the effect of the bikini in the 1950s and 1960s. "It's a costume," he said, "that a guy would like to see somebody else's girlfriend or wife in, but not his own."

39.
Miss Bikini 2000. Lebanese Carol Keyrouz (centre) with second-placed Rima Tawtah (left) and third-placed Christine Rouhana (right) in a five-star hotel in Beirut (Lebanon) on August 11, 2000.

40.
Winner of the Miss Bikini Contest, Carol Keyrouz.

41.
MGM movie stars and starlets on the beach in 1933. They carry parasols and bathing towels, but they are also wearing stockings covered in Cellophane with the erroneous belief that it acts as a barrier to the sun's ultraviolet rays.

42.
The American movie actress Ava Gardner in a two-piece swimsuit with shoes. On the sand is scrawled the date July 4, 1943 – a date on which she had yet to achieve her eventually worldwide fame. Her career as movie star in fact took off some three years later with the release of *The Killers* (1946).

On a sand-dune on the northern coast, a happy group disports itself among tuffets of coarse grass. In the company of two men, five women are wearing two-piece costumes of unusual originality. An ideologically correct red one is combined with an orange one as particularly favoured in the West. And there is also a green bikini. The girls modelling them, who in their way rather resemble standard items of confectionery on sale in large department stores in the West, are beautifully arranged. Their hair and their accessories (sunglasses, bracelets made of wood and plastic spheres, a bandeau through the hair) are perfectly in fashion. The bathing-towel the man on the right is wearing might easily have been directly imported from the West. And yet... Are the smiles on the faces of this happy band somehow just a shade too confident in the future? (Do they suggest the "gaze ever forward-looking" mentioned by ideological literature?) Aren't the bodies actually rather pale? And aren't their poses perhaps a little too sexlessly innocent?

Mind you, it is rather unfair to compare publicity pictures from East and West. The Communist ethos simply cannot be compared with that of Capitalism. By Western standards, such publicity material must seem second-rate. We can scarcely be sure of correctly imagining now, anyway, what was in the mind of someone who bought one of the costumes shown. The initially continuous copying of the Western lifestyle by the Communists quickly ran out of steam, and everything that can be seen in these pictures was thereafter recycled over succeeding decades, as necessary under a planned economy, in the process turning into the standard view of "Eastern European bathers". The fact that we may think of these people as photographed during the 1970s or during the 1980s simply reinforces that impression.

The formal origins of the bikini are in fact to be found in women's undergarments of the 1920s. With the final disappearance of corset culture at the end of the 19th century came the underwear in two pieces, comprising the brassière (bra) and the panty-briefs (panties). These accentuated body-shaped and heavy-wired frameworks – directly inherited from restrictive corsetry – had a double function: to contain and support the body and to give it form. Underwear then stayed like this, only becoming rather more attractive during the 1920s following the lengthy privations caused by World War I.

43.
The American movie actress Barbara Stanwyck (1907–1990) on the diving-board of a swmming pool on August 1, 1946. With her bikini she is wearing some jewelry and shoes. The bikini base is decorated with buttons down the left side. Her starring role in Jean Negulesco's *Titanic* (1953) brought her particular fame.

Women's undergarments thus came to define women's bodies as in two parts, radically different from men's bodies. The precursor of the bra invented in 1889 by Herminie Cadolle was made up of nothing more than two strips of cloth, and a woman could make up her own mind then whether (in the spirit of the Women's Liberation Movement) to go without any support at all for her breasts under the contemporarily very high dress frontages.

The first tops of the two-piece costumes of the 1920s strongly resemble bras. Most of the time they were carefully designed and constructed with a wire frame that could alter the natural shape of the breasts to the shape required and desired. Others, however, still consisted of a wide sash, tied at the back and gathered at the front between the breasts with a ring or circular strap. They were all made in a considerable variety of materials and were specifically to cover, not to support.

Advertisements for Jantzen swimming costumes during the 1930s pushed the sporting line. All the models featured were wearing swimming-caps, and their two-piece costumes had large trunks-style bottoms with virtually armour-plated tops, serving only to bulk up and weigh down the swimmer's body.

A photo taken in 1933 shows three MGM movie starlets sunbathing on a beach [illustration 41]. One of the girls is wearing what might be described as a fairly scanty two-piece costume: a top that leaves little to the imagination and a short pair of trunks. The other two wear close-fitting one-piece costumes with no straps over the shoulders. However, all these swimsuits have an outer covering of Cellophane and are accompanied by such accessories as a cape with a hood, and an umbrella, all made in Cellophane.

This photograph perfectly illustrates one of the great fallacies believed in for decades by swimmers and costume manufacturers alike. For the three girls undoubtedly imagine they are getting their suntan under the protection of the translucent Cellophane and there is no possibility of solar skin damage. The sun creams and barrier lotions they would be using today were only to become available near the end of 1945.

Another photo shows filmstar Ava Gardner on a sandy beach in 1943 [illustration 40]. She wears a two-piece costume that has finally abandoned a wire frame in favour of elasticated material to support the bust. The top, attached by a halter neck strap, continues underneath the bust in the form of strips that cover the stomach. Rising to the exact level of the navel, the base is astonishingly short and conceals only the very tops of the thighs. In the sand in front of the actress is scrawled the date on which the photo was taken: Independence Day, July 4, 1943. It is wartime then, which is why Miss Gardner makes the sign of V for Victory with her hand in the air.

Slender, the stomach visibly flat, and with one knee forward of the other, she precisely embodies what would later be called a sex symbol. The picture at the same time presents a fascinating contrast with the German propaganda pictures of the 1940s. A beautiful bathing belle, in a way expressing the certainty of victory and the rewards for the effort. Promised to those who returned home again afterwards was an idyllic sejourn with the bathing beauty on a paradisal beach. The radio would play intoxicating music, the sun would shine down, and the beauty would be within reach.

American propaganda thus made use of the image of the luscious bather in her two-piece costume in a way quite different from German propaganda. Firstly, the American soldier to whom she adressed herself was thousands of miles away from home. The beach paradise represented the distant homeland that the soldiers dreamed of and that kept them going. Linking a national symbol (Independence Day) with a seductive charmer who smiled while making an encouraging gesture might be sentimentally nationalistic – might even be rather absurd – but was effective. The message that came across was that young women were waiting back home for their absent heroes, and meanwhile doing what they could to speed the war efforts. If the soldiers made it back, their own beautiful bathers would constitute the prize and the reward for what they had had to contend with.

Secondly, this image as a means of propaganda, is however visibly linked with a naivety in representation that can only be explained by its immediate commercial

44.
Rita Hayworth in a white two-piece costume on a satin-covered bed. The American movie actress reached a turning-point in 1935, and during the 1940s became a Hollywood star specializing in roles as a *femme fatale*. Her films include *Cover Girl* (1944), *Gilda* (1946) and *The Lady From Shanghai* (1948).

background. For even as the prettily smiling girl in the picture, flashing her dainty legs, makes her contemporary contribution to the war effort via the entertainment industry, she is effectively also promoting herself as an intimate member of the Hollywood star system. Independence Day and the publicity machine are intrinsically bound together. It is one of the core values of American-style Capitalism, surely, to comprehend good economic performance as a patriotic gesture, therefore equating it also with the sacrifice of soldiers in wartime.

Another effect of this combination is evident in the overlapping of two deliberately less than realistic representations of the world: that of publicity groups oriented towards mass consumerism, and that of groups anxious to cherish the love of one's country. Both forms of representation carefully feature the idyllic and, make use of beautiful women to disseminate their messages. But in this photo the individual elements belonging to each representation are distinctly changing places. The happy, smiling world of the consumer-publicists is manifested without ceremony as nothing more than the date of a national festival scrawled in the sand. And at the same time a symbol of seduction (an actress in a bikini on the beach) gives an instantly comprehensible handsignal conveying national victory.

If Réard's original bikini did not actually achieve the widespread use that might have been expected following the scandal that surrounded it in the beginning, it nonetheless exerted a very positive influence on the spread of two-piece costumes. These – at this stage regarded as only just within the limits of tolerability – had actually been waning in popularity. The appearance of the bikini reversed that trend and canonized the two-piece costume, sanctifying it well into the 1960s. That was when movie actresses like Doris Day, dressed in a fairly loose-fitting two-piece costume, embodied chaste decency and a demeanour that was close to virginal. In her comedy movies with Rock Hudson, for example, her character's main anxiety was to avoid consorting with a married man, and to do nothing, before marriage, that the Catholic Church would frown upon. Having thus become socially correct, even in reactionary circles, the bikini then spread far and wide, albeit without evolving in form.

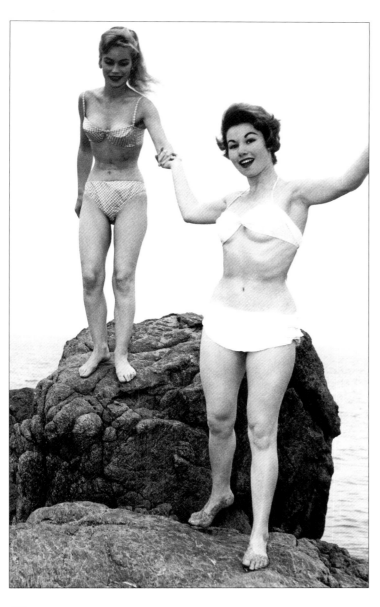

45.
Minor actresses Nadine Tallier and Estella Blain at the Cannes Film Festival, May 9, 1958.

46.
Rita Hayworth (1918–1987) stretched out on a bathing towel.

In 1946, the American movie actress Barbara Stanwyck posed on the diving-board beside a pool [illustration 43]. She wears a very busy two-piece costume, a ribbon around the bust, braces or suspenders, and a band of cloth between the breasts. The colour and the material of the top are repeated in the base, which comes up as high as the navel, and is bordered by a stripe at the top, by two more stripes on the edges between the legs, and decorated with buttons down the left side. The flowery pattern of the base suggests the theme of "woman as garden of delights" which was fashionably applied to bathing belles of the time. The movie star also has jewels on her left hand and wears sand-shoes (almost heavy enough to be full shoes) with a Velcro fastening.

Another picture shows Rita Hayworth sunbathing on a lawn [illustration 47]. Lying at full length, the beauty – in her time herself described as an "atomic bomb" – wears a white two-piece costume of which the top once more takes the form of a sash looping up behind the neck. The base, much less full than Barbara Stanwyck's, is made of a specially-shaped piece of cloth that distracts the eyes from the navel (which is meant, after all, to remain hidden). She too is wearing sandals. But the staging of the whole scene has, in this case, not been completely thought through. On the right of the picture a coiled watering-hose is visible, with a stony soil on which the shadow falls of the crown of a palm tree in the background.

Yet such imperfections have their own charm. With tongue in cheek, we might even caption the picture "Eve cast out of Eden." The palm foliage present in the picture only as a shadow, may have Eden's serpent coiled up

47.
The American movie actress Rita Hayworth (1918–1987) sunbathing on the grass in a two-piece costume and shoes. This photo of her was published in the 1940s, but her movie career began in 1935. Prior to that she had worked on and off as a dancer.

around it, exhausted by its efforts at overcoming the inhibitions of the First Woman. Having tasted the fruit of the Tree of Knowledge, she has come into possession of a bathing costume, lipstick, and false eyelashes, and who can no longer allow herself to be photographed without her hair perfectly coiffed. So this would be a possible answer to the question "What did Eve do after the Fall?": she got herself a suntan.

Eight years later, in 1954, a photo was taken that shows the celebrated American writer Sylvia Plath on the beach [illustration 48]. The author of *The Bell Jar* is wearing a white two-piece costume of a style that has hardly changed through the years. It has a generous top that emphasizes the body shape, held up by a strap around the neck, and a close-fitting trunk-style base which stretch from the stomach to the thighs.

The great difference in this photo from the preceding pictures lies not in the swimsuit but in the way it has been taken. This is not a scene staged to look even more natural than natural, for it is actually as natural as it can be – and rather banal because of it (only the expressive smile on the writer's face betrays the fact that she knows her picture is being taken.) Her costume is absolutely typical of the 1950s. The only other thing that suggests the date is the particularly dark bronze colour of the suntan, which results from the use of sun creams, and the particularly short peroxided hair.

In the meantime, sanctified by scandal, the bikini turned to the cinema for its livelihood. A photo from 1958 shows the two French actresses Nadine Tallier and Estella Blain at the Cannes Film Festival on May 9 [illustration 45]. The two young women are wearing

bikinis of intriguing shapes but very different from the deliberately outré style of the original bikini invented by Louis Réard.

On the left, further back, is a variant on the Vichy bikini popularized by Brigitte Bardot, made of a material imitating raised nap. The top, with its widely-spaced braces or suspenders, leaves a neckline as low as the top of the cleavage. The base is by no means small but does expose the navel.

On the right is a bikini that emulates the sportswear of the Roman athletes – two white sashes. The top is held up by a thin string around the neck. The bust and the hips are completely covered.

With their cosmetics heavily over-applied, these two young women – presumably promoting their latest film or looking for their next roles – look simply comic today. Their appearance is very far from the ideal to be hoped for in a bather in a bikini.

It was in this way that the evolution of the bikini stagnated until the mid-1960s, when another unlooked-for scandal had the same effect of legitimizing the bikini, just as the bikini in its time had had for the two-piece costume. This new scandal was the invention of the monokini in 1964, and the attempts to introduce a fashion for topless bathing costumes. These, then, acceded to the throne of the Court of Indecent Brevity occupied for decades now by the bikini.

48.
Writer Sylvia Plath (1932–1963) in the summer of 1954, a year after her first suicide attempt.

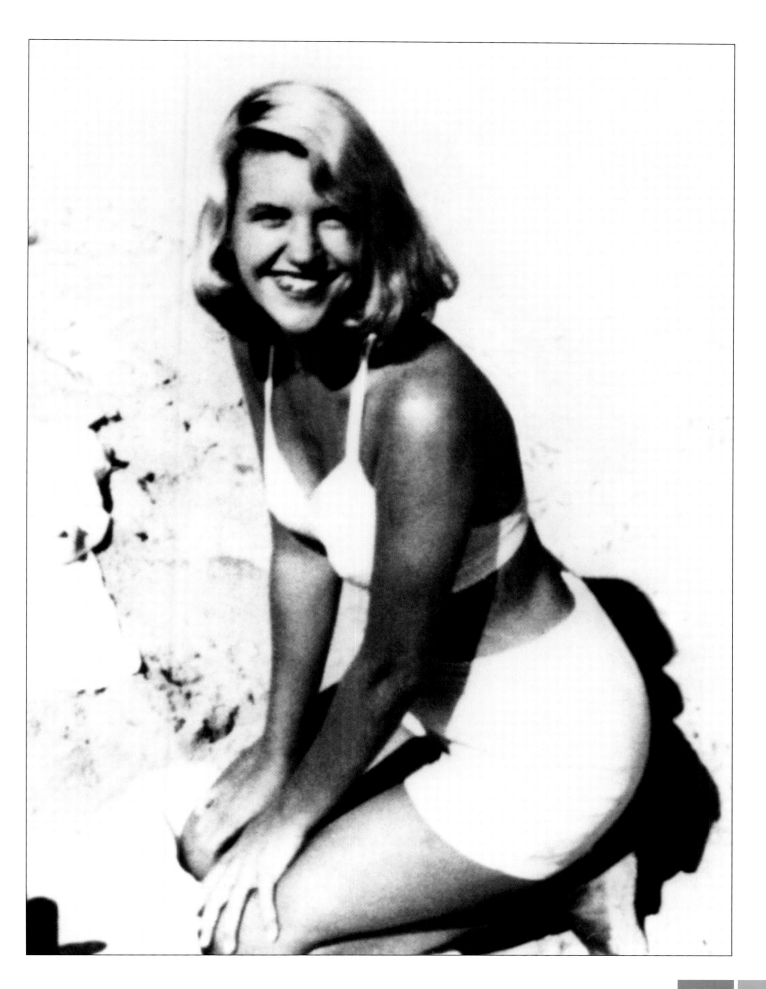

The monokini

Rudi Gernreich (1922–1985) is considered by many to have been the fashion designer who inspired the sexual revolution. His determinedly multifaceted work – from shoes to clothing through dresses, suits, and beachwear – was at all times innovative and forward-looking. In 1964 his presentation of a bathing costume that revealed the breasts caused an immediate and unprecedented storm of media outrage. Unlike Réard's scandalous creation, Gernreich's monokini (a name that seems to have been devised by the first journalists to write about it) was at once fully debated in the press. It consisted only of a larger single piece, which covered the groin and buttocks; the upper element was reduced to a couple of bands not unlike braces or suspenders. The original idea for these suspenders, as drawn in rough sketches, was that they would be worn crossed over the breasts – but Gernreich then went on to produce models with just a single suspender. The one-piece lower part or base, designed in several different styles, resembled much larger bases, such as those used in sportswear. As a costume, the monokini with its crossed suspender-bands looked quite like some of the old-fashioned military uniforms which featured crossed sashes or bandoliers. Such military connotations created a direct link with Réard's bikini. At the same time it evoked a distinct air of personal vulnerability because it left so much of the body unclothed. With this masterstroke, the designer – who was born in Vienna but who began his working-life in Los Angeles – effectively inaugurated the fashion for women's topless bathing on beaches.

The actual inspiration for it was thus the monokini (a name evidently derived as a backformation on analogy with bikini, in which case it should more logically have been the unikini) which introduced the notion to the public. After all, no bikini top meant the eradication of the lighter-coloured patches between the suntanned areas of skin. Subject of male fantasies for an entire generation, the monokini was nonetheless rarely to be seen on the beaches. Expensive and used with discretion, like Réard's first bikini, only 3 000 of them had been sold by 1985. But the idea that a costume leaving so much uncovered might be worn on the beach lent massive support to those sun-seeking women who, from the early 1970s, were determined to cast off all clothing that had no genuine function. Consequently, quite a few improvised monokinis began to appear on the sunny strands, most with very brief bases to which two braces or suspenders had been attached vertically, each supposedly covering at least a nipple. In this way, a touch of modesty was added to the original model.

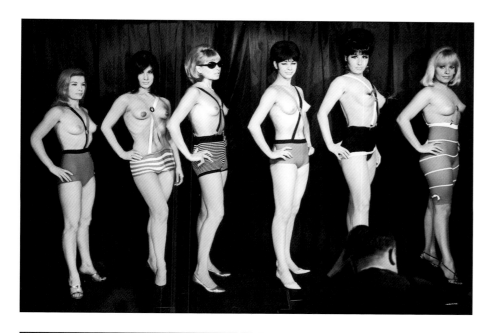

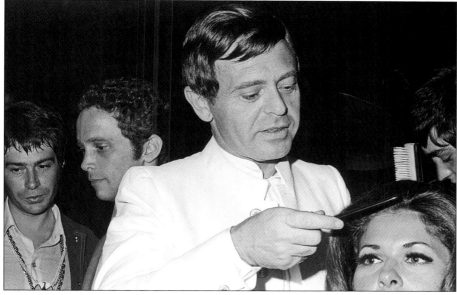

49.
Presentation of the monokini, July 1968.
Designed by Rudi Gernreich (1922–1985) in 1964, the monokini was initially railed at by the Vatican. Today, the topless look apparently comprising only a bikini base, but sometimes accompanied by a wide cape in psychedelic colours, is neither outrageous nor even extraordinary. It has even been equated with unisex fashions. At the beginning of the 1960s, however, the monokini evoked furious debates and some scandal. Monokini wearers were accosted on the beaches, magazines competed for lurid photos of monokini-clad fashion models, and Gernreich was constantly defending himself on TV talkshows. But the designer had intended only one thing: to create a fashion for the future.

50.
Rudi Gernreich attends to a fashion model.
The designer of the monokini was born in Vienna in 1922. In 1938 he fled from the Nazis to the USA, where he became one of the most influential fashion designers of the 20th century. Many of his ideas were inspired by his Viennese upbringing and its "utopian" communities. He meant his clothes to be suitable to all and to afford their wearers a self-aware confidence.

Chapter 3:
The Frontiers of
Imagination

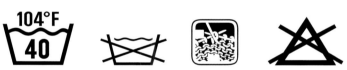

51.
Self-supporting bikini.

The "little black dress" and the bikini are today the basic items of clothing for any self-respecting woman. Quite the reverse of what was the situation during the 1950s, since the modern woman can find the latter of the two on the swimwear shelves or sportswear shelves of virtually any large department store. These "little scraps of cloth" and their straps can be found in the entire gamut of colours, of models, and of materials. From a plain bikini in a single colour and comprising simple triangles of cloth stitched together (of the type that young girls also wear) to bright red two-piece costumes in crape besprinkled with tiny stones.

No bikini model is exactly like another, as is immediately evident to all. Each one puts a different stress on some distinction – perhaps a peculiarity of body shape – in addressing itself to the specific type of woman for whom it is designed. Yet in spite of the apparently infinite choice currently available to a woman, they all represent no more than an insignificant fraction of the total number of bikinis, that have passed through the great maisons de haute couture and the office-workshops and the warehouses over the last fifty years.

Bikinis made of bearskin, of sea-wrack (a type of seaweed), with diamonds, of linked metal plaques, in cast-iron; bikinis that are inflatable, submersible, adhesive, or disposable; bikinis that are simply painted on the body, or made of flowers stuck onto it; bikinis that retain a cool temperature; bikinis that sprout windmills turned by solar energy hitting solar cells on the blades – the history of the simple two-piece costume could fill a surprising and amusing gallery of swimwear fashion, and would deserve to be immortalized in a museum devoted entirely to it. Some models are hardly wearable at all, being too heavy or just too awkward to put on. Others might certainly be used to walk on the beach in but would be impossible to swim in. Yet others are of such priceless value that they could never be taken out of the safe without a police escort. Every single bikini demonstrates the astounding range of imagination of those who thought them up.

Among the designers of bikinis, one or two are distinctly unexpected as originators. Besides fashion professionals, the list includes aeronautical and motor-car engineers, aerodynamicists, college professors, and even machine-minders. And the great couturiers are long past ignoring the opportunity in the bikini to exhibit their particular talents. For just like a wedding-dress, the bikini offers them a way to publicly display their humour and imagination.

Even Réard's original bikini was more than a simple swimsuit. With its thin straps, encircling a woman's body like ribbons around a present, and its base with its front element and its rear element linked by a mere thread, Réard himself added a touch of humour and softened the provocative edge of nudity. The triangles composed of newspaper cuttings were the equivalent of winks in the direction of the media who, as Réard was well aware, would turn this minimalist item of clothing into a scandal and name himself as the prime mover. Réard's chosen model for the inauguration herself participated in this strategy – a woman who in this smallest of all two-piece costumes nonetheless felt fully clothed, and could therefore pose in good semblance of total innocence and nonchalance for the photographers. The matchbox in her hand was simply one of the many "accessories" in or with which the bikini was to be sold. And that so small an item could itself have special accessories gave it the mark of success.

The principle behind the bikini-as-art is utterly straightforward: a small quantity of material, covering only what is strictly necessary, usable on dry land and in water, and attracting attention from all angles.

Such a definition of what was essential to the bikini remained in force after Réard's time, through all the bikini variants, until the concept itself was over-taken. Then, all kinds of different materials could be utilized, such as plastics, metals or flowers. With this evolution, came a variety of new uses. The bikini could be used for swimming or could now be an aid to

52.
Self-supporting bikini.

53.
January 29, 1968: Yves St Laurent presents a flowery wedding-dress in tulle. The spring collection of 1968 was entirely devoted to the theme of sensuality.

rently intimate revelation, perhaps with the refinement of transparent materials (or at least seemingly transparent). If a designer thought instead that the bikini stemmed from its seaside connections, then it might be covered with starfish or with bobbles resembling sea-urchins, or made to look as if it was actually made of seaweed. If a designer wanted to emphasize the sexual connotations, to suggest for example that it would make its wearer totally irresistible, it might be moulded out of chocolate and be so visibly "delicious" (if short-lived). Some insist on innocence, and work with the motifs of childhood; others see in it an extension of fierce Amazon dress and include, among its accessories, such items as a sheath for a dagger and holsters for revolvers.

In 1949, the American chromium-producer Charles L. Lang, whose product went into making Cadillacs, invented the bikini top made of two cones. Without wire frames and unconnected with each other, the waffle-moulded cones left the wearer's back entirely bare. They were held onto the skin by a clingy material that was part of the design, although every time a swimmer came out of the water, that clinginess had to be restored with a "rejuvenator" device. Lang named his bikini Posies, which some have interpreted to mean that the costume was easy to pose in [illustrations 51 and 52].

Rose Marie Reid, a rather stern woman of conservative Mormon background, in 1950 invented a material that allowed ultraviolet rays to penetrate it. From the material she fashioned a fairly formal one-piece bathing costume. Women were thus enabled to give their bodies a suntan all over while wearing a "proper" swimsuit. The costume was commercially marketed and became popular. But it was rapidly noted that bikinis made of the same stuff also permitted suntanning without any paler areas left on the body.

54.
Joséphine Prichard at the Cannes Film Festival on May 23, 1965.

preserve one's modesty while sunbathing and, it could also be worn from time to time for convenience at home. It never ceases to draw the eye, especially when what is "strictly necessary" may change – for some, the limit is just above or below the bust; for others, the base must come at least up to the navel.

Most of the variations on the bikini were inspired by its origins. If a designer believed that it derived from undergarments, then the accent would be on an appa-

In the same spirit, during the 1950s, a bikini was devised that was made of solid plastic disks – two over the breasts, one over the groin and one over the bottom. It was held up on the wearer by a complex arrangement of straps around the neck and was claimed to be "waterproof" (in that it did not deform in water). It was therefore advertised as being "suitable for swimming in."

As early as in 1963, the Japanese had stunned the world by inventing the "unsinkable" bikini. This Titanic-reminiscent costume relied on a special plastic lining which could keep afloat any woman wearer who weighed less than 150 pounds (68 kilograms). The notion of a "life-bikini" was taken up later by an American who came up with a model that inflated automatically on contact with water – not inappropriate for games on the beach.

In 1964 in France, the sponge bikini was created. Advertised as "the comfortable costume" it guaranteed a special snug coziness.

During the 1990s, the designer Moschino created the turf bikini. On the triangles that covered the bust and the groin, an actual patch of lawn had been planted on a base matting that contained its own reservoir and irrigation system. As a great number of publicity pictures (and cartoons) pointed out, this bikini required regular nourishment and trimming.

The 1970s saw a whole flotilla of "flower-power" bikinis (this "flower-power" movement projected flowers as symbols of opposition to war.) The main idea was to use plain materials with flowery designs on them. The tops might additionally have little cloth flowers sewn on to look like sprouting garlands. But even in 1965 Joséphine Prichard was showing photographers at the Cannes Film Festival a good deal of her bare skin otherwise encased in a flowery bikini [illustration 54]. And Yves St Laurent's spring collection of 1968 featured a somewhat sentimental wedding-dress [illustration 53] under a gauze veil hanging the full length of the body consisted of a bikini comprising two largish garlands of flowers.

The US/Canadian movie star Tandy Cronyn at the age of 22 [illustration 55] perfectly demonstrated the mood of the time when, on a hot day in July 1968, she walked through a London park wearing a bikini apparently made up entirely of chrysanthemums, roses, and violets.

Another example of the liberal way people were thinking during these years is revealed to us by Goldie

55.
Tandy Cronyn (22) in a bikini patterned with flowers not far from some real chrysanthemums on Ascot racecourse, Berkshire, June 17, 1968.

56.
Goldie Hawn (23) grimaces in her bikini and grease-paint in a sketch from Rowan and Martin's *Laugh-In* in 1968. Miss Hawn often played a dizzy blonde extrovert in humorous roles. One year after this she was to receive an Oscar for her comic performance in *Cactus Flower*.

Hawn [illustration 56] in a TV show called *The Cutting Edge*. Wearing a Grand Prix model bikini in black and white squares, and with the rest of her body painted, she portrayed herself as a series of signs, not saying a word. Her right arm was painted as if in a convict uniform, with a prisoner number, and a ball and chain on her foot. A notice on her left shoulder read "Beware: rocky surface!", another on her left elbow "Convergence", and on her left thigh "Beware: danger curves ahead." At the front, the viewer discovered that her legs were "Off the beaten track" and "Off target", while her right knee was altogether "Terra incognita." The male stereotypes of the pirate and the paratrooper were tattooed all across her stomach. In her left hand she held two cards between which, on her palm, read "Gamble" and "Play with me."

Other creations furnished similar evidence of a wish to communicate. There were, for example, some very brief bikini bottoms that carried the message, on front and back, "Do not touch!" Costumes might alternatively feature the national colours or even part or all of a national flag.

During the 1990s, the designer Galliano managed to come up with a punk bikini, on the back of which read the legendary "I'm yours, boys!" [illustration 57].

Back in the 1950s, though, there was even an attempt to see how visually deceptive bikinis could be. On the occasion of a beauty contest at Juan-les-Pins on France's Côte d'Azur, a certain Miss Lina presented a vine-leaf bikini which really did hide the absolute minimum. Model number 15 in the contest wore a costume called "Gold leaf" [illustration 58], which was so apparently close to Eve's original garment to alarm the organizers and promoters even as it drew the admiring gaze of the audience.

Among the creations that treated the bikini less than seriously was Luc Traineau's wig bikini of 1966 [illustration 59]. Its packaging pictured on it a smiling girl wearing a costume in a medieval setting confronted by a mammoth from the remote past – or is it perhaps a portrait of a peculiarly long-haired dog

whose coat a young lady is tenderly plaiting into a costume?

In much the same heart is the unconventional bikini designed by Bibelot in 1965 and called *Paws off* [illustration 60]. It parodies lecherous attempts to touch the bikini wearer. The top is entirely made up of two black velvet hand-silhouettes over the breasts, as if some man had left his hand-prints. It has to be said that this model is something of an invitation for a man to put his hands in precisely the locations indicated. But it was a motif repeated many times in different contexts during the 1970s, particularly as adhesive nylon bikini tops and on the seat of a pair of jeans.

Réard himself seems to have had in the 1950s, a good time putting humorous messages onto his bikinis. The collection called *Declaration* that he staged in 1955 included a three-piece costume [illustration 61] for the less original. Two red cups combine with a heart in the same colour that covers front and back of the base. Here, indeed, the revolutionary sobriety of Réard's original bikini is long gone, abandoned for commercial reasons.

In the same year, a bikini was produced that was formed out of pieces of a shiny synthetic material [illustration 62] intended to suggest the sort of bathing costume that might be worn on the planet Mars. What is remarkable about this bikini is the elegant shape of its base, which today amply demonstrates one of the great crazes of the era. For the atomic decade was also a time in which people anticipated invasion by little green men from Mars in their flying saucers. It is a bikini indelibly listed among those that belong to a specific period.

The Fantomas bikini [illustration 63] – a tight-fitting black three-piece costume worn over a shift woven into a sort of net, as presented by French fashion model Gisèle Thierry in that same year, is even less convincing.

By 1962 the space theme was still being thrashed to death. There was, for example, a false three-piece costume (false in that the cups were connected by a thin strap beneath the bust) which, like many other contemporary costumes made of flowery ornamentation, had a multiplicity of accessories meant to lend an extra-terrestrial character to it – such as a kind of transparent plastic bucket for the head intended to represent a space helmet, a pair of monster-size glasses, a set of metallic headphones, and a cape that looked as if it was made of aluminium and would have been better suited for attending a masked ball or a performance at a second-rate theatre [illustration 64].

Ragged or tattered bikinis, which afford the wearer an appearance in a way "natural," original, and potentially timeless, first appeared at the end of the 1940s, and have something of their own role in the history of the bikini. A woman who wears one seems to have just escaped from some cataclysmic disaster (perhaps even the nuclear destruction of the planet).

The designer Myriam, in 1949, presented the "vine-leaf" bikini [illustration 66] in which threads sewn into the material were intended to suggest the veins in a leaf. The costume itself looks more like a ragged bikini, and one might easily imagine that the model has only just torn it to shreds on the sharp rocks she is standing by. Shown without a title against it, it appears to follow the principles of the bikini-as-art to the letter.

A variant on the ragged bikini is to be seen on the cinema screen. In the movie *One Million Years BC*, Raquel Welch wore a very artfully cut fur bikini with braces or suspenders. The furry part of the skin is on the inside, like a lining, and gives a strange elegance to the edges. The most celebrated still from the film shows *la belle sauvage* at the moment of hurling a spear, the full weight of her body concentrated on one shapely leg

57.
John Galliano's punk bikini inscribed "I'm yours, boys!", October 12, 2000. Paris. Photo: Jean-Pierre Müller.

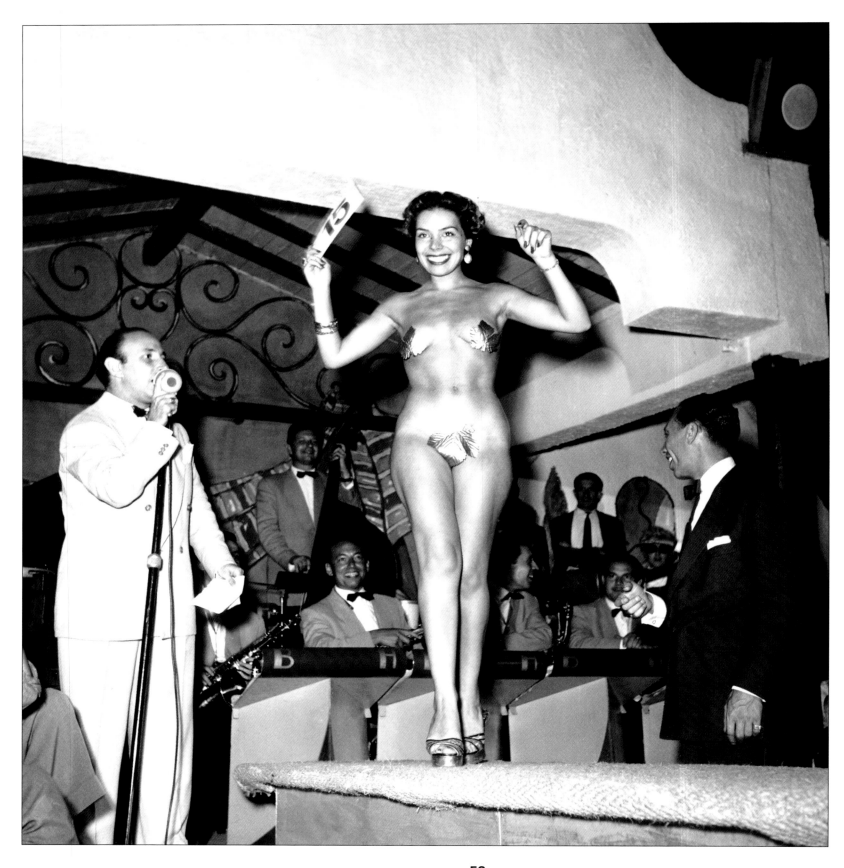

58.
Beauty contest at Juan-les-Pins on the Côte d'Azur, France. Miss Lina is wearing the extremely brief bikini called *Gold leaf*.

[illustration 67]. The fashionable cut of the clothes and voluminous length of the hair were typical elements of 1960s style, but contributed absolutely nothing to the realism of this film – not even the spiral of hair flopping languidly forward and unravelling in a manner that might well be described as neolithic (in that it might have been cut with a flint axe).

In the 1980s, the movie known in French as *Le Feu* was a little more convincing, from a prehistoric point of view, and likewise featured a Stone Age fur bikini.

A film from the 1960s showed its heroine in a fur bikini amid a desert of ice following a nuclear disaster. Therefore the past as the future is symbolized in the cinema by a fur bikini. George Lucas' futurist-prehistoric snake bikini in *The Return of the Jedi* embodies the same spirit [illustration 65].

Amazon warrior-style bikinis seem to have fascinated fashion innovators mainly because they could use materials that looked rough or shredded. The silver-smithing company *Constanze* in Paris, during the 1980s, decided to cast an Amazon bikini in solid silver. This great warrior costume, which covered only one breast and was itself covered all over in lions' heads, certainly made an excellent suit of armour even if it came nowhere close to being "suitable for swimming in."

Paco Rabanne's bikinis, made of metal plaques and a ring [illustrations 68 and 69], are much lighter and more forward-looking. They give the woman an overall appearance that is less materialistic, so that she can at least wear it to the beach without being embarrassed.

Perhaps the most rugged bikini that can genuinely be used as a bikini is the gladiator-style bikini in red leather, dating from 1970, which certainly suggests the true warrior qualities of the female sex.

Other weird and wonderful bikinis may look like seaweed, or may make wearers after a bath look like naiads coming up from their submarine kingdom (in which case all that is missing are the fins). But there are also punk bikinis, and dominatrix bikinis made of shiny leather with a knotty surface. These partly reveal the breasts or are provided with the means of an opening in certain areas to afford a more intimate use.

For publicity purposes, amazingly, some bikinis designed are actually impossible to use as such. In the 1980s, for example, a bikini was stretched around a glass tower looking as if it came from the land of the giants. And there were diamond bikinis, like the one made entirely of diamonds [illustration 72] worn in 1998 by Nelson Mandela's niece, the fashion model Awa, on whose beautiful South African skin the effect was truly wonderful. The bikini was the creation of the Italian designers Stefano Guindani and Lorenzo Riva.

And then there are the experimental bikinis, made to test out techniques that may never have gone into production – although of course in each case they are of great curiosity value. One bikini of 1970 had a shortwave transistor radio attached to a pad that rested on the skin. Another had windmills or propellers powered by solar energy and usable as cooling fans (it was invented by a Californian jack-of-all-trades during the 1980s). The windmills, one on each breast, were intended to refresh and cool men overheated at the sight of a female body so nearly bare. A variant, and an equally practical one, was the Wonderbra inflatable bikini [illustrations 70 and 71] which render silicone implants completely obsolete. Two small air-pockets in the top of the costume can be inflated to any pressure desired by means of a tiny pump. The effect produced is the same as that of a bra made by the same company.

Comic-effect bikinis like the tap or faucet bikini [illustration 73] made in the 1990s are part of the eccentric world of humoristic dressing. The taps or faucets sprout from the bikini top, one from each breast. They do not work, of course, but they do parody very well the attitudes of society towards the natural body shown by a woman in a bikini and the natural body of a nursing mother which is generally heavily – perhaps unnecessarily heavily – concealed. Yet why shouldn't a girl in a bikini be thought of as a spring of delights, cool and refreshing to the eye?

The same motif of the woman's body regarded as food and drink, elaborated on a trikini made in the form of cake-tins [illustration 74]. The wife in a bikini in the kitchen might one day become a favourite male fantasy, although it has yet to be seen in reality anywhere but on the catwalk.

The erotic functions of the parts of the body concealed are apparent in a bikini on the theme of a Venetian gondola [illustration 75]. Because of the ornamentally splayed ends of the gondolas rising on each side like huge bushy moustaches, this costume is pretty well impossible to wear.

Other bikinis have had their moment of glory and have faded into obscurity. There were the tiny bikinis meant to expose as much skin as possible to the sun – and which dissolved immediately in water. And there was the chocolate bikini designed by Chantal Thomass and exhibited in a chocolate emporium in Paris in 2000, worn on the catwalk by an otherwise unclothed beauty.

These few examples afford us a good idea of what the bikini can do and be. The limits of the imagination, when all possible ideas have been tried, have not yet been reached and realized. Indeed, the multiplicity of bikini creations from zaniest to weirdest is surely enough to suggest that such a day is unlikely to ever come.

59.
Wig bikini by Luc Traineau, 1966.

60.
Bibelot presents the unusual *Paws off* bikini, January 12, 1965.

61.
Déclaration – Louis Réard's new collection, May 26, 1955.

62.
Gisèle Thierry in a Réard bikini, May 26, 1955.

63.
Catherine Bleuze in Louis Réard's *Bikini de Mars,* May 26, 1955.

64.
A Réard bikini with a futuristic plastic casing to go over the head, June 27, 1962.

65.
Carrie Fisher as Princess Leia Organa wears a decorative form of bikini in *The Return of the Jedi* (1983), the final episode of George Lucas' six-part *Star Wars* series yet to be completed. Miss Fisher also featured in *The Blues Brothers* (1980) and *Austin Powers: International Man of Mystery* (1997), and has recently been much commended as novelist and TV/movie script editor.

66.
Myriam in a bikini with a vine-leaf intended to suggest a fig-leaf, September 1949.

67.
Raquel Welch in *One Million Years BC* with her celebrated fur bikini. Her role in this "romantic Stone Age drama" brought her worldwide fame such that in the same year, 1966, she was accounted the most photographed woman in the world and starred in a play on Broadway.

68.
Rhéa Durham in a silver bikini by Paco
Rabanne, October 9, 2000, Paris.
Photo: Jean-Pierre Müller.

69.
Victoria Bouteloup in a bikini by Paco
Rabanne, October 9, 2000, Paris.
Photo: Jean-Pierre Müller.

70.
Inflatable bikini.

71.
Inflatable bikini.

72.
The South African fashion model Awa, niece of former President Nelson Mandela, in a $1,000 bikini designed by Italians Lorenzo Riva and Stefano Guindani, September 24, 1999.
Photo: Giuseppe Farinacci.

73, 74 and 75.
The silliest bikinis in the world.

76.
Inflatable bikini top made by Gossard, at the International Exhibition of Undergarments and Swimwear in Lyon, France, September 3, 2000. Photo: Philippe Merle.

77.
A $100,000 bikini.

A brief history of bikini material

In 1939, the American company Du Pont came up with a new synthetic fibre that it originally intended to use to make stockings and tights. Given the code name Polyamide 66 or Fibre 66, the new material – soon to be spoken of by the world at large under its proprietary name Nylon – was equally soon decorously sheathing women's legs. Swimwear, until that time made in cotton and linen (the countless stitching patterns for costumes which filled fashion design-books during the 1940s look absurdly ridiculous today), then discovered a new basic medium. Much lighter than cotton, staying opaque when wet unlike linen, it was gratefully received on the beaches. But it was not available on a truly worldwide scale until the beginning of the 1950s. In addition, its unfortunate tendency to promote body-sweat and thus to encourage unwholesome odours did not meet with universal approval. The Du Pont company found a solution to such problems in 1962 with the invention of another synthetic fibre, lycra. In fact, lycra was a combination of synthetic and natural fibres, and enabled the makers of bathing costumes to produce completely new styles. Stretchy, soft, quick-drying in air, and actually lighter by 3 ounces (100 grams) when wet – a classic cotton costume might suddenly gain weight astronomically, perhaps by as much as 7.34 pounds (more than half a stone, 3.5 kilograms) when a swimmer took to the water – swimsuits in lycra, one-piece or two-piece, were extremely comfortable to bathe in. During the 1970s and 1980s, the sexual revolution – a critical period for the bikini – caused women to favour the one-piece costume. The new material thereupon proved its worth in allowing the manufacture of styles that demonstrated additional aesthetic properties. Slight bodily imperfections in the wearer might thus be compensated for by the swimsuit. As the 1970s continued, so the number of synthetic fibres increased enough to take over the market completely, and new combinations were produced. The overall aim became to find a new material light in water, pleasant to wear, and adaptable to the tastes and fashions of the time. The future of swimwear styles in this way became oriented towards materials yet to be devised.

78.
The Du Pont buildings at the time of the early mass manufacture of nylon during the 1950s. On 27 October, 1938, Du Pont laboratory research scientists reached a stage at which they felt they could put the first synthetic fibre – nylon – on the market. By February 1939 Du Pont employees were buying the first nylon stockings, which in 1940 took over the entire American market. But US women were then obliged to cut back, for all production was requisitioned as part of the war effort. Once the war was over, further progress was made, especially in the domain of underwear, although nylon remained significant in making external clothing too. In 1959 the synthetic fibre elastane was added to the range (and given the brand-name Lycra), following an intensive drive to increase elasticity.

Chapter 4:
The Bikini
and the Cinema

 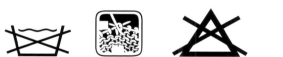

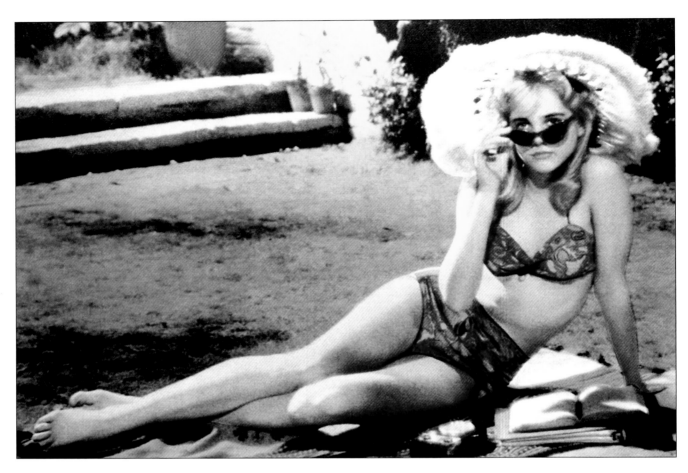

79.
Stanley Kubrick's film of Vladimir Nabokov's *Lolita* (1962), with Sue Lyon.

On the large screen, bathers with all the allure of semi-divine nymphs gambol across beaches of white sand. Seductive sirens, with oh-so-flat stomachs, lie languidly stretched out on inflatable mattresses, or alternatively sit with crossed bare legs on wickerwork chairs. Faintly feline beings, in extremely brief costumes, catch the sun on their comfortable camp beds in the lee of a powerful motorboat. A beauty with long slender legs leans coyly against the mast of a luxury yacht, or makes her way to the edge of the shallow end of a swimming pool and paddles her legs in the water with a carefree air. In some paradise in the Southern Seas, some dreamy insomniacs looking like mannequins wait at the bar counter while their cocktails are shaken. Under the palm trees and the coconut trees, a girl swimmer just out of the water raises her arms towards the sky in order to catch and meet the willing eye of the hero of the movie, at whose side she suddenly appears,

offering him a striped sponge towel. These are bodies perfect in form, lightly tanned, which at the mere sight of them evoke the scents of bath oils, of sun cream, and of vacation – and they flash in front of our eyes on the screen for such a brief moment of time. Yet those instants are enough to fix the poses as they are, half innocent and half lascivious, in our minds.

Even if we see the film again immediately afterwards, the young women in bikinis remain no less blinding visions of loveliness, like classical Greek statues, like goddesses – Marilyn Monroe, Ursula Andress, Jayne Mansfield, Brigitte Bardot, Bo Derek, not to mention the countless Bond-girls and other screen starlets and nymphets dressed in bikinis, who may or may not have any real role in the story but who nevertheless participate in and contribute to the atmosphere of the film.

80.
Stills from John Huston's movie *Night of the Iguana*
(1964), with Sue Lyon.

Since the 1950s the girl in a bikini played an intricate role in the movie industry. She was something to attract the audience's attention, she was an accessory in the story, or she was the provoker of scandal. Following World War II, this industry seemed very quickly to latch on the notion that a symbol for seduction was required. Films, which after all have always evolved more as art than as pure entertainment (which is not in any way to suggest anything derogatory), had at this point to accommodate the wishes of a population weary of warfare. A symbol of femininity was therefore created. It had nothing to do with notions of the "traditional" woman who toiled all day in the kitchen and who then welcomed her husband and his work colleagues into her home clothed in an evening dress not entirely dissimilar from a bathrobe, or who waited with chaste heart and mind for her soul mate to return from the war. No, the "new" woman who came to dominate the screen, without completely eclipsing her predecessors, was very different. She was a woman entirely conscious of her ability to seduce – a woman who, disguised by innocent actions and toneless volubility, pursued her own goals, made her own way in life without scruples. An inkling of female emancipation was visible on her face, and if at first she did not specifically demand that emancipation, well, for the time being she could at least dance the night

81.
Blonde and buxom Jayne Mansfield leaves her private pool careful to keep her stomach flat. This picture was taken in the 1960s.

82.
Letchika Chorrau at the Cannes Film Festival, April 20, 1953.

away at jazz dives with hips bumping and grinding, she could take part in intellectual discussions with a cigarette in her hand, or could lean casually up against a bar. She wasted no time on shiftless men, who were there only to light the cigarette she took from her pocket. Such a woman of course had no problem at all with the idea of lounging in the sun in a bikini.

If this is the way she behaved, it was not solely because times had changed and former barriers were being broken down, but also because she had seen examples of a new lifestyle on the cinema screen.

In Stanley Kubrick's movie *Lolita*, Sue Lyon stretches out on the lawn in the garden and, in her bikini, displays her adolescent charms on a stiflingly hot and tiring summer afternoon [illustrations 79]. The film's hero, Humbert Humbert, is not the only one to have changed outlooks on the world, as he remains living at the house of the widowed Mrs Haze (Shelley Winters), with whom he had at one stage wanted to elope.

It was a time when countless girls decided to try to be as seductive as those they had seen in the movies. So when Brigitte Bardot, in Jean-Luc Godard's movie *And God Created Woman*, slid down a steep slope towards the sea dressed in a Vichy bikini, her progress was followed not only by the camera but also by the attentive eyes of thousands of female moviegoers who intended the following summer to be wearing an identical costume.

The bikini undoubtedly owed a large part of its success to the cinema – which actually featured it at first only because it was scandalous, and scandal filled seats. But it was quite right that there should have been some hesitation over it, for Hollywood had to be careful: initially it banned the bikini from the screen as "too corrupting and immoral."

Times change, however, and the relaxing of tensions after the end of World War II also led to the releasing of inhibitions (actually, it happens all over again every year in summer, on every bathing beach around the world,

Bikini madness

It was perfectly possible to earn money by showing off one's skin without contravening contemporary codes of Western morality. During the "bikini madness" of the 1950s, various film producers regarded the bikini as an unbeatable gimmick, and almost flooded the cinemas with the most outlandish movie absurdities to feature it, starring such luminaries as Brigitte Bardot and Marilyn Monroe. Titles included *Bikini Beach* and *Bikini Widow,* with offshoots such as *Muscle Beach Party.* Among all of them, there were some fairly good productions – although they tended without exception to depict rather characterless young people scantily clad on beaches in rather weird historical or prehistorical scenarios, and to be totally forgettable within two minutes after the movie had ended. The most important element, after all, was to have pretty girls lying nonchalantly on the sand, or dancing for musclebound but apparently blasé hunks, with whom – after sexual dalliance of an unspecified nature, for the viewer never got to see much, if anything, of it (suggesting not just a reluctance to trouble the national film censor, but also a tragic dimension to the unfolding drama) – they would cheerfully drink a bottle or two of soda pop (or historical equivalent) around a bonfire on the beach. Regrettably, when it came to the bikini, bad taste knew no bounds – although there was a good deal of tongue-in-cheek about it too. *How to Stuff a Wild Bikini* and *The Monster in the Invisible Bikini* are, for instance, counted among the masterpieces of this unjustly ignored genre. Horror films also reckoned the bikini to be one of their staple elements, a guaranteed accessory for a tasty young victim. In *Scream,* for example, the first young female victim of the treacherous killer progressively divests herself of her clothing before finally coming to a full stop, hacked to pieces beside a swimming pool. In a bikini, of course.

83.
Bikini back.

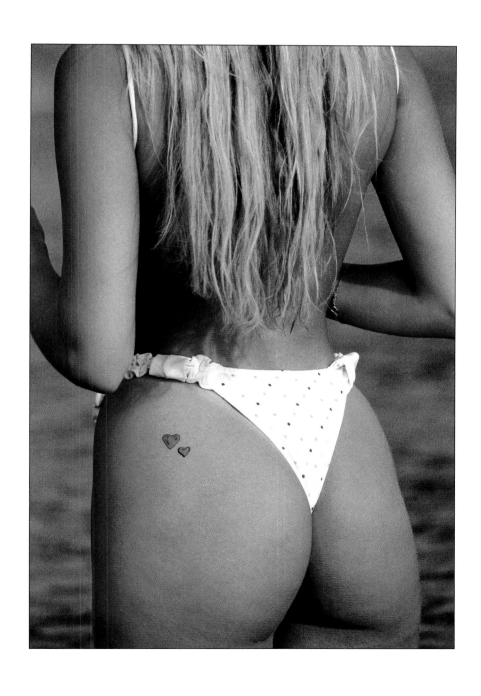

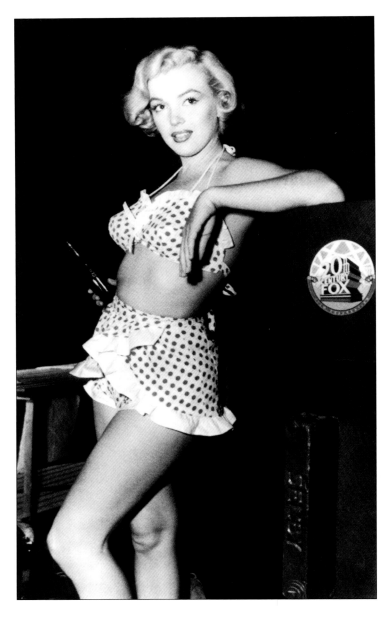

84.
Marilyn Monroe, the ill-fated "Norma Jean" (1926–1962), in an undated photo probably taken at the end of the 1940s.

85.
Ursula Andress in her *Dr No* bikini and a large shell.

as women loosen their two-piece costumes ever more slackly in order to get a "fuller" tan). The Hollywood movie industry certainly made its own contribution to this tendency, to which it yielded despite protestations from the burgeoning feminist movements.

Such a situation is merely the result of changing sensibilities modulated by progress. The cinema played a starring role in this evolution, to the extent that after 1945 it became available in colour to a vast number of people and gradually eclipsed many other social activities previously undertaken and enjoyed outside working hours. Popular, convenient, and entertaining, the movie was a response to its era, which then demanded ever more amusement within ever shorter intervals. Most often, the movies were based on themes and ideas taken from literary sources that themselves had tended to try to break down barriers and extend frontiers in relation to accepted morality.

After 1945, people began to reconsider the concept of shame – to redefine what was shameful and what was shameless. The demarcation line between morality and immorality was stretching further and further.

The French poet Charles Baudelaire had after all been hauled up in front of a tribunal in 1847 for having spoken in his poems of women who, jumping under a waterfall, immodestly showed their ankles. Writer Gustave Flaubert in the same year had to answer for himself in a similar fashion following the publication of his *Madame Bovary* – a novel that concerned adultery. Because he had dared to make the heroine of his novel an unrepentant adulteress and a very sympathetic character too, Flaubert was accused of not making it sufficiently clear how heinous a sin adultery was. Such charges were obviously based on the accepted morality of their time.

After two world wars, though, and the systematic reexamination of values of all kinds – principally under the prompting of the two major ideologies of the 20th century – the situation appeared in a different light.

In addition, public opinion had become accustomed to changes in moral perceptions, regarding such changes as inevitable when people generally had more opportunity for individual freedom. It was no longer unusual, let

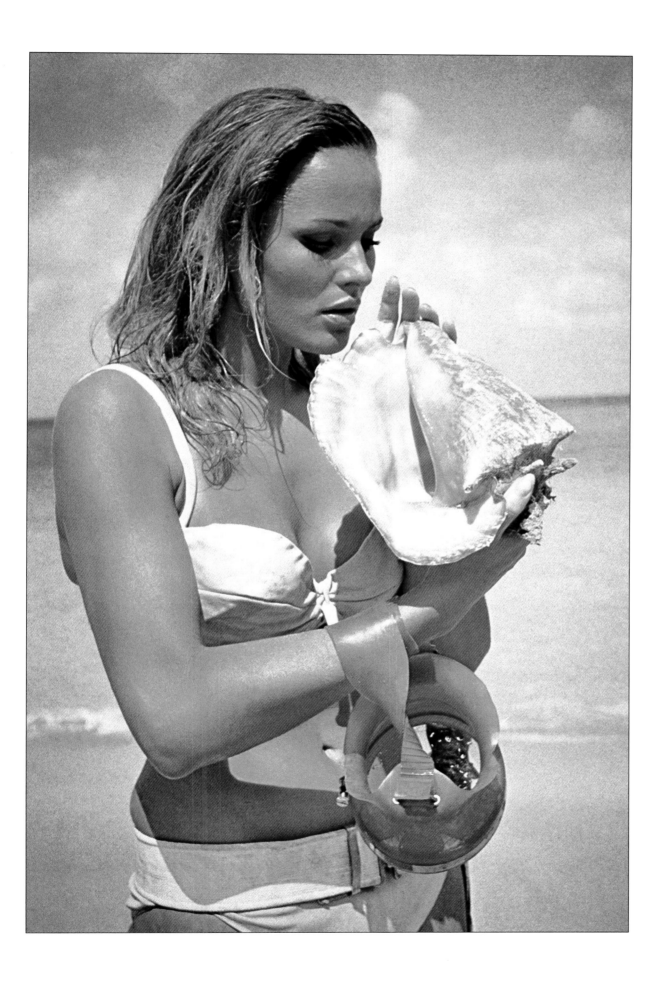

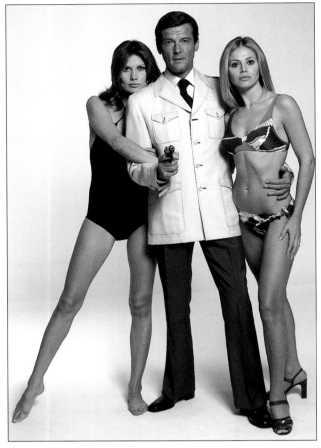

alone particularly shocking, for a person to deliberately break the established rules of society. To stay alive, to feel alive, you had to take risks. And to rise to that challenge proved that you were alive.

This mid-20th century redefinition was therefore nothing more than the logical consequence of this same vision of the world evolving through experience.

In the private sphere, testing the limits of morality manifested itself in new modes of living together (the rejection of formal marriage, having a number of partners and other sexual freedoms), while in the communal sphere it was translated into the restructuring of society. In the middle of all these considerations of what to do and how to do it, the question arose of personal possibilities – what should we do with the freedoms we now have before us? And, undoubtedly of less importance, what can we make of our bodies? How should we discipline them? What shape should they be? What use can we put them to? The latter questions are those that seem most immediately problematical today.

A fundamental change must be acknowledged in the understanding each of us now have of our own body. We nourish it in a completely different way. We preserve its health through vigorous activity. We try to protect it from getting old. We demand performance from it, at the same time being careful to allow it periods of rest. We expect it to look nice, to stay in fair shape, to be vigorous and sexually responsive.

These were all signs (or their precursors) of bodily health wished for at the turn of the 20th century. They were expected to herald a century of the liberation of the spirit – but the century actually brought with it the liberation of the body.

86 and 87.
Roger Moore was James Bond in *The Man With the Golden Gun* (1974), which also featured Christopher Lee, Britt Ekland and Maud Adams.

88.
Britt Ekland in the James Bond movie *The Man With the Golden Gun* (1974).

89.
The Living Daylights (1987) starred Timothy Dalton as James Bond, as did *Licence to Kill* (1989).

90.
Roger Moore as James Bond in *Live and Let Die* (1973), featuring a black Bond girl in a bikini.

91.
Ursula Andress in the James Bond movie *Dr No* (1962). Her swimsuit was apparently the Swiss actress's own idea – and was later snapped up very quickly (and very expensively) at Christie's. The most celebrated of all Bond girls, she was immortalized in this scene. Born in 1936 and the daughter of a diplomat in Berne, Miss Andress showed early and remarkable talent in the fields of art and chemistry. At the age of 18 she went to Hollywood to try to make a name for herself in films, and gained some support from Marlon Brando. Her debut came in 1954 with *The Loves of Casanova,* which was followed by minor roles in other movies. Only some years later with *Dr No* did she find international stardom. Among her more celebrated films are *Fun in Acapulco* (1963) with Elvis Presley, *She* (1965), and *What's New, Pussycat?* (1965). Public appearances increasingly intruded on her private life and her artistic leanings. She hit the headlines again in 1980 when she became a mother at the age of 44.

92.
A bikini-clad Bond girl.

93.
A bikini-clad Bond pin-up girl.

94.
Ursula Andress in the Elvis vehicle *Fun in Acapulco* (1963, director: Richard Thorpe).

Over the centuries, Christianity condemned and punished the body, recognizing it as the seat of evils and vices. It was, after all, ultimately responsible for "the corruption of the soul." To feel well and to be happy with one's body, then, was to be destined for the fiery abyss.

After this darkly grim era for the body, an impression slowly and gradually gained ground to the effect that perhaps the body was not to blame after all. An interest was taken in its delights and in its pleasures, and in due course – not without the occasional struggle – it was even given what it enjoyed.

When the bikini first started appearing on the big screen – when Jayne Mansfield rose up out of the pool wearing an unusual bathing costume [illustration 81] – all the conditions for juicy scandal had apparently come together. But it was a scandal that had a useful outcome, to an extent, in that the era's threshold of sensibilities was already in the process of finding itself more freedom. The long and worthy evolution of the human sense of modesty made and still makes today the business of the scandal at the Cannes Film Festival a most extraordinary thing.

111

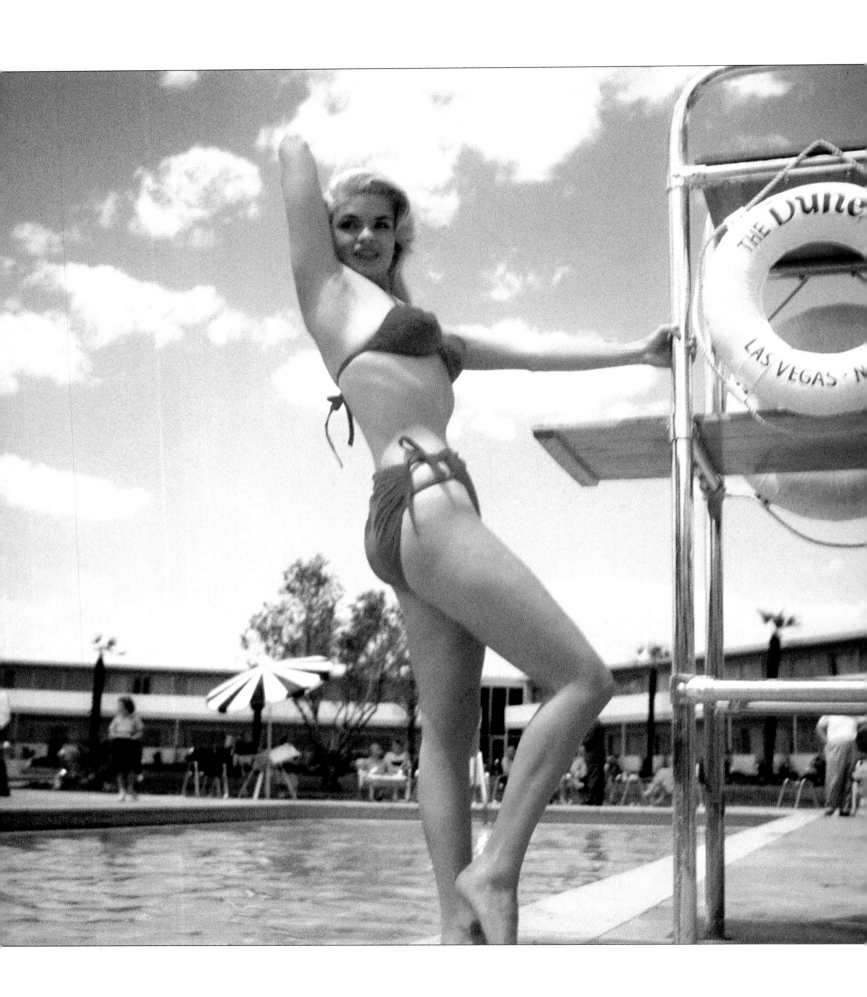

95.
Jayne Mansfield wearing a bright red bikini.

96.
Ursula Andress at a photo session, wearing a sky-blue bikini.

Since its inauguration, this film festival had been used as an event that guaranteed virtually all actors and actresses free publicity. Once interest had been aroused, the scandal detached itself from the films competing against each other and took to circulating the numerous lesser events accompanying the screenings.

So let's take as an example from the early 1950s the furore provoked by a movie celebrity who went for a walk in company with two girls in bikinis. Today there is nothing especially shocking about porno stars' showing everything they've got to a horde of photographers avid for easy pickings among the camp-followers of the "free festival" held on the beaches in parallel to the official Film Festival.

It was certainly the cinema that created the alleged persona of "the girl in the bikini." After the first appearance of movie actresses in bikinis, they had something of a contradictory character superimposed upon them en masse. Outwardly, "the girl in the bikini" is beautiful, sweet-tempered, naïve, and potentially ripe for seduction. She is visibly impressed by male biceps, and by men who look to be real men. She seems to have not a single serious thought in her head (other than spending all day on the beach, wondering what dress to put on this evening, and considering the best way to attract a millionaire). Altogether, she is the embodiment of innocence. For it would never occur to her that the beach-bums who grind around her deckchair have anything other in their minds than to chat a little with her and pay her charming compliments. At best, they might ask her to marry them, but she would give that some thought only on condition that they are owners of a great yacht, Arab petroleum millionnaires, or presidents of some wealthy and powerful nation.

This type of "girl in the bikini" was brought to life chiefly in the person of Marilyn Monroe [illustration 99] – for example in her role in *Some Like It Hot*, in which she spent time on the beach with the "multi-millionnaire" Tony Curtis. In other films the American sex symbol scarcely showed anything of herself – as in *How To Marry A Millionaire* – nonetheless remaining that same naïve girl in the bikini, now unwilling to remove her beach-wrap except in circumstances of extreme meteorological inclemency.

The "girl in the bikini" of this sort, appearing in the earliest films on general release after the war, became so celebrated that she quickly became the object of parody. The long series of James Bond films that began with *Dr No* in 1962 undoubtedly used the accepted persona of the "girl in the bikini" to full advantage, if equivocally [illustration 91]. The first and most celebrated of them was Ursula Andress, who in *Dr No* turned the naïve-little-beach-girl character upside down. She emerged unexpectedly from the waves on the shore of an islet in the Southern Seas – a figure that was disturbing, but no less seductive – in a "diving" bikini of apparently military styling, with a belt from which hung a knife evidently not just to be used in fishing. For her, the supposed naivety of the girl in the bikini was a useful camouflage – behind the seductive and outwardly inoffensive lay hidden a creature more predatory than a wildcat.

In all the remaining films in the series to date, the persona of Ursula Andress' character has been enlarged upon, multiplied and adapted. In *Octopussy* there was a whole gaggle of girls, all in bikinis and all dressed in something of an oriental fashion, but they turned out all also to be circus artists trained equally in the martial arts. In other films, the girl in the bikini was more like an Amazon girl-warrior, and was sometimes the enemy, sometimes the partner, of the British super-agent. But the scenario was always the same. Every time she seemed more inoffensive but proved to be more vicious. Every time she endeavoured to seduce and be seduced – and everyone got what they wanted: James Bond, the girl in the bikini, and the public.

In *The Man With the Golden Gun* [illustrations 86 to 88] two female tag-wrestlers cartwheel, leap, and do somersaults in an attempt to take Roger Moore off balance. Timothy Dalton, meanwhile, fleeing from his Soviet pursuers, alights upon a yacht containing an amazing number of beauties in bathing costumes who instead of taking him tenderly in their arms, pummel him unrestrainedly.

The girl in the bikini's persona is treated realistically or for laughs in any number of movies. Usually, though, it is the seductive nature of the female that is put under the spotlight. When that remains in the background,

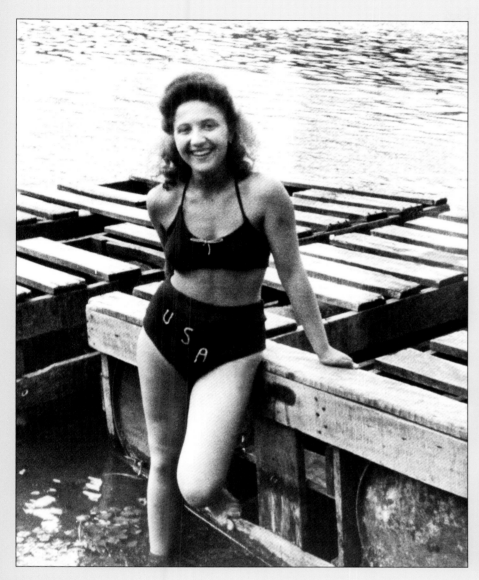

97.
Bikini at Nantes, France, 1944, before liberation.
Photo: Tony Vaccaro

98.
Kirk Douglas, now renowned as a movie star father of movie star sons, signing autographs at the Venice Biennale of 1953.

however, the persona appears in the sort of guise that often featured in those improvised medieval entertainments enjoyed in marketplaces and on feast-days. On stage there would suddenly appear, without any reference to the story being told, a juggler or a fire-eater – or a young woman cartwheeling from one side to the other before being lifted high in the air by a Hercules of exceptional strength. The same lightheartedly chaotic atmosphere is to be found in the Bond films, which in the meatiest parts of their action borrow from the battle scenes of Shakespeare as much as from contemporary

modes of merrymaking. That is why they have in them, next to the most beautiful woman in the world (the girl in the bikini, naturally), a dwarf, jugglers, fire-eaters, contortionists, fakirs, superhumanly strong men (as in *Goldfinger*), a man with steel dentition, but also bearded ladies and cripples (wretches who have lost hand or foot), along with all the marvels and monstrosities of the world (the most beautiful city, the most beautiful palaces, the highest mountains, and so on to further superlatives) and all the extravagances of nature. The girl in the bikini or the Amazon in the bikini – who in

this fairground style of presentation is virtually type-cast, given an ovation by the public who throng to see her – is very much part of this checklist of everything people believe ought to be seen and recognized.

Other films have treated the theme of the bikini in terms of parody. The Israeli series shown in France as *La Glace Sur la Tige* showed how a group of pubescent boys out for a good time (and who all the local girls had fallen for) preferred girls who were "more sensual." These were the girls who spent their time getting a suntan on the beach or actively playing sports – which of course required them to take their clothes off in beach huts or in gymnasium showers. Our manly heroes endeavoured to observe this interesting phenomenon by means of holes drilled in walls or through other appropriate apertures. Of course it ended in total disaster, and with comeuppance for all concerned, sometimes in the form of serious advances from women of distinctly masculine appearance and of a certain age. The loutish youths sought refuge instead in the arms of those damsels they had previously disdained.

But some of the parodies were not actually meant to be parodies. *Bikini Beach* – an American comedy of the 1960s – for example, was intended to portray a beach party, with a bit of schmoozing and snogging going on between students. If moviegoers were to ignore the vast numbers of polka-dot bikinis (which, as commentators aver, were part of contemporary American culture), a mindlessly superficial storyline, dialogue that was unrealistic to the point of absurdity, and the tediously repetitive crashing of the waves on the shore, there really was not much else to stay awake for.

In another sort of parody, the serpent bikini daringly worn by Princess Leia (played by Carrie Fisher) in George Lucas' *The Return of the Jedi* was determinedly futuristic. It took the form of snakes apparently wrapped around the actress's body. And yet this bikini could have been more effective than it was. In the somewhat sexless universe of Lucas, in which odd planets seem to be inhabited by relatives of Winnie the Pooh, and in which passionate love is expressed in a desire to hold the adored one's hand, the nursemaidish figure of Princess Leia can hardly be said to provide a ray of photonic sexuality.

99.
Marilyn Monroe in a bikini.

100.
Artist Pablo Picasso (1881–1973) and beauty-in-a-bikini Lilou. On the
right is the famous author Jean Cocteau. This photo was evidently taken
at a bullfight in southern France on August 6, 1956.

101.
Marilyn Monroe (1926–1962) on the beach in a deep purple bikini.

Kitsch becomes American reality

In Hollywood movies, the bikini was part of the stereotypical props by which cinema-goers were made aware of a consumer product. Such clichés made life and living more easy, more direct, on film – and still do. Hunger in the mornings is assuaged with doughnuts. In the evening it takes a hamburger, a scrumptious hotdog or an authentic Italian pizza (baked by an Indian immigrant). Police officers drink their coffee in their patrol car, spilling it still boiling away over their trousers when they suddenly have to give chase to a criminal. A bottle of wine similarly represents the peak of culture and refinement, and is therefore used systematically to lend an air of intellectual romanticism to a screen beauty. Likewise, it is simply impossible to suffer the pangs of unrequited love without from time to time holding to one's lips a bottle of whisky – which for the purposes of the story (and of publicity stills) may be wrapped in a brown paper bag. But simplifications of this kind do not stop with props. A Parisian is someone who walks around with a baguette under his or her arm. A native of Rome rides a Vespa. A German drinks only beer and thinks only of wars past or to come. Brazilians always have dull complexions, dance the samba, and turn every place they go into a carnival parade. Indians practise yoga. The Spanish fight bulls. Even the weather faithfully reflects the hero's state of mind. Lovers disport themselves in radiant sunshine. Criminals lurk amid flashes of lightning and howling gales. Burials always take place in grey rain. Soldiers' uniforms are sparklingly bright. Cool dudes wear clothes that appear distinctly slept-in (if not lived-in). Flirts look as though they have their own personal make-up studio. Elder relatives are always dressed in a rather stiffly formal manner, and are no less genteel and well-mannered. Girls who among other young people in society develop in precociously full hormonal bloom are the beloved targets of axe murderers, who in their own way in turn do no more than punish the girls' depraved conduct. And when a young lady goes walking on the beach in her bikini, it is immediately to find at her heels a whole procession of suitors asking her in marriage. This highly simplified version of reality, seeming to never vary at all, cannot be criticized simply for existing. It is, after all, extremely useful within the limitations of the cinema and TV screen, which are obliged to do their best to divert a downtrodden population at least in the evenings and on Sundays. Geographical distance and location are thus of no importance whatever. Via the screen it is possible to wake up in, say, Hamburg, and to think of snacking on doughnuts, or even of ordering in an American-style pizza delivered directly to the house. Such are the joys of globalization, which is transforming our world and blurring the distinction between reality and kitsch, the distinction between real life and what we see every day on TV or in the cinema.

102.
Abbe Lane (24) on the beach at Venice, 1956.

Another adventure story focused on the beach was the equally American TV series *Baywatch*. The major female characters weren't actually wearing bikinis, but that is quickly explained. Firstly, the bikini is thought by Americans not to be appropriate in broadcasts that might be seen by school and college students during the afternoons (although it doesn't seem to have occurred to anyone that the shapely lifeguards are no less sensational in their one-piece costumes). Secondly, the beautiful lifeguards are so well-proportioned that it would be difficult for a bikini to contain their generously rounded forms, let alone remain in place during the frantic sprints across the beach that seem frequently necessary. Despite all this, the series – which has achieved some success around the world – manages to stay on the right side of the bikini cliché. For the episodes offer no more than a naïve view of the reputed "sex bombs": they show nothing that might titillate a man, no matter how far the girls run across the beach. The roles, for all the close-fitting costumes, imply nothing but innocent lives for beautiful people.

More significantly, such naivety – really no more than a background element – was itself in due course carica-tured in another American TV series, *Friends*. Here, two of the "friends" devote their afternoons entirely to watching videos of the Baywatch beauties running across the beach in slow motion.

This tongue-in-cheek style of representation – which is directly linked to the female body but affects to ignore it altogether – is a phenomenon that is typically American. In Europe, which has till now defended itself pretty successfully against the puritanical norms of Disneyland, the tendency is rather the opposite. What is scandalous is clearly within the domain of the pornographic, and may sometimes make an appearance as a minor element in serious productions but is not something that one tries to sell to the viewer discreetly.

103.
Brigitte Bardot in a bikini made of fine chain-links of metal.

104.
Brigitte Bardot in 1964.

105 and 106.
Brigitte Bardot at Saint Tropez on the Côte d'Azur, France, 1964.

4. THE BIKINI AND THE CINEMA

107.
Joseph L. Mankiewicz's *Suddenly, Last Summer* (1959), with Elizabeth Taylor.

108.
Raquel Welch in a white bikini contrasting with a red towel.

109.
Fathom (in Europe sometimes cited as *A Girl Called Fathom;* 1967), featuring Raquel Welch on a pedalo. In the opinion of some critics, she never succeeded in becoming a sex symbol – but then she also had ambitions as a stage artist. Her entry into a large-scale singing and dancing competition in Europe did not, however, bring the hoped-for success. The summary cancellation of her contract with MGM meant an equally sudden end to her film career, for which $5.3 million compensation awarded by a court in 1989 seemed to her to be no consolation at all.

110.
Raquel Welch in a yellow bikini on the beach.

111.
Raquel Welch in an orange bikini in front of some fishing-nets.

112.
Raquel Welch was born in Chicago in 1940. While still comparatively young, she had two children by the first of her several husbands. It was after their divorce that she left for Hollywood, where she took on minor roles. In 1963 she met producer Patrick Curtis who became her manager and second husband. The years 1967 to 1971 were the most successful of her career – it was at this stage that millions of pictures of her were to be found throughout the many military encampments of US soldiers in Vietnam.

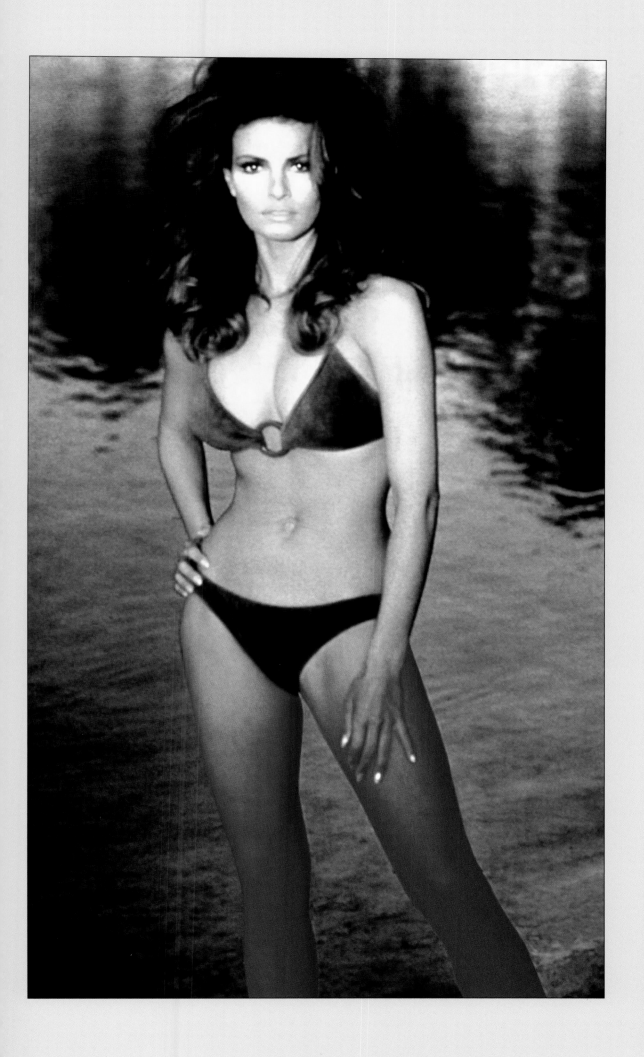

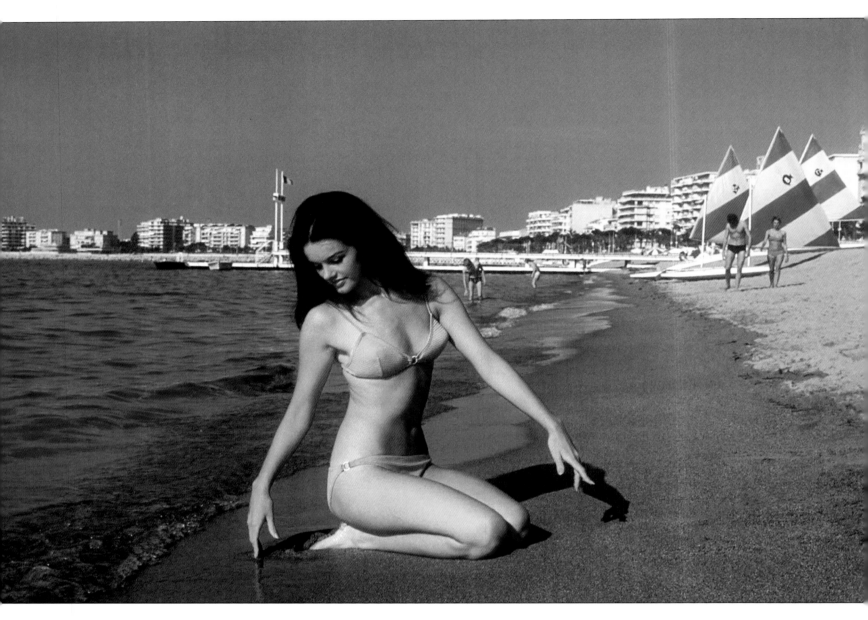

113.
The French actress and novelist Annie Duperey – considered by many to be the woman of their dreams – in a sky-blue bikini in Saint Tropez, France, in 1969. Later, aged 31, she was named "Sex Star of 1977" by *Playboy* magazine. The novels she has published since that year have been bestsellers. Her movie career began in 1967, with Jean-Luc Godard's *Deux ou Trois Choses Que Je Sais d'Elle ("Two or Three Things I Know About Her")*. Other films in which she has featured include André Hunebelle's *Sous le Signe de Monte Cristo,* Claude Mulet's *La Rose Ecorchée,* René Gainville's *Un Jeune Couple,* and (with Brigitte Bardot) Jean Aurel's *Les Femmes.*

114.
Annie Duperey relaxes in Saint Tropez, France, September 1, 1969.

115.
Romy Schneider (1938–1982) gets out of a pool sometime during the 1960s. In her native Austria she first became famous during the 1950s for a series of three films on the life of the Empress Elisabeth ("Sissi").

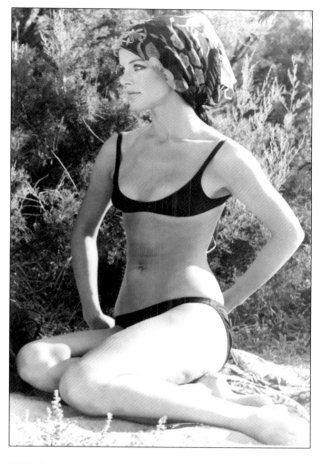

In all movies, and indeed in the countless advertisements and posters that are everywhere to be seen, the tiny costume that is the bikini becomes ever more widespread. The more it features on cinema screens and later on TV, the more it is readily accepted to wear one during the summer holidays and in the swimming pools. The more widespread pictures of bikinis become, the more bikinis become common in public places – so much so that the original scandal they caused has now all but disappeared.

But the self-assured woman of the 1960s, 1970s, and 1980s was not just buying a particular swimsuit that had its own scandalous history and might doom its wearer to eternal perdition. She was taking on, in these two scraps of cloth which after all were available in her favourite shops, the image of a personality, a role, which she might almost make use of as a mask for herself, to hide her own face and feelings, and which also implied a certain stance in relation to various ideals and conventions.

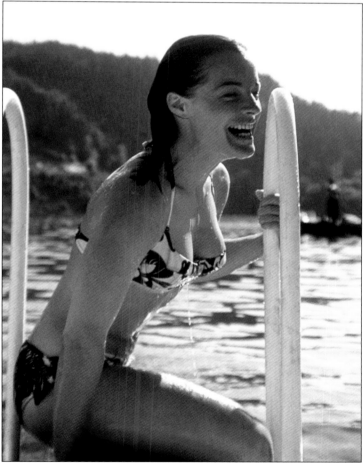

Putting on a bikini was possible for the average kitchen-bound housewife simultaneously to slip into the role of "the girl in the bikini" on summer vacation, transforming herself equally instantly (and according to individual preference) into a naïve beauty like Marilyn Monroe, or into an Amazon beauty like Ursula Andress [illustration 85]. It goes without saying that from this moment on, the persona of the bikini wearer as seen at the movies, once the bikini was bought and put on, was to be found in ever greater numbers in everyday reality.

After all, the fact that in almost every language there is an equivalent to the expression "clothes do not make the person," is evidence of the direct link between fashion and the taking on of a personality with it. But such sayings also emphasize how socially important any sort of uniform is that provides an easily recognizable indication of communal and financial status. A businessman in his outward appearance, with smart suit and tie and expensive shoes, says much about himself before ever opening his mouth. The effect of clothes seems even more pronounced in those who wear them. It is easy to imagine this same businessman at ease with himself and confident in his social status – it is a form of self-gratification that he is first of all aware of, and that he exhibits to others when wearing those clothes on his body.

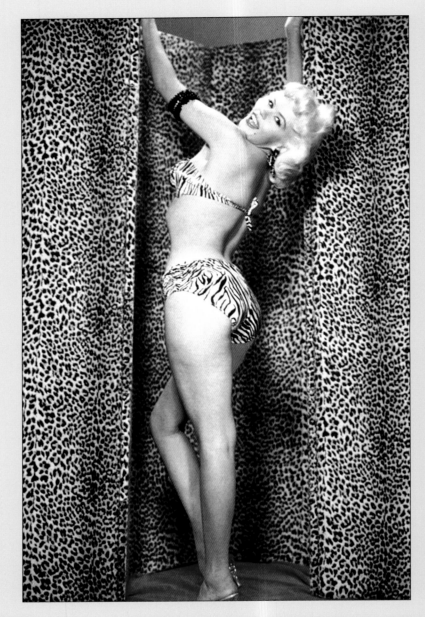

116.
Jayne Mansfield (1932–1967) in a zebra bikini.

117.
Jayne Mansfield (1932–1967) in a leopardskin bikini keeping to the shade on a chaise-longue in the garden.

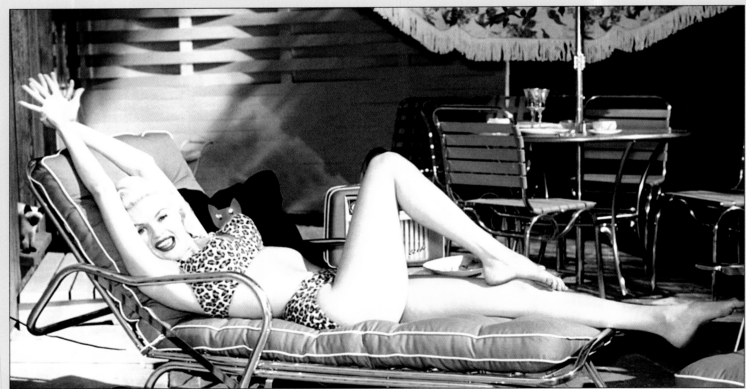

The psychological effect that clothes have on those who wear them has been evident in every society throughout history [illustrations 97 and 98]. Entire modes of fashion have been created not in order for people to share a social status but for a single individual to feel that he or she is someone else.

Goethe's Werther, in the 18th century, for example, wore a blue greatcoat over yellow trousers. And a romantic poet of the 19th century might wear swirls of black material around his neck signifying sadness, melancholy. In the first case, Werther's choice of costume was very much deliberate: an invitation to love. The second mode of dress was a sign of sensibility – that one thought of oneself as both delicate and decadent – of condescension motivated by sheer aetheticism.

Certainly, such outlandish costumery was meant primarily to be understood by those who saw it – it was above all a means of communication. "Look at what I am; look at what I am saying." But to an extent clothes change the person who wears them. They give him or her a false history and background; they give him or her attributes that were not apparent before but may have been there unrealized. It is like putting on a disguise at a masked ball and taking on a new personality hitherto unknown not just to one's friends and acquaintances but even to oneself. Clothes seem to have the capacity to transform their wearers by getting right under their skin and subtly influencing their inner beings.

And that is why when Jayne Mansfield, shivering deliciously, gets out of the pool with a seductive smile [illustration 81], it is not just the men in the movie auditorium who lapse into a daydream but also a fair number of women, who recognize what could be themselves in the so carefully composed appearance of Jayne Mansfield, who want themselves to receive the special smiles she gets from the men who speak to her, and who want themselves to be the object of the men's admiration and adoration. Some of these women, next time they get out of a swimming pool, will use exactly the same gestures – the same slight shiver, the careful holding in of the stomach so as to accentuate the thrust of the breasts, the same slow movements. And they will wear the same flowery bikini so that they too will find men flocking around them, around the girl in the bikini – men who will undoubtedly also have seen the film and who will be unable to resist identifying the girl in the bikini with the Jayne Mansfield they saw up on the screen.

"It's not art that imitates life, but rather life that imitates art," wrote Oscar Wilde early on in *The Portrait of Dorian Gray*. And so it was that during the summer that followed the release of Kubrick's *Lolita* – in which the eponymous young girl danced around coquettishly on the screen or sat carelessly leafing through a book with one leg across the other and up in the air – thousands of nymphets on beaches all round Europe copied her. They wore her polka-dot bikini and heart-shaped dark glasses; they laid nonchalantly on the sand, kicking their feet up in the air... under the strict gaze of their elders.

The second great transformation brought by the cinema screen to everyday life today, although it was not visible as such, turns once again on the subject of imitative behaviour, of posing. Taking on the persona of a screen hero, as we have seen, is not solely a matter of aping external details. Well, that is certainly a very important part of it – the external details that are the clothes imply a set style, an eye for design, and may seem from the beginning to guarantee a change in personality from one's own. But to imitate a hero with utter realism it is necessary to place oneself entirely within context. So one changes the way one talks; one uses certain beloved catch-phrases of one's hero. Therefore, one might even go as far as Arnold Schwarzenegger's "I'll be back!" and "Hasta la vista, baby!" In affecting the more psychological elements of the hero, one may change one's style of walking in order to express nonchalance or suppressed power; one may adapt hand mannerisms, the position of one's head, facial expressions, and possibly even a nervous twitch.

The girl in the bikini in this way adopts a slowish way of walking, but in a style in which she can proceed provocatively along the beach, and make the best of all her bodily qualities. She uses certain provocative gestures she has seen – but not so that anyone could accuse her of being at all indecent. Her arms may be above her head, exposing her armpits; she may stride with her hips, like a mannequin on the catwalk; she may seem playful, lost in her thoughts, twisting the strap of her bikini round her little finger (suggesting quite clearly a character stronger

Pictures can tell a different story

In recent decades, technical improvements in producing and reproducing pictures have fundamentally altered our way of looking at things. Whereas a picture was traditionally a faithful rendition of a subject at a specific time and in a specific place, it has since become an object like many other objects. Following the 1980s and the spread of computer technology, we live in a world of images that can be manipulated, altered or disposed of at will. We can download any image from the Internet whenever we want. We can transform what our surroundings look like in any way we wish by changing settings on the camera or digitally processing the image electronically. In a way, the image has become a fetish object, a hallowed substitute for the original. The structure and organization of our notion of reality have been altered: truth is no longer expressed in words – as had been the case for millennia – but as a picture. We believe only what we can see – and we can see everything. For there is no nook or cranny, no secret place in all the world, to which the camera does not have access and to which we cannot find a way to get to see. The consequence is the wholesale substitution of images for reality. We may well be for example, more familiar with a town in the USA that we have seen a zillion times in movies, web-cams and postcards than we are with the neighbouring community to where we live (and to which we may also never have been, despite its proximity). Such familiarity with a town thousands of miles away may even lead us to think of it as a "home from home" and be nostalgic for it – even though we do not know what it is really like!

Although the image has now become the sole reality, it is no longer true to describe other things as unreal. Space and time have not been modified: they have been abolished. Marilyn Monroe was timelessly radiant on our TV and cinema screens in her striped bikini. She is a timeless sex symbol and for all time. Like some tangible object available everywhere, she is closer and more real to us than any "ideal woman" that we may have come to know personally in our lives. The word "artificial" perhaps best characterizes what reality has become following its structural transformation. We are living in a form of reality in which only actions of substitution lead to anything of consequence. We are part of a symbolic universe in which we have lost any notion of how to tell the difference between the reproduction of an object and the object itself. In a bikini, we are symbolically undressing ourselves as we are not entirely naked in one: we are turning ourselves symbolically into a sexual being since we do not only want to go swimming in it. However, with the technology now at our fingertips, nothing could be easier than manipulating an image. We can turn Marilyn into a brunette, give her a hat, straighten her nose, enlarge or diminish her bustline, and replace the beach on which she is standing with a flowery meadow and some cows chewing the cud. The falsehood – which we would appreciate as such very quickly if the depiction was by way of verbal description – is more immediately convincing as an image than it is in words. Because it is so possible for us to take as real an image that has been manipulated, we really ought to find some means of

visually distinguishing, a way of spotting at some critical distance which is the image and which is the reality. It used to be eminently possible in words, but we have currently abandoned that gauge of truthfulness. We must be able to restore to objects the reality they had and should always have before images replace them once and for all.

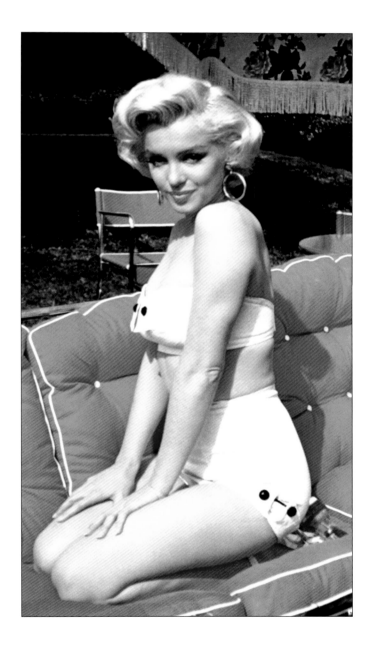

118.
Marilyn Monroe kneeling on a garden chair, 1953.

than her body language – enough to twist a man she fancies round her little finger too).

These almost unnoticeable but seductive aspects (which the girl in the bikini would deny having or using) should be categorically understood as emphasizing her innocence. She intends only to go swimming, after all. But they are spread all over the screens like infectious rashes or nervous twitches. Whoever sees them, single or in company, seems to be contaminated to the point at which imitating them becomes compulsory, if nothing else to indicate to those around them and to themselves that these aspects are now indelibly part of their own personality. It is "youth", it is "being cool", without reference to gender or sexual allure.

It could be maintained that society should be regarded as an attitude, or better, a means of expression, much like an artistic talent or a practical disposition. Against that, it could be contended that real life requires one to live in reality, and has nothing to do with putting one on display. Enough for us here, though, to reflect briefly on our daily tasks – having a coffee, waiting for the bus, doing one's work, making a phonecall, and so on – to realize that we are effectively putting on something of an act the whole time. There is not a single moment when we are not making some sort of gesture, showing our feelings – not a moment when we are not communicating via body language. And even if we try to keep the body expressionless, the face entirely immobile, that in itself does not subvert the instinct for communication. It simply but adequately reveals that a person refuses to allow his or her feelings to become visible and wishes to remain impenetrable.

All these postures, which seem to us quite natural and involuntary, have nonetheless been learned and practised over time. But above all, they have been observed in someone else, taking special note of the effect that they have produced. The postural effects of the bikini – the overall allure, the set of the body, even a studied look across the top of the sunglasses – belong to this staged enactment in which we all comply with our more

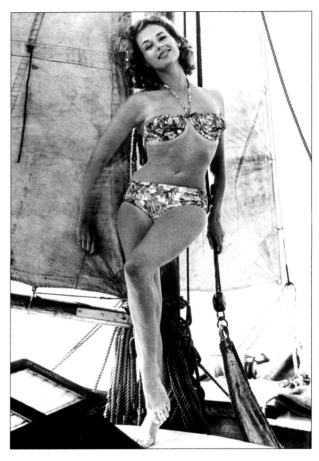

119.
Annie Alliston in a bikini for a charity in London,
June 23, 1960.

120.
Two bikini-clad girls on the beach.

121.
Yesterday, Today and Tomorrow (1964), starring Sophia
Loren (aged 30) in a bikini.

or less customary way. It is only since the invention of
the movie screen that body language has itself become
much more significant.

To look now at one of the early black-and-white
movies from the beginning of the 20th century is to find
in it, at first, a certain pleasure. Yes of course the images
flicker so that everything looks as if it is happening in
heavy rain, and the movements are speeded up so that
people, animals and machines frenziedly hare about as if
the turn of the century had driven them all mad. And
there are also films of the time in which hair styles seem
vastly amusing, clothes seem more than merely weird,
and pieces of furniture appear that are now impossible to
find even at an antique dealer.

Strangest of all, though, is the fact that the people in
these movies adopt poses that are both outlandish and
comic. A person keeping his arms rigidly down each side
of his body strides briskly along the street with an
haughtily proud bearing, as if wearing a vast number of
military medals. A woman interminably puts on and
takes off the hat on her head using exaggerated
movements, while opening and shutting her mouth at the
same time like a fish. A well-dressed Edwardian gentleman
seated on a park bench cleaning his nails with a sharp twig
and smoking a cigar, regularly raises his right eyebrow.
Three poses – pride, exasperation, contemplation – all of
which seem amusing to us today, and make us smile. They
seem too naive. They are now more expressive than is
required. They have turned into caricatures.

You might think we have become more discreet, then.
But the fact is that there is a huge difference now in the
art of using the poses we adopt. Whereas for a man at the
end of the 19th century and the beginning of the 20th
the main point of reference in respect of the image he
presented to the world was his mirror, for us today that
reference is the movie. The proud man who stuck his
chest out and kept his arms down by his sides as he
walked along, did so after long sessions in front of his
mirror to make sure he got it just right. We likewise

133

entrain our body language, including gestures and other mimicked poses, with constant mental reference to what we have seen in the movies or the way we might be seen if we were ourselves filmed. Rarely do we remember, however, that we are equally visible from the back – and then we might well look in a mirror. Conversely, just a passing glimpse of ourselves on the security CCTV monitor at a supermarket will set us immediately adjusting our posture, our movements, even our facial expressions, to achieve the mental ideal we have set for ourselves, to be seen as we want to be.

The evolution from the pose-as-reflected to the pose-on-film is singularly evident in relation to the girl in the bikini. If she was still a bit rigid, a bit statuesque, at the beginning of the 1950s, she has since become totally natural and good-humoured – even if in each incarnation it is to some extent clearly staged, a good humour adopted by way of imitation.

All of us, though, like our predecessors, are inevitably prisoners of our times. We can scarcely expect ourselves to be taken absolutely seriously in later years, when our poses, attitudes, and body language will be perceived as heavily outdated, prompting just the same sardonic remarks as today the people who strut and flap about so weirdly in those early silent movies do.

122.
Jodie Foster – who went for her first movie test at the tender age of 2 – modeled to advertise the special qualities of a sun cream. She played her first major television role at the age of 7, and at that time (that is, during the 1970s) was already highly regarded for her work and expected to be a future megastar.

123.
Barbara Eden in *Ride the Wild Surf* (1964).

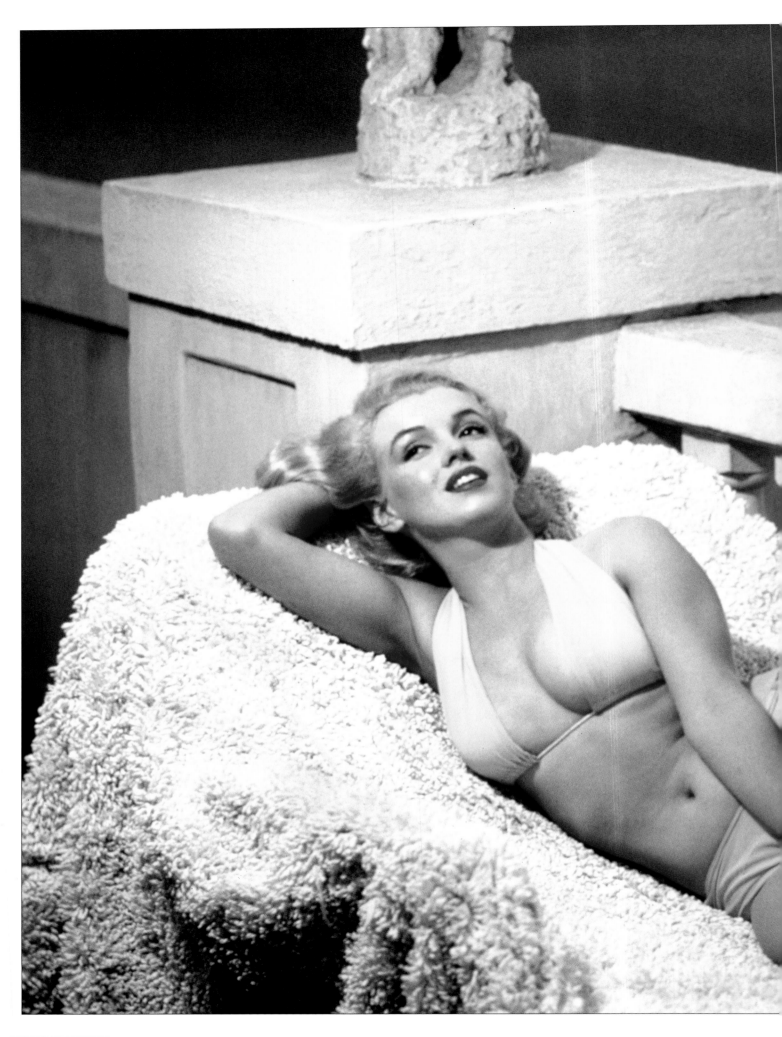

124.
Marilyn Monroe.

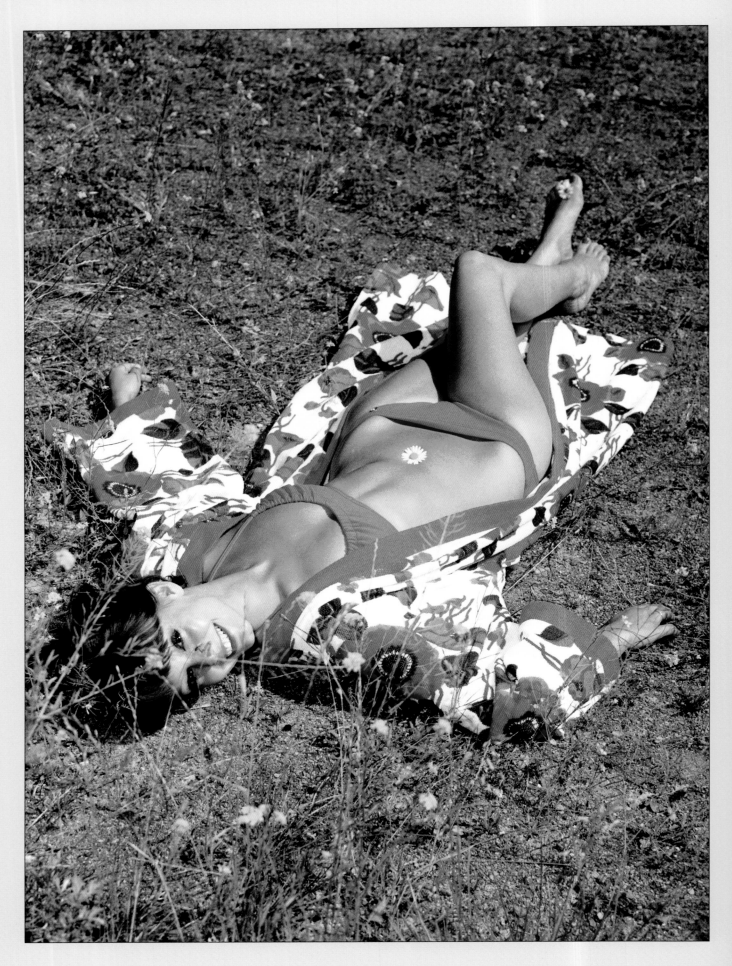

125.
Bikini and bathrobe with a red-flower motif, photographed for *WB-Coton*, leisure fashion, 1977, RDA.

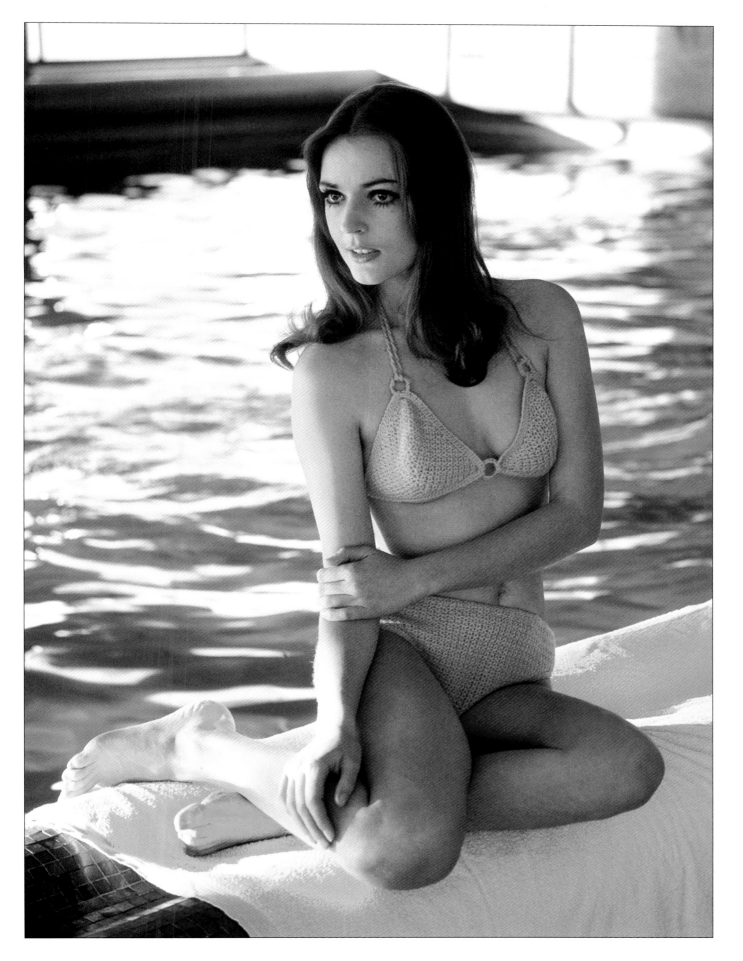

126.
Knitted bikini, photographed for the fashion magazine *Editions pour la femme* in 1971, RDA.

From pin-up to poster culture

A picture hanging on the wall of a room was formerly one of the indications of a certain status in upper and middle-class society. During the 19th century, people thus greatly prized paintings and collected them with a systematic passion still visible today in the countless visitors who throng the huge art museums of Europe. But on the wall in the old days, that picture was not just decorative: it expressed the wish of many to break free of the narrow restrictions of class and society, and to enter the realm they could see through the symbolic window hanging there. But it was neither a gesture of protest nor a genuine attempt at rebellion. The countryside as featured above the sideboard, the historical scene lording it over the living-room, the portrait of an unknown personage looking down pensively from the wall – all these simply represented the upper and middle-class' desire to grasp and preserve the way the world really was, and to be able to look at it in their own restricted and private viewing zones. Everything had to fit in neatly with the bourgeois mentality by which the world worked – money at the centre, the axis of their universe, around which turned everything physical and emotional. Money made it possible to collect art, to hoard it, to count it. If the upper and middle classes were not exactly artistic, they nonetheless owned the best works of art in their homes. That art, which their households and their estates acquired with exemplary mundanity by paying for it, represents the sublimation of the self by forces and desires it has denied itself. And to those who were subject to such repression, a nude painting hidden behind heavy curtains in the bedroom might well seem the most exquisitely sinful of all secrets. Changes in social class structure during the 20th century reawoke this passion for the picture hanging on the wall, and adapted it according to contemporary technology and methods of unlimited reproduction. This removed the need to hide and repress one's desires, and led instead to the pin-up culture. The middle-class nude hidden behind the curtains became an illustration of a shapely girl in a bikini – therefore almost nude – that could be attached to the inside of a locker door or stuck up on a dormitory wall. So from the beginning of the 1950s the printed image was king. The magazine market was flooded with pin-up pictures with titles like *American Beauty, Fabulous Females, Exotic, Hit Show, Paris Life,* and *Whisper.* Such magazines – made to have pages individually torn out – did not, however, show only women with long legs and large chests but were careful also to embody an interest in contemporary bikini style. They specifically featured what the more conservative fashion magazines were deliberately leaving out: hundreds and hundreds of "authentic" bikinis, polka-dotted or plain, but always very brief, affording the "undressed" look. Movie stars photographed before the start of their cinematic careers, countless unmemorable and long-since forgotten fashion models, the pin-up magazines contained all a man could dream of. Jayne Mansfield, Marilyn Monroe, and others owed much of their initial popularity to these under-the-counter publications. Yet these magazines had their own stars too. Betty Page, for exam-

127.
Pin-up girl in a blue bikini, about to reach out for the phone.

ple, became legendary as a pin-up girl. The only thing that might now seem a little bit tacky about the pin-up pictures is the staged sensuality of the poses adopted by the girls on the glossy pages. They smile at the camera, showing as many teeth as they can, their arms above their heads and exposing their armpits. Their hands sweep rather too languidly through their hair. Their bodies take up strangely, even unnaturally, contorted postures then thought to be particularly seductive. But they demonstrate perfectly the image of woman that contemporary man wanted – that contemporary man wished the entire female sex to imitate and discipline themselves to be. They also illustrate the dual nature of socio-sexual morals in the 20th century, both elements independently recognizable as different clichés: on the one hand woman as mother and as exemplary mistress of the household, and on the other the darkly angelic creature so seductive that a man cannot help but succumb to. It is obvious at once that a combination of both these ideals of femininity within a single person was the authentic

image men were really after – and still are, to some extent. Having survived the wars and the sexual revolution, upper and middle-class society has responded in the direction it prefers – by sublimating sexual attraction in the form of pin-up pictures it has once more taken up the custom of plastering the walls of its houses with reproductions. The bedrooms and playrooms of adolescents have likewise become grottoes, hideaways, in which Elvis Presley, Madonna, the Pope, and large and beautiful reproductions of horses' heads smile in a knowing way down on the records, CDs, and other bits and pieces lying around in the higgledy-piggledy disorder of a childhood scarcely ended.

128.
Mamie Van Doren, former protégée of Howard Hughes, in a gold leaf bikini with a paradisial apple on the Tree of Knowledge.

129.
Movie actress Christiane Schmidtmer on a yacht.

130.
1970s B-movie star Susanne Benton by a pool.
131.
1960s B-movie star Susan Hart on the beach in front of a projection of high surf.

132.
Movie star Rhonda Fleming in a panther bikini.

133.
Popular British actress Susan Hampshire.

4. THE BIKINI AND THE CINEMA

134.
Long-term movie star Stella Stevens.

135.
An unknown Miss Newman.

136.
1950s cheesecake model Betty (or Bettie) Page.

137.
Pin-up girl of the 1950s. In those days of compulsory conscription (draft) of young men into the armed forces, there were hundreds of thousands more lockers and cubicles for such pictures to be pinned up in than there are today.

Chapter 5:
The Conditioning
of the Body

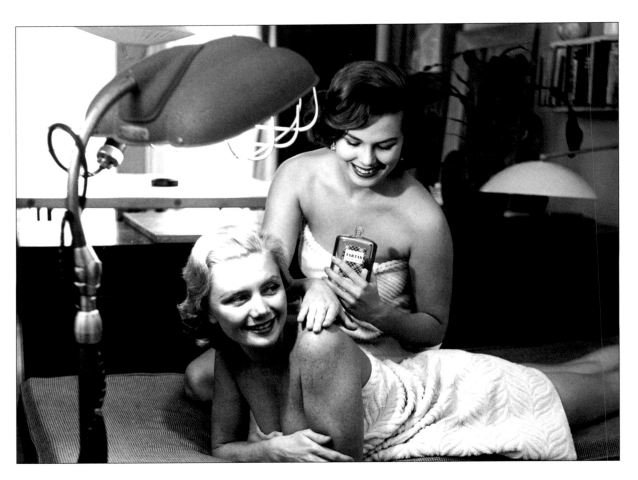

138.
Early "sun-ray lamps." The women in the bathing towels were apparently in need of Tartan.

When Micheline Bernardini showed off the original bikini on July 5, 1946, at the Molitor Pool – holding a matchbox in the air and standing like a worldly Statue of Liberty, to the ribald abuse of some of those present – she set in motion a scandal that diminished beachwear, accustomed us to the further display of flesh and of skin, and also instigated another revolution altogether, not specifically related to two-piece costumes but concerning what they reveal. For the bikini (and this is undoubtedly one of the least publicized reasons for the scandal) is a scrap of cloth in which it is only possible to display what is already there.

The whole tradition of fashion for women relies on the opposite principle. A dress, made from great volumes of material whenever possible, is precisely meant to conceal, to veil the body while giving it form. It covers what ought to be covered, while implying the presence of what the body may not actually have – and implying it in a way

that may inspire heady dreams (describable in such terms as "wasp-waisted", "curvaceous", "slender outline").

The old-fashioned dress of two hundred years ago, with its padding and its corsets and crinolines that made a woman look like a scarab beetle stuck stiffly in its carapace, did at least fulfil those principal functions of fashion – to suggest the presence of something that was not there and to suggest the absence of what was.

Everything that represents the ideal of the craft of a couturier can be summed up in the expression "Beauty does not exist: it is achieved by adornment that itself relies on the body." It was put into effect in the old days first of all by using cloth, and then by using other "prostheses" (everything from the bustle to a padded bustline, including even a wig), cosmetics and powders. If that was not enough, one could wear different perfumes, or one could hide most things by insisting on

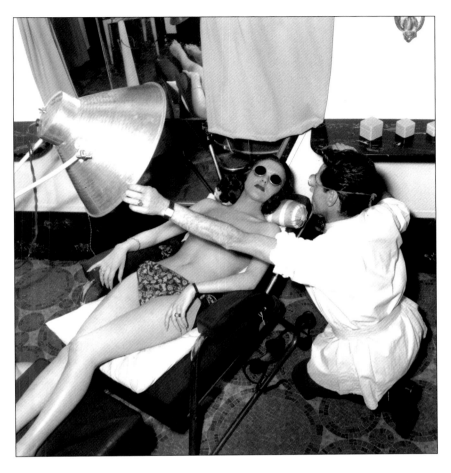

139.
The Estrée Riquelme Beauty Institute in 1949.

being seen only in semi-darkness, or one could instead peer out from behind a fan which otherwise concealed, say, a spiky nose, nastily crossed teeth, or an unsightly boil. Thus prepared according to the ancient principles of fashion, a woman might look well enough – although of course she was in no condition to do anything energetic or indeed to test her beauty in any climatic conditions other than perfect.

Swimwear fashion has followed the same tendency since its inception. Reflecting much the same considerations, it has to be functional, it has to guarantee minimum standards of comfort, and it has to withstand the special perils of contact with water. It is inevitable that it allows more of the body to be seen than previously permissible, because a certain lightness of clothing is essential for swimming, and no one – not even the most formidable guardians of public morals – would wish women to be dragged down under the

waves by the weight of their bathing costumes (even if they are simultaneously well protected from the prying gaze of others).

The appearance of the bikini, however, marked a rejection of these long-hallowed principles of fashion. So when, on that afternoon of June 5, 1946, Micheline Bernardini posed and then turned at the request of the photographers to give them a rear view, it was a sensation and an innovation. What might have been expected to remain the hidden side of this truly liberating concept of swimwear fashion was being put on display! The costume at the back on this Statue of Liberty was no more than a scanty strip of cloth. It could not be more minimalist! Well, it could – but only with the thong that came later. And it therefore displayed to the photographers and to the packed audience behind them that unwanted condition of skin tone that has been combated now for many decades with increasing

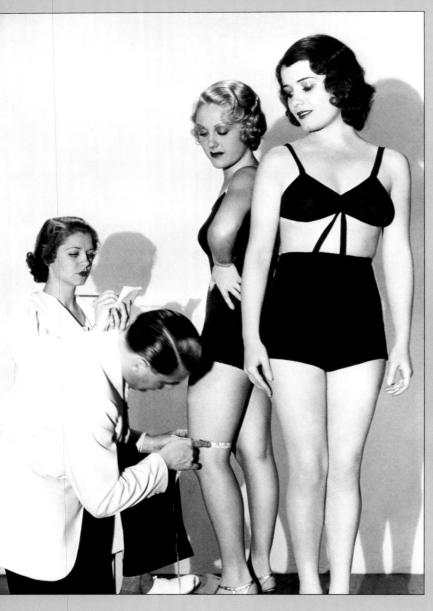

140.
Auditions at Paramount Pictures, held under the stern eye of
choreographic director LeRoy Prinz, July 24, 1933. For the movie
spectacular *Too Much Harmony* he was looking for two actresses
of specific leg measurements.

141.
Top fashion model at the age of 17, Twiggy leaves London for the USA.

success, and that is described in different women's magazines and health journals as "orange-peel" or "cellulite". The two hemispheres exposed to view seemed covered in little dots and small hollows more or less visible in the shade, and with faint and blurry outlines.

From the front, then, the picture of the first bikini seems right up to date, absolutely current with our time. From the back, however, the view is more reminiscent of the less appetizing images supplied of Soviet bathers in the Baltic during the mid-1970s.

The bikini turned fashion's contemporary value system on its head. It was no longer enough to be well dressed – the body in its clothes itself became an exhibition piece. Both clothes and body were expected to draw attention. And so, as the 1950s progressed, it became even more normal to take greater care of one's body. During the summer months in particular, such care might take the form of various regimes – either of physical exercise or of constant skin treatment with creams and lotions. Fashion magazines devoted whole pages to lists of advice on food, on how long to sleep at night (or any other time), and on what to expect of the skin in the case of overexposure to the sun. In their many pages of advertisements, the same magazines promoted the solarium, "bust creams", and slimming products. There was also considerable debate on the details of what physical exercise was necessary to achieve the perfect bodyshape. And there were recommendations for the first of the oils and creams supposed to produce the best and most even tan. Beauty, the new watchword asserted, derived primarily from the constant care of one's own body.

A completely new and different branch of the industry emerged – the beauty-care specialists, including beauty therapists (working from "beauty institutes"), the manufacturers of suncreams and sun barrier lotions, the manufacturers of solariums, and others. It was now possible to cosset the female body with all kinds of relatively expensive courses and treatments that would make one feel attractive and beautiful in so many ways.

A picture from the 1950s shows two of these "modern" women, smiling avidly for the camera, who are demonstrating new beauty treatments[illustration 138].

A blonde woman lies flat on her stomach on a divan while a smaller brunette applies suntan lotion on her shoulders. Over both women leans a primitive sun-ray lamp, an early solarium.

Another photo from 1949 [illustration 139] shows a scene inside the Estrée Riquelme Beauty Institute. A slim woman is lying on her back. An assistant in a white coat is in the process of installing a sun-ray lamp. The woman is wearing a bikini bottom, and the assistant protects her presumably naked breasts from our eyes with the arm he is using to adjust the sun-ray lamp. There is nothing particularly cheerful about this photo. The two people in it are both wearing protective dark glasses, and the face of the woman – who lies at full length as if enjoying the sunshine on the beach – is serious and a trifle supercilious.

The first of these two pictures is redolent of publicity material. It presents the world of mass consumerism in full bloom – everyone in that world rejoices in possessing the product that is here being promoted. The financial value of happiness, and the fact that life is good, are explained to us simply by the existence of the product and by an ability to purchase it. Only after that happy event can we in our turn wear a smile like the somewhat fixed one on the faces of the two women in the photo. The two are exemplary specimens of their type. Absorbed and apparently much taken with their activity in selecting the degree of tan and choosing between various creams, they desire nothing else than to use the creams and to have someone apply them to their skin.

The other picture shows us only part of a scene. Under a chair that can become a settle lie what seems to be a pair of light summer shoes that a client has inadvertently left behind. The interior of the beauty studio is furnished in a higgledy-piggledy manner: there is no consistency of style, a curtain that is much too short tries vainly to hide the mirror behind the woman taking the tan, and on the sill on the right, in place of any more imposing item, are four thimbles that might well contain lotions or some other beauty products. There is evidently a long way to go yet before beauty-houses come into being that have been well thought-out and are carefully styled, in which the tools for creating beauty have their own spaces from the floor up or stand

142.
Twiggy, born Lesley Hornby on September 19, 1949 in Neasden, London.

in pyramids on large tables, all to the delight of clients surrounded by an atmosphere of well-being that itself lends suppleness to the arm reaching for the credit-card-wallet.

Efforts at body care following the war first concentrated on matters that were simple and straightforward. Maintenance was concerned primarily with external appearance, specifically that of the skin. It should not be too pale, yet exposure to strong sunlight (for purely aesthetic reasons) should if possible be gentle but continuous; regular protection against sunburn should be provided by oils and creams.

Bathers in bikinis would naturally appear to be slimmer than those in more old-fashioned costumes, generally through exercise and dietary regimes (perhaps with additional slimming aids) before the summer holidays. Sport was recommended, although not regarded as compulsory. Certainly, illustrated magazines in the 1950s showed many women in sporting costumes (equestrian events, playing tennis, sailing) but they seem all to have been selected for their looks. In a way, sport at this time was more like a masked ball – an excuse to dress up in an evening for women of wealth and leisure.

But convention, which sets the norms that society then exercises over a woman's body, was not slow to make a comeback. Social norms of this type are among the most ancient features of human communities although they are perhaps the least consciously recognized among these ancient communities, until now. However, they still remain little recognized even today because they have something about them that seems superficial, possibly vain. For fashion and its external manifestations are the stuff that conversations at the hairdresser's are made of, and are not generally deemed worthy of meticulous critical or social analysis. Yet putting parameters on and around the body is itself making a culture out of the body – and that must be a positive step: a concept that effectively illustrates the old but ageless Latin tag *mens sana in corpore sano*, "a healthy mind in a healthy body".

Behind this concept lie hidden other aspects of consideration corresponding to the way society regards the individual – aspects particularly susceptible to prejudice on account of the body. We all learn very quickly that we have free will but that our bodies are not entirely subject

to that will, firstly on the level of sheer physiological capacity, and then to the extent that our bodies may from time to time simply fail to do what we expect of them. That we cannot do anything we like with our bodies in public is something else we learn very early on.

The power that other individuals or groups are able to exercise over us is linked to this too. We fear they may take hold of and illtreat our bodies. But the whole of Western civilization and its progressive culture is based on being able to correct people through such punishments. We are not born human: humanity has to be inculcated in us – that is the basic tenet behind education in our culture. And although such tenets have at last begun slowly to be discredited, disciplining the body is still very much current. Physical discipline as an element of teaching retains deep roots in many of our customs. We may now be more lax in relation to our children, but when it comes to teaching domestic animals to behave – a dog, for example, may be rendered completely (and usefully) docile through a system of punishments and rewards – our almost instinctual and indelible belief in such methods is readily illustrated.

The classic expression of such an educational principle is to be found in Goethe's *Dichtung und Wahrheit* (*"Poetry and Truth"*): "Who has not been physically disciplined has not been educated."

To try to make ourselves perfect – or at least to become different and better – we are all consequently ready today to inflict upon ourselves punishments that verge towards the masochistic, whether to take up a military career, to become a movie star, to turn a man's head, and so forth. This is quite an ancient practice.

So you learn all kinds of things at school, and especially how to make sure you have the easiest time possible at it. Your day is carefully divided into periods of work and of leisure (the first are longer than the second; meanwhile, the hypocrisy in such expressions as "free period", "free time", as used unthinkingly in our language is breathtaking). Sport is almost always organized for and by individuals of the same sex – so that girls are taught by a games mistress aware of what girls' bodies can and cannot do – although until a short time ago, at least, "domestic studies" (i.e. cookery and kitchen-craft) were regarded as much more important. Boys are encouraged more to use their physical qualities,

143.
Twiggy in Yves St Laurent, February 27, 1967.

so that they might in due course make good army recruits. The training involved in various sporting challenges which effectively develop aggression and strategic thinking, both presented as entirely normal and natural, are generally accompanied by activities – rope-climbing, endurance courses, throwing javelins, hammers, and weights – used by the army to evaluate the physical capacities of recruits and to assess regular troops.

What we learn at school – how to exercise or to respond to the exercise of real power, power with immediate and personal force – follows us into later life. Only now, that power has additional aspects: a bias towards mechanisms that utilize subtle influence and suggestion.

In its most primitive manifestation, power represents an ability on the part of one person to subject the body of another to his will, and to do with it whatever he likes. Conversely, power is in the strings attached to a person's head and limbs with which another can make him or her jerk around like a string-puppet.

To be "put on the active list" – and even to find work at all – in a large company today, it may well be necessary for your body to fit an existing profile: young, dynamic, sporting, muscular without being musclebound, glowing with vitality… the list continues.

In traditional communities around the world, a woman when getting married and being led by her husband to his hearth, used to have a fairly substantial frame. If she was too thin, she might have to be "fattened up" by her new family before she was allowed to take on her duty of childbearing.

Criteria for female beauty – always said to be based on aesthetic measurements – stem from the same origins. The norm that is held to be the ideal of beauty, although that ideal changes according to definitions of what a female is and does, would be better described as a way of promoting an influence and as a discipline involving long-term conditioning. These criteria for body form have become so much part of everything to be seen around us today that we no longer even bother to think critically about them. It is an absurd situation, and a peculiar one, evident primarily by way of contrasts.

So, for example, in a photo from the 1930s which shows the initial casting of dancers for an American TV show called *Too Much Harmony* [illustration 140], two women with legs of the standard length (14 inches/35 centimetres from ankle to knee) stand still to allow themselves to be measured around the knee by a thin bald man dressed impeccably in a white jacket. A female assistant in a white blouse behind him, frowning with concentration, writes down the measurements obtained. It is not unlike a circus act, you might think, or a modern version of *Hansel and Gretel* at the point where the witch tests the finger held out to her for flesh and bone.

This practice of measurement has meanwhile been thoroughly overwhelmed by the obsession for "vital statistics". The ideal vital statistics were actually cited as 36-24-36 (or 90-60-90 in centimetres), a standard to which every woman who examined her own shape with a critical eye wanted to conform to. And of course vital statistic became all the rage for a time, especially on TV, and especially in Italy, where presenters might be surrounded by up to several hundred beauties of those precise measurements as part of the décor of the production. There was also the regrettable occasion when dancers were being selected for the celebrated Moulin Rouge in Paris as if they were no more than minutely varying bread rolls.

If a bather in a bikini was not certain of corresponding exactly to those ideal measurements, she had nonetheless to try to get near them or face being laughed at. For the modern woman that meant a complete change in what she thought about her body. Either she refused to acknowledge the tyrannic rule of the bikini and restricted herself to one-piece costumes and other bits of material she could drape over herself while on the beach (such as hats and one or two accessories), or she knuckled down to the new physical discipline which might (or might not) get her nearer to the ideal figure.

The aspiration to achieve a new body shape took on some aspects of caricature during the 1950s. Jayne Mansfield, one torrid summer afternoon, came out of the pool wearing a flowery bikini, her stomach held so flat as to be virtually concave, with the result that it was possible to clearly spot several tucks in her bikini

144, 145 and 146.
The bikini is also commonly worn by female bodybuilders.

Sports Illustrated

From 1964 on, the American magazine *Sports Illustrated* printed an annual selection of bikinis in all shapes, sizes, and colours – and of beautiful girls wearing them. Occupying more than 200 pages, the most celebrated fashion models, movie stars and, in latter years, sporting greats strut their stuff elegantly and even provocatively on beaches, in boats and cars, on town streets and inside historic buildings. The magazine – which had as its subtitle *Nothing But Bikinis!* – initially tried to be the cult publication for bikini fans. It therefore contained very little by way of text, but a great number of pages promoting the latest and most hip things a man of the moment could not do without if he was to stay on top: fast cars, expensive watches, strong cigarettes, even stronger alcoholic drinks, seductive after-shaves, and of course the most seductively beautiful women. Concerned with portraying the most perfect lifestyle possible, *Sports Illustrated* is directed primarily at men who reckon sooner or later to possess Armani slacks and the best Hugo Boss outfit, a Rolex pocket-watch, and a BMW sports saloon, who know which hotels are most convenient for the most expensive golf courses, but who also have enough leisure time to appreciate pictures of Laetitia Casta, Naomi Campbell, Steffi Graf and Eva Herzigova in bikinis and carefully posed as if in familiar situations – relaxing alongside oneself on the beach, perhaps, or preparing breakfast together. Projected somewhere between the home and the office, printed in impersonal colours reminiscent of an airport's business lounge, *Sports Illustrated* corresponds exactly to what a huge number of men want from a magazine. No real need to read anything from start to finish (the occasional paragraph of text between pictures tends to undermine the idea of reading anything at all, with facetious headings like "Skip This"). No rundown of the economic situation. No literary columns. A healthy spiritual diet quite unlike the hypocritical fare served up by the pin-up magazines, most of which present pornography in the guise of innocent reportage. Here there are not too many words, and not too few pictures. A shining example of a paper that portrayed the world as a man's dream, *Sports Illustrated* could be openly taken anywhere, for it is and was the most popular magazine for bikini fashion. Fashion creators in America then reinforced their influence with the innovatory "Californian look" – "Beautiful, happy, athletic bodies in shrimpy swimsuits in a paradisal landscape" overenthused one commentator. This, together with the magazine, contributed to the final abolition of traditional classifications applied to the human body – that either sexy was beautiful or athletic was beautiful – ideas that dominated the 1950s but are given short shrift today. Recently, *Sports Illustrated* has expanded to the extent even of launching a French edition devoted to bikini fashion. No doubt shortly to be followed by German, Italian and Spanish editions.

147 and 148.
Cover page of *Sports Illustrated.*

bottom. This response – pretending to be slim by means of temporarily contracting specific muscles of the body, a form of "mind over matter" – anticipated a discipline and a process of conditioning that was to have the same effect and to symbolize the future evolution of the ideal body shape.

There were two ways in which a bikini wearer might attain it – vigorous sport and rigorous regime. The model Twiggy [illustrations 141 to 143] who in her own style was all the rage in the early 1960s, and whose trademark was a certain schoolgirl gaucheness rather than her clothes, pushed the notion of being slim to its limits. It might also be described as the result of systematic starvation, as a body reduced to just skin and bones, discarding all the usual feminine attributes hitherto normally associated with sexual allure.

When Jane Birkin, under the direction of Serge Gainsbourg, sang *Je suis plate comme un garçon* ("I'm as flat-chested as a boy"), what might have seemed self-mockery was at the same time the mark of a feminine ideal. For it was very quickly noticed that a bikini sat far better on a young girl before she began to fill out into a woman, than on a woman who had achieved maturity.

The ideal of Lolita, who with her apparent innocence softened the burgeoning sexuality of the body within her bikini, rendered the brief two-piece costumes acceptable in fashion salons and shops, and marginalized the problem of outsize body shapes.

In respect of which, Twiggy's form as an ideal at the same time constituted a response to the demands of society. Women of the 1960s, free at last from many restraints, meant now to protect themselves against being depicted in ways that were contrary to their principles. They specifically wanted to be likened neither to an opulent maternal figure nor to a massive-bosomed sex bomb. Twiggy's style instead established the figure of woman as schoolgirl – cheeky, pert, and a bit coy – far from the images of male fantasies. Moreover,

it could easily be associated with cult fashions for suntanning and capitalist wealth. Paleness of the skin was once more outmoded; in came the body slimmed right down. Not natural, fair, but disarming.

Such a lively desire to subvert the favourite mental images of a male-oriented world – recalling the avowed designs of the feminist movements against what they held to be oppression and exclusion – quite unexpectedly became a vogue, and then for a time became an ideal of beauty in its own right. Bikinis, which at the beginning of the 1960s had still been experimenting with methods of holding them up and of retaining and improving body form, were simplified and became rather shapeless. The top was made fuller; more material was used; deceptive effects were introduced. Women thus showed themselves as they were – sometimes looking rather slovenly – without bothering to seek male approbation. The fashion world, whose economic existence was palpably under threat of being marginalized, responded immediately by proclaiming as the ideal of beauty the very thing that had started at least partly as a protest against itself.

Sporting activity as an alternative method for slimming to fit into a bikini was not generally adopted, but was taken up mostly by extremists, and was popular in great numbers only during the 1960s. Yet since that time, sport has not once ceased to influence our daily lives. Joggers, cyclists, tennis players, swimmers – wherever you look, there are sports-minded women at every turn. Aerobics classes and fitness courses fill the TV screens every morning. The gymnasiums and keep-fit emporia, in which macho men have traditionally developed their aggressive attributes, have been thoroughly invaded and occupied by women. And at the same time women can have a massage, they can go on a low-calorie diet or they can suck up slimming products (supposedly whole meals at once) with the aid of a straw, and they can choose the sport they prefer, even as they shun what might once have been thought of as natural weaknesses.

And once sportingly active, they will finally fit into their bikinis – without wishing to wear them everywhere and anywhere, for the bikini is both impractical and downright unsuitable for a good number of sports.

149.
Jayne Mansfield swimming, with bikini-clad dolls.

150.
Esther Williams, US national swimming champion as well as a highly regarded singer, in her film debut with Mickey Rooney in Andy Hardy's *Double Life* (1942). The director of the Hardy Family movie series, George B. Seitz, himself suggested her for the part. The swimming movie star was, however, fiercely antagonistic towards the bikini, the introduction of which she classified as "a thoughtless act" (a no-brainer, as we might say today). Excluding them, she went on to found her own costume collection.

151.
Swimming costume from the 1991 summer collection of Rasurel. A two-piece black-and-white striped swimsuit in lycra, its top is strapless but comes with a blouse made of stretched synthetic fabric.

So the objective of slimming and wearing a bikini is achieved. Yet since the inception of the notion of conditioning the body in such a way, one thing has become evident in it that does not help to meet the target of attaining a gratifyingly beautiful shape. There is an idea that is a collective dream in a vast number of adult heads, which has developed a momentum of its own that in turn has led to excesses and peculiarities: it is the notion to slim for its own sake. This is a compulsion, even a fixation, that has much to do with the improved economic and social conditions in the West since these conditions have completely changed in recent times. Everybody eats well, and indeed too well, becoming bloated caricatures of themselves. Rolls of fat hang over the edges of tiny costumes like horizontal streams of molten candle-wax. And it is that state of obesity that has brought about the world's ideal norm. Fashion models are selected according to how closely they fit this norm but also on whether they can still actually get into the clothes to be displayed. And for women in general the overall result has been the nullification of everything that once made a woman's shape feminine. Strange, new creatures, amorphous hermaphrodites, now stride along the catwalks staring past the flashing cameras – as hybrid and asexual as the clothes designers presumably imagine is the beauty of angels and divinities.

Regular sporting activity produces an athletic body visibly unrelated to the original ideal of beauty. Muscular thighs and deliberately well-developed shoulders do not fit well with what most people perceive as beautiful, but they are useful for specific bodily functions: running fast, throwing a great distance, and so on.

As perhaps the weirdest caricature of the bather in a bikini, then, is the female bodybuilder in a bikini. She – bronzed, well oiled, and flashing a brilliant smile – puts on an exhibition in masculine-style poses, bunching her muscles and flexing them against each other in authentic display mode [illustrations 144 to 146]. Clenching her teeth in moments of effort, this athlete embodies an altogether different ideal combining all kinds of different notions in which many different aspects of both sexes are represented. For a bodybuilder's body is a grossly altered form of the ancient Greek ideal of beauty (as is evident from statues of discus-throwers and runners). The carefully balanced proportions of the Greek athlete are in the bodybuilder replaced by disproportionate elements: the bull neck, the outsize thoracic six-pack, the figure-of-eight legs like a frog's. It is not insignificant that the greatest distinction in this sport is to hold the title of Mister Universe – megalomanic pretensions in which the Greeks had little or no interest.

But apart from for the purposes of competition, the female bodybuilder shares with the enthusiast the slimmer's ideal of rendering her body sexless, so disqualifying herself from beauty contests and restricting her to sporting competitions.

The female bodybuilder is thus an example of the disordered array of collective dreams representing a multiplicity of ideals of male and female form, of male and female beauty. And at the same time, in the same way, the perfect mannequin on the catwalk is now no more than a doll to be dressed up. In both cases, conditioning of the body has led to ambiguity. The "healthy mind" that the Latin tag made its ultimate goal, together with a healthy body, has been entirely forgotten. Our era is much more interested in the pathology of the case, as witness so many books and films about serial killers and gruesomely detailed forensic evidence. Now there is only the desire to attain the perfect body: a desire that gratifies itself by replacing the original ideal of beauty with narcissism.

But the greatest of all caricatures of the ideal of beauty as the girl in the bikini has in fact been brought into reality within the last twenty years – by means of plastic surgery. Liposuction, nose-jobs, ear-retractions and chin-tucks, breast-lifts and silicone implants have opened up a whole new field of body conditioning. It is already possible to take almost for granted that what previous generations of women endured months and maybe years of sweat and suffering to achieve is now readily available through "simple surgical intervention." Perhaps surgery has at last discovered the absolute limits of what is actually possible in body conditioning.

Are you dark-skinned, and would you like not to be? Are you unhappy with your nose? Would you prefer a pop star's, roguishly retroussé? How's your chin line – baggy? Crow's-feet around the eyes? Does your

152.
Swimming costume for the 1991 summer collection of Rasurel. A two-piece swimsuit, it is print-decorated with yellow, green, pink, and mauve flowers. December 3, 1990.

partner dream of big breasts? Do you hanker after them yourself? Would you like a bosom that elicits a veritable cacophony of wolf-whistles as you toddle down the street? One or two odd marks on your skin? Your lips not pouty enough? Are you afraid people think you cannot be sensual? Your hips are too wide? Do you want, in fact, to be quite certain of being the dream woman to other people that you may already have been to them for a long time? The answer to all of these questions, with modern surgical techniques, is "No problem!" You can acquire the body that other women dream about – if you've got the money – whenever you want. Justice and equality for all!

And yet there are one or two things to be aware of with such techniques, and they may cause some inconvenience. Things like sore spots and tender areas, wounds slow to heal and scars slow to disappear, paralysis of facial muscles, an allergic intolerance of light, numbness, nervousness and diffidence about the face that seems no longer your own, breasts that seem to jut out each side unnaturally, interminable precautions that have to be taken before diving into a swimming pool, the ever-present fear that something will give, that there will be a horrible gurgling, tearing, sucking, popping sound, and everything will go back to the way

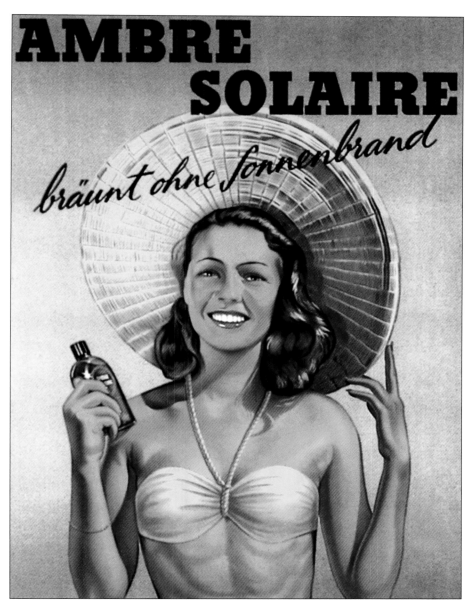

153.
Publicity campaign for *Ambre Solaire*.

it was. And then there is the need to find an answer to the eternal (and eternally embarrassing) question "Are they real?"

But perhaps you will be able to snap your fingers at all of that for twenty years – until the scars start showing again. In the meantime, the silicone-implanted girl in the bikini (who may have back trouble as well as problems when in the water) can go on dominating the scene. Sooner or later we shall have to accustom ourselves to the sight of a bikini top in which the two triangles of cloth cover only the final extremities of the breasts and not much else.

As breasts advance savagely upon us, however, they are followed by lips "made for kissing", like those on a Barbie doll. Such lips require three times as much lipstick as previously and finally accustom us to dreaming of the woman whose lips they are not as she is but as she is made up to be, perhaps in a seductive pose on a poster or in an advertising feature, and never as someone we might meet and kiss in real life.

The "new history" introduced for study in French schools during the 1930s declared that what we had formerly believed to be the primary content of the

169

subject of history – important occasions in which kings, princes, and army generals when called upon would go off to battle and kill or be killed in order to feature in great paintings after the event, which itself might have come about for no particularly tenable reason – was not actually, entirely, or exclusively what mattered in history. New history instead put the accent on the infinite multiplicity of tiny details all of which might have virtually no importance by themselves but which together formed a dimension, an "everyday context", that told us more of the past than lists of events and their dates learned off by rote ever could. We had been risking getting a completely false idea from documents and pictures dating from the relevant times and incorporating contemporary understanding. The refined world of the 17th-century royal court – which had seemed to comprise only of gallantry, determination, intrigue, and perfume, and in which ladies between cups of coffee discussed literary metaphors while men sang their praises in elegantly turned verses – suddenly took on a different aspect when we learned that the same august dames used to spit on the floor during theatrical interludes, while the men, inspired as they may have been by poetry, used the hems of their tunics as handkerchief, towel, and whatever else.

Yet to slow history down in this way in order to try to pick out what might in some future period be regarded as something surprisingly disagreeable in our own times is impossible: we are of our own times – we cannot look back at them from another point of view.

All the same, the history of fashion, and indeed the history of understanding and clothing the human body, might well furnish us with a new outlook on the 20th century. We might learn that with the onset of World War I a world of starched collars (stiff enough to hold up heavy heads) disappeared, as did corsets which effectively tied up the body as if to force it to conform with what was thought to be right and proper. We might see Fascism as a passion for military dress, for uniforms and for highly polished riding-boots. We might discern Communism as the children's story of *The Shirt On Your Back,* in which the shirt is taken off the proletariat to reveal a back hard as steel through the weight of work that has been pressed upon it. And we might judge that the sexual revolution finally led to the right to wash your jeans once a year.

The contrast between the significance and the tragic nature of historical events and the strange clothes by means of which they may be regarded less seriously, both distances us in time and gives us a different view of those same events. Above all, we glean a new sense of unease about them.

The history of the bikini as the story of "liberating the skin" seems to be part of the larger story of the freeing up of the human body – undoubtedly the story that best characterizes the 20th century. But this freeing up of the body, engendered by a scandal, at the same time created a new set of restrictions of its own. The body was to be freed – but only if it was to be honed by dietary regimes and courses of strenuous exercises. The skin was to be liberated – but only after many a long session of ultraviolet treatment. There was to be freedom and liberation – but only following prior conditioning involving severe constraints.

In this light, the history of the human body during the 20th century seems hardly to be the history of emancipation so much as the history of oppression. Think of the benefits and pleasures promised by all the disciplines and regimes! And now think what the body has actually suffered in wars and in absurd ventures of all kinds – how it has been flayed, gashed, lacerated, and torn to pieces! It has been taken to the north pole; it has been made to climb to the highest summits; it has been plunged down into the icy dark depths of the deepest oceans; it has been strapped into the uniforms of test pilots demonstrating the effects of centrifugal force; it has even been propelled into space. The body has also been measured for its reactions in groups: thousands, even tens of thousands, of individual bodies have been enclosed in a stadium and required to respond to orders as if they were a single body. The body has discovered the delights of high speed; it has fallen through the air to be held up by a parachute; it has been made to run so hard as to burst its lungs; it has been punished, and has punished others of its kind, with and without boxing gloves, for the sake of sport. Everything possible that could have been done to it has been.

And then there is the obsession with its beauty. The body, which has not a hope of ever achieving such a notional ideal, is made nonetheless to strive to attain it. It is made to suffer. It is forced to pedal bicycle frames

that go nowhere, to row boat-shaped apparatuses that stay put, to run on automatic tracks that record how fast and how far it remains stationary. There are many times the body is worked so hard that it forgets the outside world altogether.

And afterwards, in front of the mirror, there is unadulterated narcissism. Yet it is impossible to reach the goal set – the body can never be perfect. Even when the mirror did show something to be happy about, it cannot last. And so, back at once to more running on the stationary track, more rowing on the ever-grounded boat, more "tightening up" with lead and iron weights.

Such conditioning of the body – the body that is forced to sweat and to toil, is kept under stress, and is pushed to achieve truly extreme performances in a world that has become one giant adventure park; the body is pampered with all kinds of preventative medications and miracle cures including folk medicine and placebos in an attempt to give it "harmony with the stars" or keep it "in touch with nature" – remains, by a strange irony, at the service of freeing up the body but in a process that has effectively amounted to a grand obsession.

154.
Bathing costume made by the Israeli company Gottex. September 19, 1983. Jan and Sarah.

155.
Showgirls at Caesar's Palace, Las Vegas, during the 1960s.

Sport as a metaphor

After World War II had come to an end, and during the subsequent ideological numbness felt by the Western democracies, sport took on an unaccustomed significance. It became something of a symbol of their rivalry with the Communist world, and thus a measure of national and personal prestige. The use of sport for ideological purposes – a tool much appreciated by many a totalitarian regime and dictatorship – might seem strange to those who live in liberal democracies. But it was one of the special features of the Cold War, taking on much of the urgency of strategic warfare. In this highly visible, if symbolic, arena it was possible to confront the enemy – albeit to throw a javelin or hurl a discus, and so on – with every bit as much ferocity as in a military conflict. The two political blocs thus went on striving against each other on track and field, football pitch, basketball court, and ice rink for 45 years rather than take to lobbing atomic bombs at each other. The prizes were accordingly gold medals, silver cups and bronze statuettes rather than captured territories, towns, and trenches. Sport in this way became something of a gauge to a nation's well-being and confidence. If the national football team won, the nation was doing well and felt well. If it lost, the nation despaired. And this was true of all countries involved. It is for adjudicating in such a way on "winners" and "losers" that sport may be described as a metaphor. But it was a metaphor in both directions, for a sporting individual might at the same time come to comprehend how the world worked – competition inevitably impresses upon those who go in for it exactly how much is necessary in terms of determination to achieve the goal, training to reach peak condition, and luck, together with self-discipline, self-denial and, where appropriate, team spirit. The outlook of the sportsman or woman, which can of course be turned into a political statement, is nonetheless in itself totally apolitical and thus ironically applicable to all ideologies. The world as theatre of combat, in which one has a place only if one competes for the privilege, and which lasts for only a short time, courtesy of others; that is the tacit lesson of sport. After 1989, sport as a metaphor acquired a new, supplementary significance. Genuinely combative forms of competition (which no longer had political applications) were relegated into the background, while into the foreground came the "extreme" sports, participated in for individual pleasure and excitement. People began bungee-jumping off bridges, riding mountain bikes over cliff edges, and white-water rafting down rapids in river-gorges. Everyday life in Western cultures had evidently become too boring – extreme sports now provided the adventures people believed they were missing out on. And yet at the same time, such activities might prove to the individual that in the new, global configuration of the economy, a readiness to take risks and to react appropriately to real dangers remained personal qualities essential for survival. Sport as a metaphor nonetheless also points out a fundamental flaw in our modern life and times – the often complete meaninglessness of our working lives, which are mostly no longer dedicated simply

to the earning of money and which may not even seem to have any real purpose; the absurdity of a personal career that no longer has a goal or direction and relies on lucky breaks in the employment market; an existence that has become pallid and unreal, monotonous, and incorporating more free time than one knows what to do with. For all these complaints, sport can furnish an answer, a substitute to fill the gaps. Leisure hours are occupied, adventures are provided, enthusiasm and inspiration are evoked – and apathy and lethargy can be cast off. In such a mode of living, sport is an essential factor that pulls everything together: it is the repository of those dreams, desires, and ambitions that remain. Sport is not simply sport – it is a metaphor.

156.
Sporting bikini in neoprene.

Chapter 6:
The New Freedom

 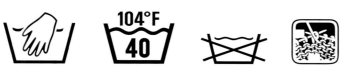

The metaphorical and physical breaking down of the Berlin Wall, which brought to an end the 1980s and four decades of the Cold War, changed all the preconceived notions long adhered to in the West. Many saw in the downfall of Communism the beginnings of a new freedom that heralded the end of political ideologies. Western nations had picked themselves up from the depradations and deprivations of World War II, and had so considerably developed their technologies as now to be able to think of applying that technological advance, and its material benefits, to the enjoyment of life. The proportion of each state's budget allocated to the armed forces decreased, and military rivalry all over the world was transformed into an economic rivalry.

At the beginning of the 1990s the bikini at last acquired a new status. It became socially acceptable – no longer capable of shocking, no longer symbolizing the amoral flaunting of private parts. The obscene properties it had been accused of having by society throughout the 1950s and 1960s, had become part of the domain of the pornographic – which had itself in turn begun also to take on social acceptability.

Any anxiety surrounding the bikini was thus a thing of the past. Likewise, there was little point in wearing a bikini if you specifically wanted to look "sexy" – a one-piece costume would do you just as well. So the woman of the 1990s could wear either a bikini or a one-piece costume, whichever she felt like wearing or whichever she thought more suited to being active or relaxing and getting a tan.

In terms of fashion styling, the final decade of the 20th century was also an era of liberation. Nothing was off-limits: virtually anything designers could come up with was permitted. Outside of specific movements and directions, fashion began to turn back to history for reference, producing "retro" styles designed by individuals on behalf of one fashion house. There seemed to be only one major principle – the more colours were included, combined without any apparent coordination, the better it was.

More interesting were the attempts by various couturiers to alter their status. Fashion could be perceived as an art, and the creator of a fashion style should

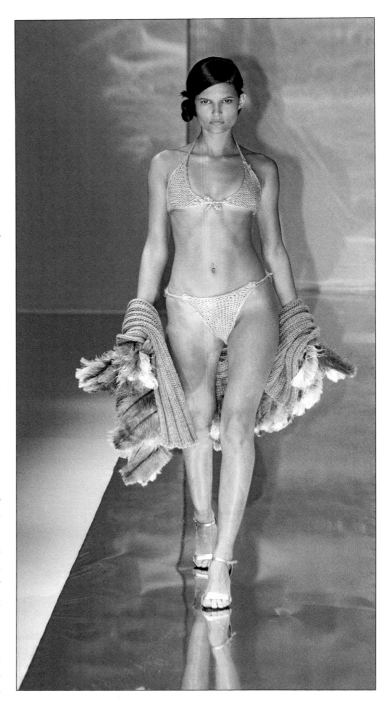

157.
Heather Knese in a mass-produced bikini by Stella Cadente, part of the ready-to-wear autumn-winter collection 2000/2001, Paris.

158.
Yamila Coba in a bikini top by Agatha Ruiz of Prada at Cibeles. Fashion show, September 8, 2000, Madrid, Spain.

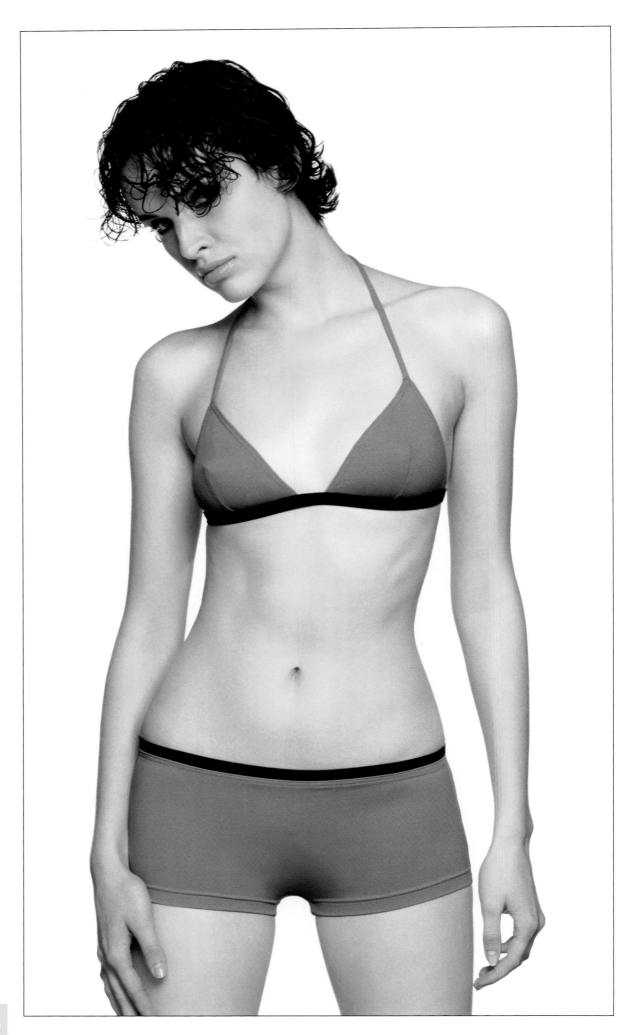

159.
Tanya Rudenko in a bikini
belonging to the Eres
summer collection 1999.
Photo: Jean-Marie Delhostal.

therefore be seen as an artist. His or her work was not restricted to putting clothes on bodies, it was at the same time making a statement. No longer passively silent, fashion was now communicating: clothes were signs and symbols by which the body spoke.

Critics of the time noted that fashion-as-art seemed to find a place for itself quite easily in the intellectual vacuum of the 1990s. Bearing no political allegiances, and constituting a supremely inoffensive mode of self-expression. The fashion designer as artist operated within a system governed by a dialogue worked out in advance – this is what a beautiful body looks like; this is what a beautiful dress looks like – which afforded him or her ever more significance. If you had the body, you could buy this dress in my boutique. In view of such criteria ("If you have the wall to hang it on, you can buy this picture I have painted") the designer could only be a parody of an artist of the materialist type who invented Western civilization. He or she thus represented the inevitable and exclusive result of a Capitalism that had become more and more megalomanic, dreaming of dominating the world – and not by chance did the fashion designer choose the hollow speech of the fashion universe to express himself or herself. What he or she produced was just external appearance, a perfect outer casing, but the whole was empty, comprising simply of objects notable for rarity, a personal design involving unique clothes made from expensive materials.

To a great extent this principle of haute couture overtook classic individualism based on culture and particular elements of personality. Haute couture "art" might from now on be acquired in the form of a unique item of clothing. The fantastic sum of money required to purchase an evening dress that is an original model from a fashion designer guarantees to the purchaser that she is unique in herself and of her type, not solely for the gala dinner at which she wears this fabulously expensive creation, but afterwards and for the rest of her life.

And so the great couturier was transformed into an artist in the eyes of society. It was his or her task to furnish the leisure hours of life with guarantees of delightful décor, with fascinating costumes involving things used in original ways. He or she was the provider of beauty that was always on exhibition and had no other purpose in existing than to be on exhibition.

It would not be unreasonable to compare such a couturier and his or her creations with the French Sun King Louis XIV's master of ceremonies who with his fireworks spectaculars strove to establish the image of the royal court as one of theatrical ephemerality while always advertising his own name and accomplishments to the rich and the powerful. The contemporary fountains, cascades and light-shows transformed the world into an impressively well-staged background for a pretty dress. Today, then, the world is there to provide an adequate background to the fashion parade. Such a diminution – of life in general to a fashion parade, and of the world to an "adequate background" for it – corresponds to the blind spot of our times. It is a blind spot that no one cares to cast light upon.

The most significant change in beachwear fashion occurred during the 1990s, although it was more to do with the way costumes were designed than with innovatory ideas or techniques of production. Computer-assisted design techniques opened up a vast field of possibilities, notably in endowing photos with a quite unforeseen degree of perfection. They could be retouched, improved and/or modified without reference to a negative. The original picture could be thought of as no more than a base to start from, to manipulate at will using computer graphics programs.

A second sea-change was quantitative. Totally unlike the 1950s – when to get a daring swimsuit displayed meant hiring the services of a stripper – fashion models in their droves these days are ready to submit to almost anything (and show virtually everything) without putting up any moral objections. The aesthetic qualities of the pictures are improving all the time, whether the images are in prestigious magazines or in advertising brochures brought out specially by renowned photographers on behalf of specific swimwear designers.

And at the same time, the aesthetic awareness of the general public is also expanding. It is no longer enough to show a reasonably pretty girl in a brief two-piece costume if you want to attract mass publicity. The fashion model who displays the latest creations of the great maisons de couture on the most expensive of catwalks, or the model who shows off a sportswear company's seductive bikinis on the beaches of a banana republic, must satisfy equally crucial aesthetic criteria.

Just as preparation of the candidates for the most prestigious beauty competitions has become very professional, fashion models similarly may have to undergo correction of their bodily imperfections through modern techniques. The most celebrated example of such treatment is undoubtedly to the teeth, which can be evened out or straightened or, in the last resort, replaced with dentures so that the smile that features in the photos shows a dentition of perfect whiteness perfectly aligned, as required. Other frequent surgical interventions include reshaping the lips.

The model in a bikini may have undergone such procedures twice over – first physically by means of surgery and through the conditioning processes of sport and dieting, and second pictorially by means of computer graphics. But the result is that her picture corresponds in exact detail to the ideal demanded by the photographers and the fashion designers.

Branding in beachwear has become as important – if not more important – than the costumes themselves. Since the end of the 1980s it has been the designer who decides which model or models will show his or her collection. But meanwhile the girls in the bikinis and the bikinis themselves have together become the product, and publicity on them both is pushed to the very limits of possibility.

For that reason, bikinis during the 1990s were shown in deliberately suggestive poses, albeit no longer shocking. The long-limbed beauties half-seated half-lying on the beach tilted their heads back in a gesture of apparent ecstatic pleasure. Their perfect bodies, revealing the underlying musculature, were caught suspended absolutely between tautness and utter relaxation. A brilliantly white bikini contrasted with the bronze coloration of suntanned skin – a juxtaposition appropriate to an image of summer. Brown skin, white clothing – putting into perspective a contrast that until only a short time before had to remain invisible. The bikini's function was now no longer to conceal but to emphasize the pleasantly rounded shape of the model.

The appearance of swimmers in bikinis began to have a knowingly sexual aspect about it. Given publicity in a particular way, a bikini explicitly suggested a certain

promise. The client who purchased one would be acquiring not just a bathing costume but a good amount of sex appeal – now a positive property sought after as much by women as by men.

The publicity categorized such images of swimmers in bikinis according to the types of women reckoned to be potential buyers. A bikini might thus be shown quite a number of times worn by different models (blondes, brunettes, etc.) and in poses suggestive of various characterizations: deliberately sexy, formally correct, seductively coy, happily romantic.

Another method of classification relied on stereotypes of women's relationships: a married woman of a certain age, who wanted primarily to ensure that others knew her situation and station in life, would prefer a bikini modelled by someone who looked similar; a younger and single woman would instead prefer a model who looked like her. The same bikini might be modelled in both cases but by different wearers.

The new freedom of the 1990s extended also to the cut of the bikini. No restrictions were recognized. They could be long, covering as much of the body as a full two-piece costume, or short and much more revealing.

In 1991 Valentino presented a two-piece costume featuring large white dots on a black background. A beach blouse in the same material and style came with it. Paco Rabanne in 1996 showed off a violet bikini made of light material, cut in a style resembling sporting underwear. The top had two tiny rings like diamonds between the breasts, above the hips, and over the navel. This bikini was intended to be worn with a pair of trousers, also violet, as everyday or town wear. A year later, in 1997, the house of Eres was using a flowery pattern on a bikini that again looked rather like underwear and that gently satirized the "girl in a bikini" cliché. In 1996, Poi Moreni had one of his fashion models dress in a swimsuit with a geometric maze in black and white on it, recalling – with its black swimming-cap and goggles – styles of the 1930s.

Then Chanel came up with the *Eye-patch* bikini, the top of which was classical in shape, comprising two triangles, but in sky blue with little black squares. The

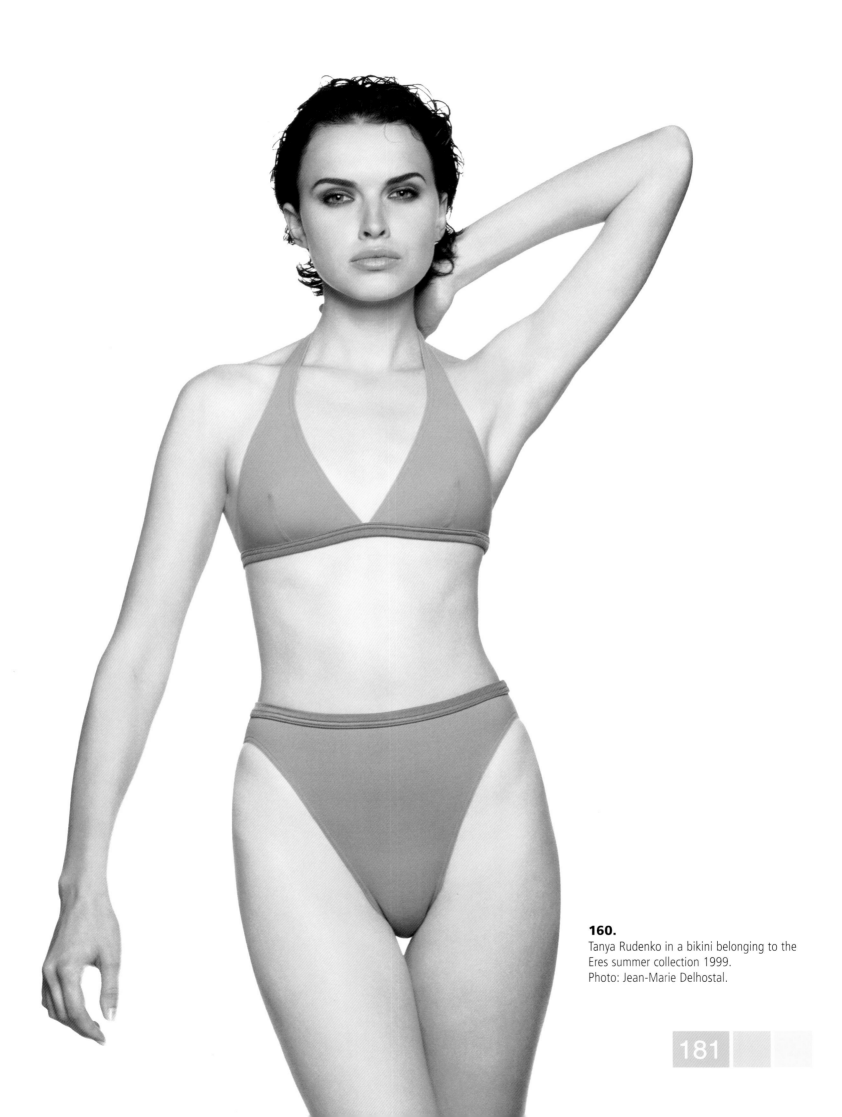

160.
Tanya Rudenko in a bikini belonging to the
Eres summer collection 1999.
Photo: Jean-Marie Delhostal.

181

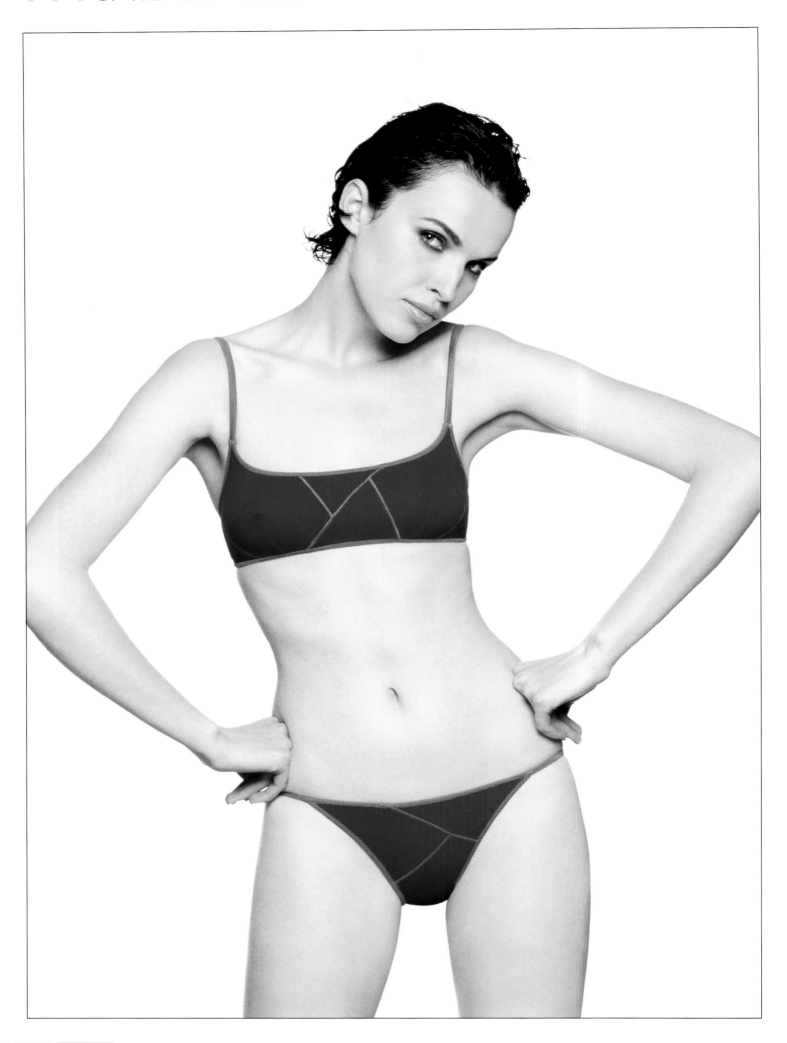

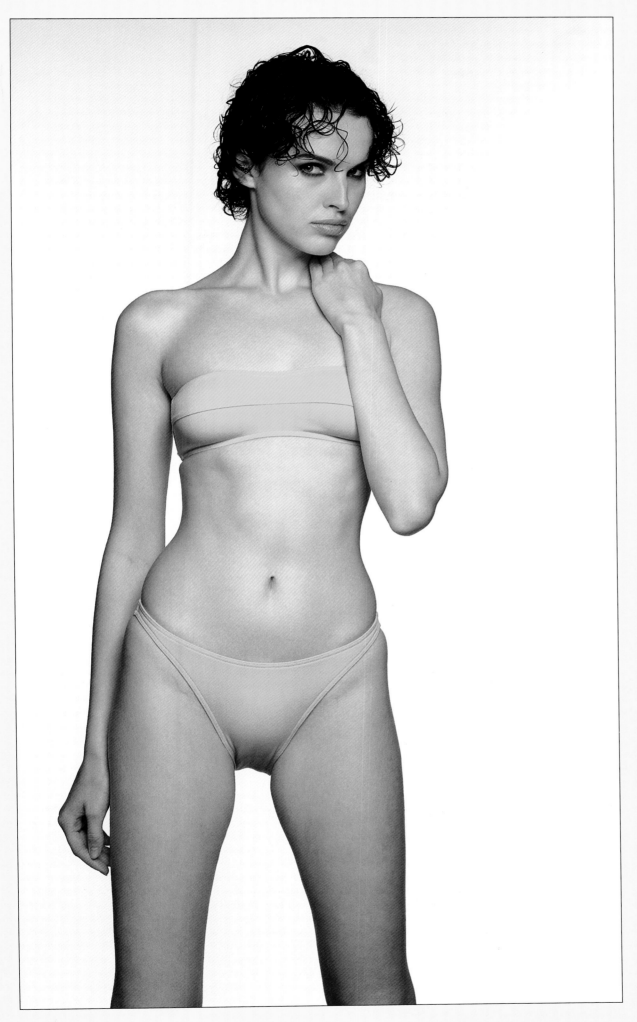

161. and 162.
Tanya Rudenko in a bikini belonging
to the Eres summer collection 1999.
Photo: Jean-Marie Delhostal

163.
Portuguese designer Fatima Lopez presents her diamond bikini, October 7, 2001, in Paris as part of the ready-to-wear collection.

costume had a number of accessories. Chanel also devised a three-piece costume, in black and in sportswear mode, which left uncovered the top of the bust at the level of the shoulderblade when extended round. The eclecticism by which these diverse elements of style and fashion, drawn from various different times and tending ever more towards brevity and minimalism is typical of the 1990s.

On beaches all around the world, from Rio de Janeiro to Majorca, two further tendencies may be observed. One is the matter of colour. The tops and the bottoms of bikinis do not have to be the same. Variously coloured combinations are entirely acceptable, and some designers have proposed up to ten different bottoms to go with one single top. In an Argentinian bikini of the 1990s, the top was thus red and blue, while the bottom was yellow. This costume also came with a sky-blue pullover long enough to be tightened with a drawstring around the hips, for use when leaving the beach in order to go to a bar for refreshment.

The second major tendency is that of the thong, which comprises no more than an elastic string between the legs and buttocks, and thus fulfils Réard's original idea of reducing clothing to a minimum. Skin surfaces are thus revealed to a maximum and, especially with a deep tan, take on more importance, while the costume itself is diminished to the status of mere adornment, no longer bothering to make out that its function is to cover anything. The bikini-with-a-thong – of which only the bottom is generally worn – is effectively no more than body decoration, like a necklace or a bracelet.

But for many designers such a spectacular reduction of a swimming costume is a step too far and comes too close to nudity. A naked body is of no interest to the world of fashion ... although nudity might hold some possibilities for it if nakedness could be made somehow to fulfil fashion's basic tenets – if a state of nudity could somehow be passed off as one of being clothed. This is one reason for current insistence on a stack of beach accessories: hats, sunglasses, beach bags, sandals, swimshoes, and so on – all of them are really no more than unnecessary additions there, only to compensate for the minimality of the swimsuit. Whatever they are and do, though, they do not cover any more skin that may safely be tanned.

164.
Juliana in a bikini by the Portuguese designer Fatima Lopez, presented October 7, 2001, in Paris as part of the ready-to-wear collection.

Sunglasses and hats can nonetheless be quite sizable for what they are. Some sandals, however, are simply a sole and a couple of strips of leather or plastic to be attached round the heel or at the ankle. The bikini as no more than a decoration should perhaps now be considered in the same way. For now, just as during the 1950s when it all began, a woman can go onto the beach wearing ornaments that are beyond any of the requirements of actually swimming. A shiny belt worn tight against the body and covering the navel; a large brooch attached to the bikini base at the hip; another brooch looking as if it clips a towel thrown over one shoulder, so making it seem like a toga – all these are examples of the new decorative mode. But there are also bikinis made with gold thread so that the whole costume looks like one big decoration. And there are all kinds of ornaments that can be added on, some perhaps even to the top of the thong (so lessening the minimalist effect).

Body decoration itself has undergone a parallel revival. Now that more of the body is to be seen without clothes (and indeed without inhibitions), more of the body can be decorated directly. So we see tattoos, both those that are genuine and those that can be washed off afterwards; studs and gems in the nose; little rings through the earlobes, the ear-rims, or the eyebrows; and diamonds, real or false, at the navel. Body-piercing has become all the rage. A couple of years back, a stud through the tongue was the ultimate in intimate decoration (to the fury of many a shocked parent).

This return to an artistic culture of the body that predates Christianity – which adds a completely different experience of living to the body one inhabits – combines all the elements of the most primitive cultures that we know of. Body-painting, as done in Australia and by some African tribes. Tattooing, as done on Pacific islands in the Southern Seas. Studs and spikes, as applied to and through the skin in India and in some ancient civilizations of Europe. Such widespread usages clearly indicate the influence of imagination inspired by the possibilities of being different or being different together. The purpose in each case is not solely that of commu-nication, of making immediately recognizable the members of a family or group (as might have been the case with ancient tribes) but to deliberately alter what the body feels like.

A part of the body that has on it something new and decorative may make the whole body feel new and

different, but will certainly change one's feelings about that part of the body.

And indeed, the emergence during the 1990s of a fad for body decoration in the manner of a tribal symbol can be understood as part of a defensive reaction against the rampant globalization of the period – against uniformity and conformity imposed from above and in all reaches of life, against groups and ideologies determined to make everyone the same, and measurably so. Advertising during the 1990s was full of notions of the group, the clan, the tribe. The telecommunications industry, for example, was forever vaunting its products as enabling us "to keep in touch with the family."

The change in the perception of the human body, and above all, the desire to make that change, may well be thought of as the latest consequence of the criticisms of metaphysical and Christian thought by such luminaries of Western philosophy as Nietzsche and Freud. That the human body has been hidden away and repressed for centuries, that it has been refused any right to pleasure or significance, would seem now to be compensated for through generalized decoration of the body in an endeavour to make a "living statement", and perhaps sometimes overdoing it.

For the body, which we care for and may be proud of, which we keep looking nice (or as nice as we can) through physical exercise, training, and the use of cosmetics, is no longer a vehicle for a soul destined to the hereafter but has become an end in itself. Its goal is to enjoy life and to leave the uncertainties of what comes afterwards to the speculation of the theologians.

Revealing the body, which gratifies irreligious frustrations, also modifies our own attitude towards nakedness – an attitude that inevitably conforms to the parameters of a society devoted to display, of a society that sees itself as forever on stage. Since 1990, girls in bikinis have demonstrated that a taste for exhibitionism

165.
Camilla Balbi in a superb chestnut bikini, model Timika-Maluka of the Sugarloaf. Photo: Patrick Mouïal.

166.
Camilla Balbi in a magnificent white bikini, model *Dolak of the Sugarloaf*.
Photo: Patrick Mouïal.

167.
Camilla Balbi in a mauve bikini, model *Iwik of the Sugarloaf*.
Photo: Patrick Mouïal.

is no longer beyond the pale, and indeed is but the reverse side of an economic system based on publicity. Revealing all, now perceived as simply another sales strategy employed by the promotion department, has come thus to have its own uses, its own rewards. People want their likenesses plastered on advertising boards all over town, on the sides of passing buses, or on subway walls, ever smiling brightly at the passer-by in the crowd going home from the daily grind. People want to be an object of admiration by all, and so they are glad to be selected to advertise brands on behalf of the promotions industry.

Sex symbols of the 1990s, such as Pamela Anderson, did not restrict their appearances just to movies and magazines for men. Most weeklies print their covers well in advance so that they can use them on large notices as shop windows to advertise their latest issue. If a cover shows a girl in a bikini, well, that is the stuff of modern mythology, and word gets round quicker than lightning. The effect can be just as electric. A publicity campaign for H&M once featured Pamela Anderson revealing much of her curves within a bikini. The campaign had to be brought to a sudden and premature halt because of the number of serious car accidents and resultant court cases it seemed to be precipitating – for her picture had been put up on hoardings at important road junctions, and drivers had been too busy looking at her to pay attention to what they were doing, obey the traffic regulations, and avoid each other or the ditch. Even when no actual collision was involved, long lines of traffic built up behind drivers slowing down to rubberneck at the picture. The fashion house was finally obliged to withdraw the by now notorious hoarding and replace it with something less mind-blowing.

Much the same story is told about other stars of screen or catwalk who literally turned people's heads at inappropriate moments when driving, so causing a catastrophe that was difficult to explain afterwards.

All the same, this not unamusing story proves that it is more than anything else a tall story put about for publicity purposes, promoting a product (the bikini) and a person (Pamela Anderson, although it could have been any star or model) as much as a company (in this case H&M). And it is part of a larger-scale strategy

emanating from the promotions department, seeking to imperceptibly blur the line between what is real and what never happened. The world as presented by advertisements, after all, is always an ideal world, too good to be true. It requires the mind of the reader/viewer/observer – who has to work out what is real and what is unreal – to be anaesthetized and so be susceptible to believing the unreal (the vaunted benefits of the product) as being the real, first when purchasing the product, and then when making use of it.

A man who smokes *Marlboro* should always feel like a cowboy when he draws on his cigarette. A certain make of ice cream is held to be particularly refreshing on a sultry summer afternoon, and thus to make consumers "cool people." And even a mass-produced bikini can turn men's heads and assure the success of the woman who wears it. Such strategies are completed by what is called branding – using specific company or product-group names that sell because they are already associated with a range of qualities (which individual products may not all have). We are all subject so much to branding these days that for many people the only pleasure in buying anything at all is then to possess a particular brand.

This is how the bikini's "personality" was treated with more freedom during the 1990s. Once de-scandalized, it was used by haute couture as a less than serious stylistic exercise. In the year 2000 Prada presented a bikini with a base in four colours (yellow, orange, red, and blue) and with a top that consisted of two plastic triangles that were completely transparent. Oh yes, and it lacked only one accessory – a largish beach bag, also in four colours, that could at a pinch be used as a pillow.

One year earlier a bikini had been shown on which certain marine motifs predominated. Shining starfish spread over the triangles of black material that covered just the very tips of the breasts, leaving a good deal of bare skin above. The starfish theme was elegantly repeated on the belt around the top of the bikini base.

Another bikini by Prada's Agatha Ruiz in the year 2000 had a top like a T-shirt that came down only just below the breasts. In the middle of the front of it was a heart-shaped transparent plastic window, which afforded a rather daringly full glimpse of cleavage [illustration 158].

168.
Camilla Balbi in a superb sky-blue bikini, model *Kilifi of the Sugarloaf*.
Photo: Patrick Mouïal.

169.
Camilla Balbi in a fiery red bikini, model *Mahera of the Sugarloaf*.
Photo: Patrick Mouïal.

To invert things and to turn things back on themselves was another trait belonging to the 1990s. So it was to be expected that what might once have been worn on the inside would very soon turn up on the outside. Underclothes suddenly appeared on top of jeans and T-shirt, presenting an original contrast – the well-dressed woman showing what she would not normally show except when undressing. And if some of these underclothes, traditionally made of cotton, made a good impression, then they might in due course be replaced with examples of lingerie that were, let's say, more alluring.

In terms of bikinis, Chanel in 1999 presented an extremely brief two-piece costume that featured a T-shirt top with braces or suspenders which more or less covered the area from the top of the breasts down to the navel. A bikini of another design, this time by Karl Lagerfeld, worn sweatshirt-style, remained visible under a sleeveless T-shirt in vivid orange.

Materials generally discarded since the invention of nylon were dug up for reconsideration. Stella Cadente presented a silvery bikini in cotton, with matching shawl and pullover as accessories, for its autumn-winter collection 2000/2001 [illustration 157]. Eres offered bikinis made of the tough linen parachutes are made of. Various textural combinations were similarly tried out, some of them giving swimsuits not only a futuristic look but a metallic glitter as well.

Yves Saint Laurent returned to his flowery bikini-style wedding dress of the 1960s and, with Laetitia Casta in 1999, reproduced it, but this time in pink and green tonalities. The flowers were now intermingled with foliage, and together they formed a sort of wreath-style garland that swirled around the hips and up past the bust to the head, where it turned into a sort of coronet. The veil, which in 1968 had draped the length of the body, was replaced in a pink material that swept over the back rather like a peahen's tail to be drawn along the ground behind the bride [illustrations 171 and 172].

170.
Camilla Balbi in a pretty black bikini, model *Marafa of the Sugarloaf.*
Photo: Patrick Mouïal.

The Portuguese fashion designer Fatima Lopez presented a bikini made of diamonds. It did not cover very much, and was really no more than a sparkling chain around the bustline. The diamond motif continued as decoration for the fringed hips on a bikini base as visible from the back as from the front [illustration 163]. On another of Lopez's bikinis, presented by Juliana, the traditional triangles of the top – which some have called a symbol of femininity – were replaced with squares. The austere quadrilateral shapes in black cloth formed an interesting contrast with the tenderly rounded form of the female body – a successful play on the notions of severity and gentleness [illustration 164].

And finally, it has been announced that now is the time for the theme of camouflage, for colours, models, and costumes. To be sure, a bikini *à la combat*-suit cannot fail to appeal, involving as it does the already successful motif of the Amazon in a bikini. Equipped for all military contingencies, fully prepared to enforce the peace, the modern woman can divest herself in a second of her heavy combat uniform and go for a swim in a pool still wearing camouflage should there be a momentary lull in hostilities.

Such a bikini "uniform" also parodies the true function of a two-piece costume – to hide the dangerous weapons with which the female sex conducts its warfare. Yet it seems that no one really minds that a bikini like this does not actually camouflage the female form all that well on the beachheads – that is, the beaches. In front of the inimitable backdrop of the blue sea it is not all that well hidden either, in its olive-green shades. But as a bikini of the forests and of the grassy sward combined, it no doubt protects its wearer admirably as she walks in shady wooded glades searching desperately for a pool to swim in.

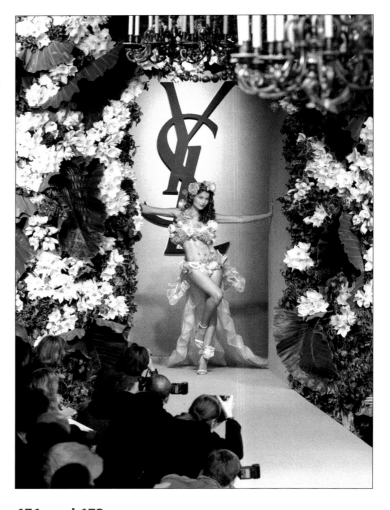

171. and 172.
Laetitia Casta in a wedding-dress created by Yves St Laurent at the presentation of the spring-summer haute couture collection, January 20, 1999. Photo: Frédérick Florin.

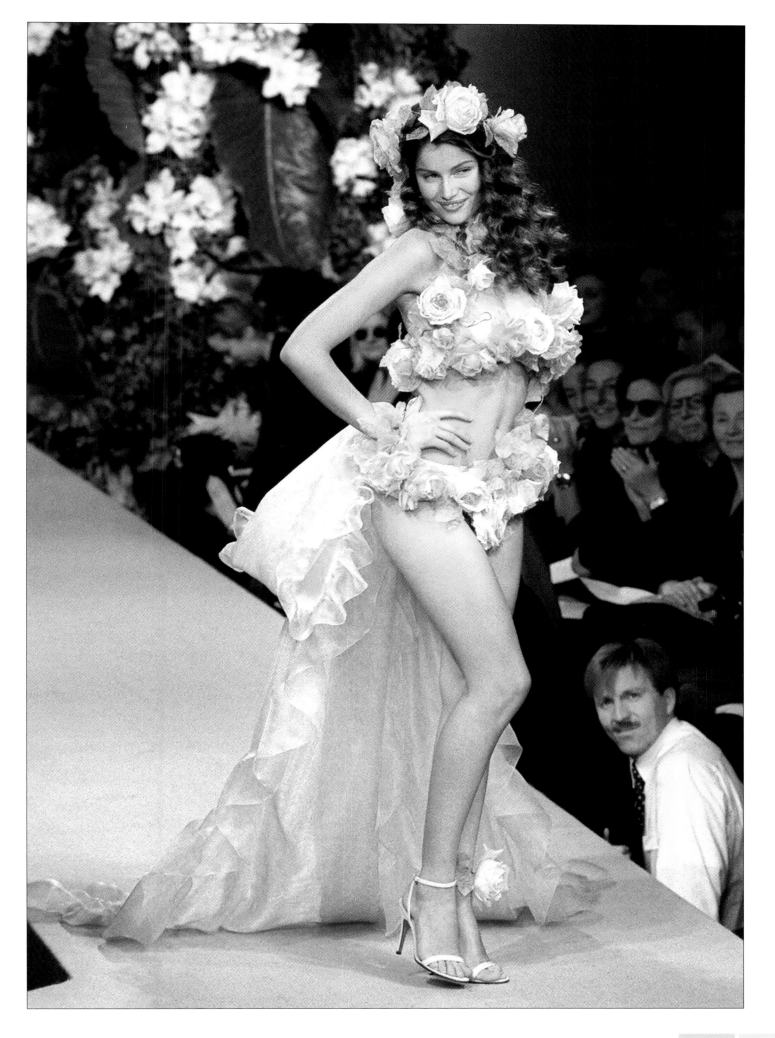

Chanel — forward-looking and futuristic

Chanel is considered to have been the quintessence of classic fashion design, well ahead of her time. And that is precisely the paradox that confronts and astounds every observer of a Chanel fashion parade. The dresses and ensembles displayed belong to an unknown future age in which alternative aesthetics are apparently in use. It is like being taken ever further forward in time, travelling through the future and somehow recognizing, as if one was a connoisseur, each "classic" fashion of tomorrow presented. Such forward-looking familiarity with styles to come, such evidently classic designs of the future – these are the qualities that elevated the haute couture of the house of Coco Chanel to the level of art. Above all, these qualities derive from the man who has been responsible for designing the Chanel collections since 1984: Karl Lagerfeld. This inexhaustible workaholic, as he describes himself, has brought to Chanel a unique fashion style that is simultaneously avant-garde and classical. The vision that Karl Lagerfeld had of the bikini was at its most creative in 1995, in the form of the minimalist black *Eye-patch* bikini. The original definition of Réard's bikini followed innovatory and aesthetic notions. It was a slow but purposeful revolution, and one of which nobody has yet truly perceived the full scope, by which Karl Lagerfeld finally arrived at "the smallest swimming costume in the world." The turning of the bikini into an aesthetically designed fashion item plucked the brief two-piece costumes out of the atmosphere of scandal in which they'd been born. If Réard had conceived the first bikini amid an unstable political context, Lagerfeld's two-piece drew attention for its shape and line. The functional purity that made the *Eye-patch* a respectable item of clothing that also attracted attention transformed the swimwear fashion catwalk. Natural, elegant and sensual all at the same time, the *Eye-patch* caused something of a renewal of beach etiquette, which now found it necessary to incorporate aesthetic ideals, to get rid of some of its excessive commerciality, and to adopt design aspects that would blend with the bikini. The fashion world thus changed the real world, relieving it of its more amorphous and banal elements. It is in this way that fashion, which contemplates reality from the viewpoint of its aesthetic criteria, became something that could be created. Only with the addition of creative artistic factors does reality discover such aesthetic components, and it produces such factors only irregularly and contingently. Alongside the *Eye-patch*, the house of Chanel in its collections also presented other ready-to-wear two-piece swimsuits that harked back to classic swimwear designs. There was, for example, a black two-piece costume with braces or suspenders and a hat, all of which featured advertising logos printed on the material in white lettering. Basic characteristics of this model were the elegant accentuation of body form and classic simplicity. Another Chanel production constituted a complete beach outfit: a light jacket and short skirt complemented a bikini which had a top in the form of a strip or band of material with frilled edges. In shades of rose pink and red, with some fibres specially worked so that they stood out, the ensemble's overall appearance had an air of time-

lessness. Karl Lagerfeld is not just a fashion designer but was also a photographer and technical artist. And in addition to presenting Chanel collections and collections of his own, he contributes to various books such as an illustrator in the beautifully produced revised edition of Paul Morand's biographical *L'Autre Chanel* (1996). But it was the publication of his own photographic works that led him, briefly, to head his own publishing-house.

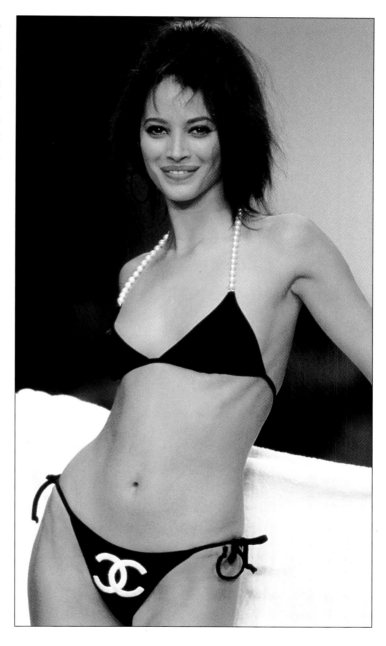

173.
Christy Turlington in a black bikini by Chanel for the spring-summer ready-to-wear collection 1994. The straps around the neck are made of pearls. The bikini bottom is tied above the hips. She is carrying a large white bathing towel.

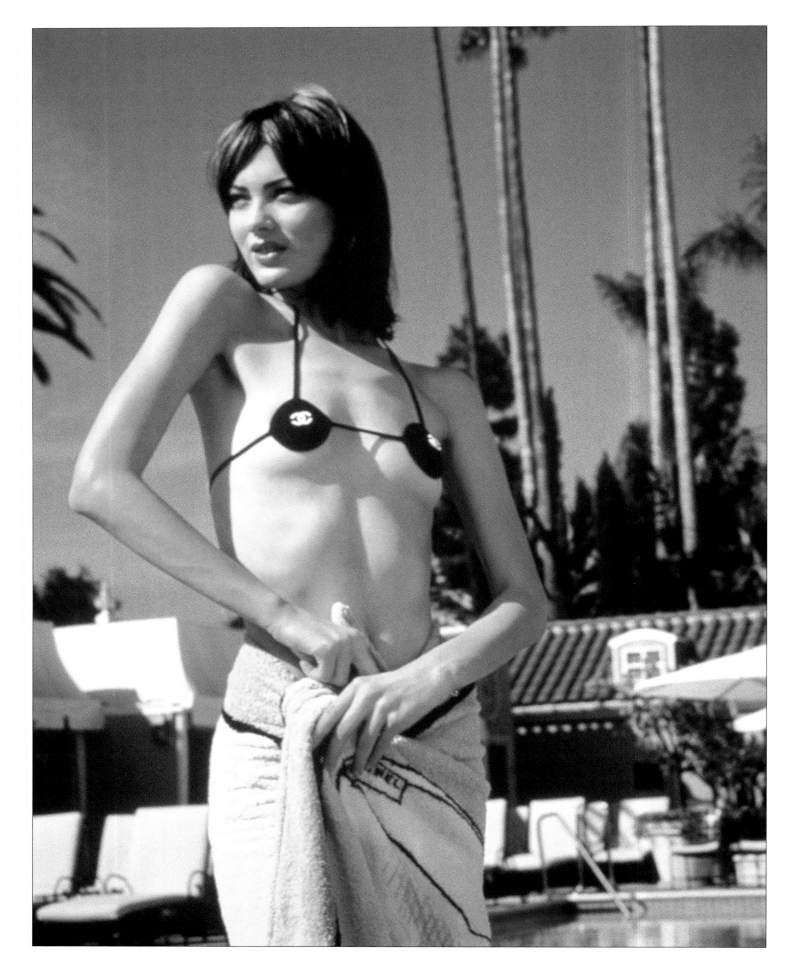

174.
Fashion model Shalom in a black Chanel bikini at the spring-summer ready-to-wear collection 1996.
Photo: Karl Lagerfeld.

175.
Helena Christensen in a pink Chanel costume at the spring-summer ready-to-wear collection 1995. Photo: Wolf Schuffner.

176.
A black Chanel bikini for the spring-summer ready-to-wear collection, 1997. Photo: Frédérique Dumoulin.

177.
Stella Tenant in a black Chanel bikini
at the spring-summer ready-to-wear
collection 1996.
Photo: Wolf Schuffner.

178.
Kristy Hume in a black Chanel bikini
at the spring-summer ready-to-wear
collection 1996.
Photo: Wolf Schuffner.

203

Epilogue:
The Beach as Arena for Social Liberty

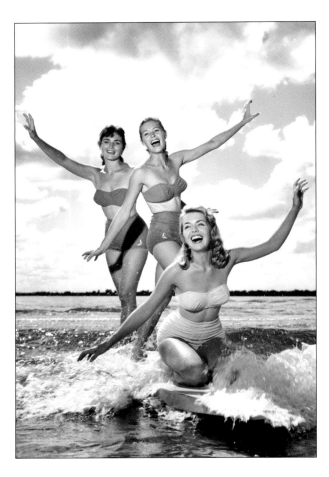

179.
Shirley Larke (23) and Vivien Hattam (19) having a good time waterskiing on the mere at the Scarborough Water Ski Club, North Yorkshire. On August 4, 1966, when this photo was taken, both girls were professional dancers on tour.

Recent trends indicate the general direction of freedom for swimming costumes of all kinds. But two things should be emphasized.

First, there is an element of self-parody in the design and manufacture. Both one-piece and two-piece costumes now commonly have "tears" or "rips" in them, held together by safety-pins or by threads stretched across the holes. This is part of fashion's lighthearted liking for tattered shipwreck-style clothing, as is after all not inappropriate for swimming costumes, although it is quite different from traditional formal design meant to suggest careful styling and dignity. Beachware at the beginning of the third millennium is proving itself to be wilfully and impassionedly refractory.

On the other hand, the sexual element is increasing, as the body is shown ever more openly, ever more intimately. The swimsuit is now an excuse for showing off the body inside it – for emphasizing form rather than disguising or concealing it. In the summer of 2001, for example, Dior presented a one-piece costume that left the breasts exposed: a shiny metallic material covered the abdomen and the stomach, which went only slightly farther up the body towards the bust.

And in *Vogue*, a short, black, nicely-shaped bikini was pictured from the back and seemed to present nothing innovatory. But the way the model wore it was certainly innovatory. With her right hand the girl was tugging down the bikini bottom exposing her buttocks. Clearly, the costume was only of secondary significance.

This is a tendency that could shock people, since it relegates the swimming costume and promotes the body. Yet to derive the desired "nude look" – a look with specifically sexual connotations – there must be some form, some item, of clothing. Hence, these are not inspiring towards complete nudism.

The bikinis remain confirmed in their opulent status. Most are made of materials that are more difficult to manufacture and more expensive to buy. As do the *Sugarloaf* models, they may incorporate knitted or crocheted wool and/or lycra, and have complex decoration on them such as starfish or multicoloured metal tiles. The current tendency is for unique and original, quite different from the "mass-produced" styles of the 1980s.

At the same time, the future of swimwear fashion relies heavily on what becomes of the beaches. From the 1900s, mill and factory-owners in northern England would organize communal holiday trips for their employees to the seaside for a week. The departures of huge numbers by rail to the coast during the summer is an enduring image of that time. Such a practice became common all over Western Europe (some employers actually paying their employees for the time off) – but in many countries, especially Italy, there were class restrictions involved. Some restrictions of this kind remain in force even today.

In other areas, it is beach-owners and local authorities who place restrictions on their use. Commercialization of the beaches in this way may be categorized as operating in three major areas: the bathing site and the beach proper; the road behind it, which allows traffic access to it and to other bathing areas each side; and the complex of houses and hotels behind the road but as near the beach as they can be, welcoming tourists and vacationers. Today, the bathing site may well be divided into independent strips, as marked perhaps by the colour of a row of beach-chairs or a line of beach-umbrellas. These may at least define the boundaries of the beach and allow visitors, unfamiliar with it, to orient themselves when walking round. In the strip of territory between the beach and the road is the "service area", where there may be open-air cafés and bars, and where people may wander around selling goods.

This style of holiday guarantees that there is in fact no free time for the vacationers. Every minute of every hour is scheduled with an agenda of "things to do" – activities that are virtually compulsory even if alternatives are allowed for. The beach and its surroundings are therefore based upon the concepts of entertainment and diversion.

An infrastructure necessary to the evolution of the beach complexes was developped: rail links and major road routes were constructed towards the coast; accommodation for visitors, and particularly long-term visitors were built. Little by little, then, the tourist industry was established, including the travel agencies and holiday clubs set up in capital cities and industrial conurbations. Above all, the tourist industry came quickly to be a useful contributor to national economies, generally benefiting from an ever-increasing and superbly regular annual income.

More precisely, it was in 1945 that such economic expansion really got off the ground in coastal areas. The economic potential for making something out of the very little present on the shorelines was especially true in countries of the Southern Hemisphere. Moreover, it was not just the countries but private interests that could benefit from this. As travelling became ever more easier, new horizons opened up, new opportunities presented themselves. In the Third World countries today, the tourist industry often provides, by far, the greater part of the nations' revenue.

Tourism in any case relies more on geography than on history. It was a way for Third World countries in the Southern Hemisphere – under-developed and unable to guarantee continuous economic growth, let alone independence – to benefit from a second "colonization." This time the colonists did not arrive as dour occupation troops and piously officious missionaries but as hordes of free-spending pleasure-seeking tourists.

The movement of tourists around the globe today is measurable on a demographic scale, and is equally evident in some areas of the Northern Hemisphere, notably the Mediterranean. Majorca in summer, for example, is renowned for being an almost entirely German enclave. And of course the initial enthusiasm of the residential population in many of these areas has in the meantime worn rather thin. They have become prisoners of the tourist industry, trapped in an unreal world where all is meant to be constantly uproarious fun and laughter. For locals it may well become a horribly ironic scene in a never-ending farce as they may come to see themselves as a sideshow in exhibition, without hope of escape.

The vacationer on the beach – who sits comfortably under a beach-umbrella doing a crossword, a cool drink in the hand, revelling in how slowly the holiday is going, and thinking how much nicer it would be never to go back home at all. The social function of the beach is to create a space where one can relax, away to escape the hustle and bustle of working-life. Ibiza, a marvelous island among others, is a place where one can transgress social prohibitions and cross certain barriers. The tourists find, on the beaches, an atmosphere comparable to Dionysiac celebrations and mascarades of yesteryear, which then become a nesting place of all excesses and debauchery.

The beach is an arena for social liberty. With its openness to excessive behaviour, it offers a range of

180.
On the beach.

181.
The Côte d'Azur, France. June 1992.

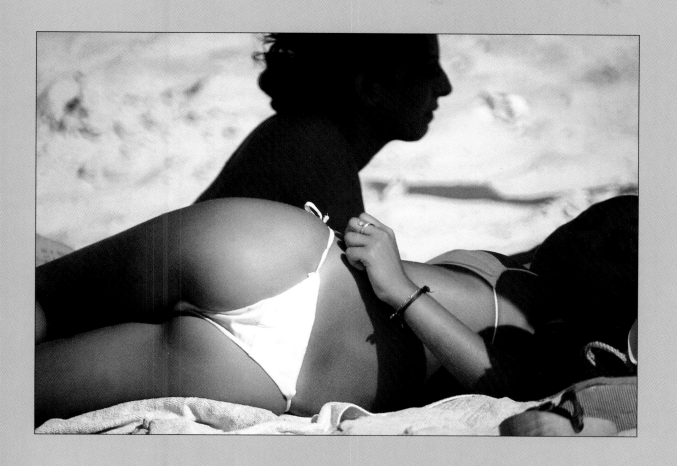

quite different experiences that our daily life cannot afford us. All kinds of happenings are possible there – adventures, surprises, frights. Creative activities may lead to unexpected revelations, perhaps even a change of personality. The beach becomes a childhood paradise, a magical place in which all boring constraints are lost and forgotten. To regain this magic year after year, to nurture it and to revivify it, is for many a yearly quest.

Beachwear fashion thus inspires a sort of joyous excitement in the anticipation, over lengthy preparations, of holidays that have been long worked for. Through it we can taste some of the pleasures to come on the beach. In due course that anticipation will itself add to our actual delight in being there on the beach.

The bikini, which beyond its ability to add visual significance to the human body, forms part of the spectacular order of the world in which we live, while representing a central focus of our wishes and desires to which we aspire, without necessarily believing them to be attainable.

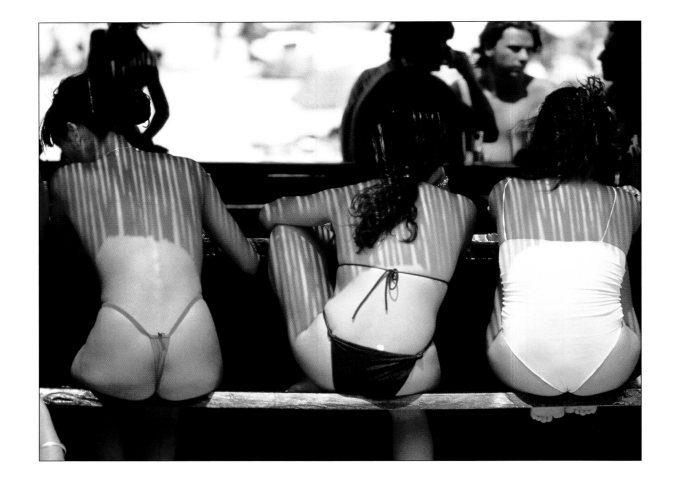

182.
Three women in a bar at Saint Tropez, France.

183.
Rio: a string at the back of a bikini.

Bibliography

Pedro Silmon, *The Bikini*. Diadem Books, New York (1986).

Lena Lencek and Gideon Bosker, *Making Waves: Swimsuits and the Undressing of America*. Chronicle Books, San Francisco (1989).

Joy McKenzie, *The Best in Swimwear Design (Over 100 contemporary designs for one-piece costumes and bikinis)*. B. T. Batsford (1998).

Olivier Saillard, *Les Maillots de Bain. Les Carnets de la Mode*. Editions du Chêne (1998).

Les Bains de Mer: Une Aristocratie de la Plage, 1880–1930. Bleu (1997).

Marie-Christine Grasse, *Coups de Soleil et Bikini*. Editions Milan (1997).

Fédération Française du Prêt-à-porter Féminin, *Vivre en maillot de bain*. Proform (1986).

Werner Timm, *Vom Badehemd zum Bikini: Bademoden und Badeleben im Wandel der Zeiten*. Husum Verlag, Husum (2000).

Fritz W. Kramer, *Bikini: Atomares Testgebiet im Pazifik*. Klaus Wagenbach, Berlin (2000).

184.
Bikini with tattoo.

Iconography

© AFP 10, 16, 22
© AFP/Joseph Barrak 39, 40
© AFP/Jean-Pierre Müller 57
© AFP/Rhéa Durham/ Jean-Pierre Müller 68
© AFP/Victoria Bouteloup/ Jean-Pierre Müller 69
© AFP/Barritt/Giuseppe Farinacci 70
© AFP/Philippe Merle 76
© AFP/Heather Knese/Jean-Pierre Müller 157
© AFP/Yamila Coba/Christophe Simon 158
© AFP/Fatima Lopez/Jean-Pierre Müller 163
© AFP/Juliana/Jean-Pierre Müller 164
© AFP/Laetitia Casta/Frederick Florin 171, 172
© AKG Paris/Gert Schütz 17, 18
© AKG Paris/Werner Forman 31
© AKG Paris/Erich Lessing 32
© AKG Paris 35-37, 84, 90, 94, 102, 125, 126
© AKG Paris/Günter Rubitzsch 38
© AKG Paris/Paul Almasy 49
© AKG Paris/Cameraphoto Epoche 98
© L'Aurore 15
© Bibliothèque de documentation internationale contemporaine (BDIC), Musée d'Histoire Contemporain, Paris/Tony Vaccaro 97
© Camilla Balbi/Patrick Mouïal 165-170
© Frédérique Dumoulin 176
© Fritz Kramer 21
© Gamma 77, 83, 180, 183
© Gamma/« Editorial Atlantida » 1
© Gamma/Brylak 51, 52
© Gamma/Giboux/Liaison USA 71, 72
© Gamma/Franzo Adolfo 73-75
© Gamma-Liaison/Sander 156
© Gamma /Christy Turlington 173
© Gamma/ Mattez Ford/FSP 181
© Gamma/Sigla 182
© Helena Christensen/Wolf Schuffner 175
© Imapress/Felix Aeberli 67
© Imapress/Theodore Wood 92
© Imapress/Brigitte Bardot/Sam Levin 103
© Keystone 23, 24, 26, 30, 50
© Kobal Collection 93, 127, 130, 131
© Ursula Andress/United Artists (mit Erlaubnis von Kobal Collection) 85, 91

© Eon Productions (mit Erlaubnis von Kobal Collection) 86
© Britt Ekland/Eon Productions (mit Erlaubnis von Kobal Collection) 88
© Jayne Mansfield (mit Erlaubnis von Kobal Collection) 95
© Raquel Welch (mit Erlaubnis von Kobal Collection) 108
© Raquel Welch (mit Erlaubnis von Kobal Collection) 110, 111
© Barbara Eden (mit Erlaubnis von Kobal Collection) 123
© Marilyn Monroe (mit Erlaubnis von Kobal Collection) 124
© Mamie van Doren (mit Erlaubnis von Kobal Collection) 128
© Christiane Schmittmer (mit Erlaubnis von Kobal Collection) 129
© Rhonda Fleming (mit Erlaubnis von Kobal Collection) 132
© Susan Hampshire (mit Erlaubnis von Kobal Collection) 133
© Stella Stevens (mit Erlaubnis von Kobal Collection) 134
© Kristy Hume/Wolf Schuffner 178
© Lucas Film/Twentieth Century Fox 65
© Newsmakers 145, 146
© Brasilianisches Fremdenverkehrsamt, London/Ricardo Azoury 184
© Paris-presse 20
© Rue des archives, Paris 2-9, 11-14,19, 25, 28, 29, 33, 34, 41-48, 53-56, 58-64, 66, 78-82, 87, 89, 99-101, 107, 109, 122-122, 136-144, 149-15, 179
© Rue des archives/Brigitte Bardot 104-106
© Shalom/Karl Lagerfeld 174
© SIPA 27
© Sports Illustrated 147, 148
© Stella Tenant/Wolf Schuffner 177
© Tanya Rudenko/Jean-Marie Delhostal 159-162